EACH WILD IDEA

THE MIT PRESS CAMBRIDGE, MASSACHUSETTS LONDON, ENGLAND

EACH

WILD

IDEA

WRITING PHOTOGRAPHY HISTORY

GEOFFREY BATCHEN

©2001 MASSACHUSETTS INSTITUTE OF TECHNOLOGY

ALL RIGHTS RESERVED. NO PART OF THIS BOOK MAY BE REPRODUCED IN ANY

FORM BY ANY ELECTRONIC OR MECHANICAL MEANS (INCLUDING PHOTOCOPYING, RECORDING, OR INFORMATION STORAGE

AND RETRIEVAL) WITHOUT PERMISSION IN WRITING FROM THE PUBLISHER.

THIS BOOK WAS SET IN ADOBE GARAMOND, ENGRAVERS GOTHIC, AND OFFICINA SANS BY GRAPHIC COMPOSITION, INC.

PRINTED AND BOUND IN THE UNITED STATES OF AMERICA.

LIBRARY OF CONGRESS CATALOGING-IN-PUBLICATION DATA

BATCHEN, GEOFFREY.

EACH WILD IDEA : WRITING, PHOTOGRAPHY, HISTORY / GEOFFREY BATCHEN.

P. CM.

INCLUDES BIBLIOGRAPHICAL REFERENCES AND INDEX.

ISBN 0-262-02486-1 (HC. : ALK. PAPER)

1. PHOTOGRAPHY. 2. PHOTOGRAPHY—PHILOSOPHY. I. TITLE.

TR185.B32 2001

770—DC21

00-042355

Not however expecting connection, you must just accept of each wild idea as it presents itself.

—Thomas Watling, *Letters from an Exile at Botany-Bay,* 1794

CONTENTS

PRELUDE

There can be something quite disconcerting about anthologies like this one. Nine essays by a single author are garnered from a variety of sources and presented as a coherent narrative. Congealed each in the moment of its initial publication, such essays usually provide little more than an archaeology of these past moments, a history of the unfolding of history itself. *Each Wild Idea* certainly repeats this model; its chapters incorporate essays already published elsewhere (in academic journals, exhibition catalogues, and art magazines). But this book is not only a record of past publications, for these publications all appear here in revised and/or expanded form, having been brought up to date and often stitched together into broader arguments bearing on photography and the writing of its history. In other words, like the photography they discuss, these essays take up the kernel of an initial exposure and subject it to continual development, reproduction, and manipulation. Written through a process of accretion, they are presented here as works in progress, coming from the past but still in motion, (never) to be completed, and therefore also of and about the present.

The subjects of these essays range widely, from a discussion of the timing of photography's invention to analyses of the consequences of cyberculture. In between there are reflections on the Australianness of Australian photography (another indication of my own historical trajectory), the state of contemporary art photography, and the place of the vernacular in photography's history. In each case, readers are faced with having to determine the relationship of form and history, and therefore of being and identity, a crucial yet complicated spacing too quickly stilled by the formalist and postmodern approaches that continue to dominate photographic discourse. Thus, despite its variety of themes, *Each Wild Idea* is marked by a constant refrain throughout: the vexed (and vexing) question of photography's past, present, and future identity.

A brief note on method would seem to be appropriate. Informed by the aspirations and rhetorics of postmodernism, this book engages the semiotics of photographic meaning.

It assumes, in other words, that the meaning of every photograph is imbricated within broader social and political forces. However, my writing does not want to regard this production as simply a cultural matter, as if meaning and politics infiltrate the passively waiting photograph only from the outside. What is the photograph on the inside, before it enters a specific historical and political context? The question is an impossible but necessary one—impossible because there can never be an unadulterated "before," necessary because the positing of an originary moment is the very condition of identity itself.

This Prelude, for example, comes before the chapters that make up the rest of this book and yet was written after them. To read it now is to experience a peculiar convolution of spatial and temporal orders, a kind of convolution that constantly reappears throughout these essays. For my interest here is in the way photography is inevitably an "impossible" implosion of before and after, inside and outside. I want to articulate photography as something that is simultaneously material and cultural, manifested as much in the attributes of the photographic object as in its contextualization. Philosophy has a word for all this: *deconstruction*. In the words of Gayatri Spivak, "The sign must be studied 'under erasure', always already inhabited by the trace of another sign which never appears as such. 'Semiology' must give way to 'grammatology'." The language is difficult to grasp, but so is the agency it seeks to describe. And even when this agency is conceded, one might well still want to ask, So how does this tracing embody itself in and as the flesh of a photograph? This could be taken as the motivating challenge of *Each Wild Idea*.

The essays that follow ponder this question in any number of ways, but they all take their cues from a consideration of the particularities of specific photographs. If nothing else, my discussions should remind us of photography's wonderful strangeness (inference: you do not have to read theory to encounter the dynamics of a photogrammatology—just look at the evidence of history itself). *Each Wild Idea* is a compendium of such evidence, finding it in everything from a master work by Alfred Stieglitz to a humble combination of baby photo and bronzed booties. I show that both examples incorporate their own singular histories (they are not just in history; they *are* history). The difficulty is conveying this process through a piece of writing. To my surprise, I have often found myself gravitating toward sheer description as a mode of analysis, thus insisting that we look right at, rather than only beyond, the formal qualities of the photograph being discussed. This attention to form has little to

do with a desire to reveal photography's essential characteristics as a medium (the purported ambition of the kind of formalism to which postmodernism has traditionally opposed itself). It is, rather, an effort to evoke directly the lived experience of history, a reminder that history is continually unfolding itself in the materiality of the present—in the presentness of whatever photograph, from whatever era, happens to be before us. Once again Roland Barthes is proved right: "To parody a well-known saying, I shall say that a little formalism turns one away from History, but that a lot brings one back to it."

All intellectual work is a collective enterprise, and the endnotes to the essays that follow testify to the degree to which my own thinking has always been dependent on that of others. But this Prelude also allows me to thank the many people to whom I am more personally indebted. These acknowledgments in turn reveal the degree to which this anthology is autobiographical in character. The book's shifts in focus and methodology, and the pattern of individuals who contributed to those shifts, speak to my own developing career as a writer of historical criticism, as well as to my current identity as an expatriate Australian working in the United States.

Some of these essays were begun ten years ago in Sydney, Australia. The insights and suggestions of Vicki Kirby considerably improved my early work and still guide my thinking today. The work of Australian artist and writer Ian Burn offered a model of engaged cultural criticism that I continue to try to emulate. More recently I have been particularly fortunate in having graduate students at the University of New Mexico who have tolerated, challenged, and encouraged my work in all sorts of ways; these students have included Monica Garza, Shari Wasson, Nina Stephenson, Patrick Manning, Marcell Hackbardt, Are Flågan, Erin Garcia, Rachel Goodenow, and Sara Marion. I especially want to thank Danielle Miller for fostering a life in which critical writing could be produced. I also acknowledge colleagues at UNM—Christopher Mead, Thomas Barrow, Charlene Villaseñor Black, Elizabeth Hutchinson, and Carla Yanni—who have given me both moral and physical support whenever I have needed it. Tom Barrow in particular has been a constant source of encouragement and assistance.

Both Marlene Stutzman and Monica Garza worked as my research assistants during this book's formation; their dedication and care have been essential to its completion. Mar-

cell Hackbardt made a number of the reproduction photographs that appear here, for which I am duly grateful. Are Flågan also helped by turning some of the illustrations into digital files. The employment of all of these people was made possible by generous grants from the University of New Mexico: a 1996–1997 Research/Creative Work Grant from the Dean's Office of the College of Fine Arts and a 1998 Research Allocations Committee Grant.

Many other individuals, some of whom I have never met in the flesh, have been very generous in sharing their advice, ideas, and research; these include Sue Best, Carol Botts, Martin Campbell-Kelly, Helen Ennis, Anne Ferran, Are Flågan, Douglas Fogle, Holland Gallop, Monica Garza, Alison Gingeras, Michael Gray, Sarah Greenough, Kathleen Howe, Elizabeth Hutchinson, Daile Kaplan, Tom Keenan, Richard King, Vicki Kirby, Caroline Koebel, Josef Lebovic, Patrick Manning, Danielle Rae Miller, Gael Newton, Douglas Nickel, Tim Nohe, Alex Novak, Eric Riddler, Larry Schaaf, Ingrid Schaffner, Susan Schuppli, John Spencer, Ann Stephen, Peter Walch, and Catherine Whalen.

I thank the many institutions that granted permission to reproduce images in this book. A number of individuals also generously provided permissions and/or illustrative material; they include Hans Krauss, Jill White, and James Alinder. Some of the artists discussed here have been unusually helpful in providing information about their work; in particular, I thank Sheldon Brown, Jennifer Bolande, Anne Ferran, Jacky Redgate, Laura Kurgan, Ellen Garvens, Rachel Stevens, Andreas Müller-Pohl, Lynn Cazabon, and Igor Vamos. Most of these essays appeared in fledgling form in journals and magazines (listed at the end of each essay), and I thank the many editors and publishers concerned, both for their initial support and for agreeing to their reproduction here. I also gratefully acknowledge the support and advice of my editor at The MIT Press, Roger Conover, the editorial expertise of Sandra Minkkinen, and the marvelous work of designer Ori Kometani.

Finally, I simply thank all those friends who in various ways have sustained my life while these essays were being written. Their interest and care are what make such writing possible.

EACH

WILD

IDEA

1 + +

+ + +

+ + +

DESIRING PRODUCTION

"Begin at the beginning," the King said, very gravely, *"and go on till you come to the end: then stop."*
—Lewis Carroll, *Alice in Wonderland*

The King's advice to Alice, has been taken to heart by those who write the history of photography.[1] The end is apparently not yet in sight, but the beginning is in almost every account identified with the invention of a marketable photographic apparatus and the successful production of the first photographs. Not only does this originary event mark the starting point, or at least the first climactic moment, of their narrative structures; it has come to represent the one common empirical incident in an otherwise unruly and quarrelsome ensemble of photographic practices and discourses. For this reason, the story of the invention of photography has become the stable platform on which all the medium's many subsequent manifestations are presumed to be founded. (To paraphrase Jacques Derrida, photography's historians have a vested interest in moving as quickly as possible from the troubling philosophical question, "What is photography?" to the safe and expository one, "Where and when did photography begin?")[2] At the same time, the circumstances of photography's invention are commonly used to establish the medium's continuity with a linear development of Western practices of representation reaching back to, inevitably, the Renaissance. Any questioning of photography's beginnings therefore also represents a questioning of the trajectory of photography's history as a whole.

It was on January 7, 1839, in the form of a speech by François Arago to the French Academy of Sciences, that the invention of photography was officially announced to the world.[3] Further enthusiastic speeches about Louis Daguerre's amazing image-making process were subsequently made to the Chamber of Deputies on June 15 and finally to a combined meeting of the Academy of Sciences and Fine Arts on August 19. It was only on this latter date that the daguerreotype and its camera apparatus were ready to be introduced to an already eager market. Indeed, so eager was this market that within the space of a few months, the daguerreotype had found its way to almost every corner of the globe and infiltrated almost every conceivable genre of image making. Meanwhile, over in England, William Henry Fox Talbot had been motivated by the news of Daguerre's discovery to announce hurriedly

that he had also been conducting some experiments with a photographic process. His process, significantly different from that devised by Daguerre, was subsequently described in detail on January 31, 1839, in a paper delivered to the Royal Society. After undergoing a few refinements, Talbot's paper-based image and negative-positive method proved even more amenable than the daguerreotype to a wide variety of uses and provided the basic principles of the photography we still use today.

So no one would want to deny that 1839 was an important year in the life of photography, particularly with regard to the direction of its subsequent technical, instrumental, and entrepreneurial developments. However, the traditional emphasis on 1839, and the pioneering figures of Daguerre and Talbot, has tended to distract attention from the wider significance of the timing of photography's emergence into our culture. This essay aims first to establish this timing and then to articulate briefly something of that significance.

In the introduction to his authoritative tome *The Origins of Photography*, Helmut Gernsheim went so far as to describe the timing of photography's invention as "the greatest mystery in its history": "Considering that knowledge of the chemical as well as the optical principles of photography was fairly widespread following Schulze's experiment [in 1725] . . . the circumstance that photography was not invented earlier remains the greatest mystery in its history. . . . It had apparently never occurred to any of the multitude of artists of the seventeenth and eighteenth centuries who were in the habit of using the camera obscura to try to fix its image permanently."[4]

Why 1839 and not before? Why, for example, didn't any of the great thinkers of the past—Aristotle, Leonardo, Newton—come up with this idea, even if only in the form of textual or pictorial speculation? This is the question that continues to haunt the history of photography's invention. But how are the medium's historians to engage with it? More to the point, how are we to develop a critical, and, from that, a political understanding of photography's timing? Perhaps the historical methods of French philosopher Michel Foucault may be helpful. Foucault's various archaeologies have, after all, concerned themselves at least in part with a critique of traditional historical ideas about invention and beginnings.

"Archaeology is not in search of inventions, and it remains unmoved at the moment (a very moving one, I admit) when, for the first time, someone was sure of some truth; it does not try to restore the light of those joyful mornings. But neither is it concerned with the

average phenomena of opinion, with the dull gray of what everyone at a particular period might repeat. What it seeks is not to draw up a list of founding saints; it is to uncover the regularity of a discursive practice."[5]

Following Foucault, we might find it useful to shift the emphasis of our investigation of photography's timing from 1839 to another, earlier moment in the medium's history: to the appearance of a regular discursive practice for which photography is the desired object. The timing of the invention of photography is thereby assumed to coincide with its conceptual and metaphoric rather than its technological or functional manifestations. Accordingly this essay will ask not who invented photography but, rather, At what moment in history did the discursive *desire* to photograph emerge and begin to manifest itself insistently? At what moment did photography shift from an occasional, isolated, individual fantasy to a demonstrably widespread, social imperative? When, in other words, did evidence of a desire to photograph begin to appear with sufficient regularity and internal consistency to be described in Foucault's terms as a discursive practice?

One historian, Pierre Harmant, has already offered a surprisingly crowded list of twenty-four people who claimed at one time or another to have been the first to have practiced photography; seven of these came from France, six from England, five from Germany, one from Belgium, one was American, one Spanish, one Norwegian, one Swiss, and one Brazilian. Upon further examination of their claims, Harmant concluded that "of these, four only had solutions which were truly original."[6] However, this is not a criterion that is particularly pertinent to an investigation of the desire to photograph. It is, after all, the timing and mythopoetic significance of such a discourse that is at issue rather than the historical accuracy or import of individual texts or claimants. Originality of method, accuracy of chemical formulas, success or failure: these irrelevancies need not be taken into account when compiling a list of names and dates of those who felt a desire to photograph. All that need be deleted from such a list are those persons, and there are many of them, who began their experiments only after first hearing of the successes of either Daguerre or Talbot.[7] These missing figures were often important to the future developments of photography as a technology and a practice. However, as far as the emergence of a photo-desire is concerned, they represent no more than, as Foucault unkindly puts it, "the dull gray of what everyone at a particular period might repeat."

Here then is my own roll call, undoubtedly an incomplete and still speculative one, of those who recorded or subsequently claimed for themselves the pre-1839 onset of a desire to photograph: Henry Brougham (England, 1794), Elizabeth Fulhame (England, 1794), Thomas Wedgwood (England, c.1800), Anthony Carlisle (England, c.1800), Humphry Davy (England, c.1801–1802), Thomas Young (England, 1803), Nicéphore and Claude Niépce (France, 1814), Samuel Morse (United States, 1821), Louis Daguerre (France, 1824), Eugène Hubert (France, c.1828), James Wattles (United States, 1832), Hercules Florence (France/Brazil, 1832), Richard Habersham (United States, 1832), Henry Talbot (England, 1833), Philipp Hoffmeister (Germany, 1834), Friedrich Gerber (Switzerland, 1836), John Draper (United States, 1836), Vernon Heath (England, 1837), Hippolyte Bayard (France, 1837), José Ramos Zapetti (Spain, 1837).[8]

These are the persons we might call the protophotographers. As authors and experimenters, they produced a voluminous collection of aspirations for which some sort of photography was in each case the desired result. Sometimes this is literally so. We find Niépce writing in 1827 to Daguerre—for example, "In order to respond to the *desire* which you have been good enough to express" (his emphasis)—and find Daguerre replying in the following year that "I cannot hide the fact that I am burning with desire to see your experiments from nature."[9] On other occasions we are left to read this desire in the objects these people sought to have represented—invariably views (of landscape), nature, and/or the image found in the mirror of the camera obscura—or alternatively in the words and phrases they use to describe their imaginary or still-fledgling processes. Davy's 1802 paper about the experiments of himself and his friend Tom Wedgwood, for example, records their attempts to use silver nitrates and chlorides to capture the image formed by the camera obscura, followed by similar efforts to make contact prints of figures painted on glass as well as of leaves, insect wings, and engravings. The Niépce brothers seem to have been inspired by lithography in their experiments to make light-induced copies of existing images, although from 1827 on, Nicéphore concentrated his energies on the possibility of making "a view from nature, using the newly perfected camera." This is an ambition also expressed by Indiana student James Wattles, who in 1828 made a temporary image in his camera of "the old stone fort in the rear of the school garden." In about this same year, French architect Eugène Hubert attempted to produce camera images of plaster sculptures, and in 1833 Brazilian artist Hercules Florence made experimental views from his window.[10]

So the celebrated photographic experiments of Henry Talbot, begun only in 1833, should be regarded as but one more independent continuation of a desire already experienced by many others. Once a technical solution to this desire had occurred to him, Talbot quickly produced contact prints of botanical specimens, pieces of lace, and his own handwriting, then images projected by his solar microscope, and finally pictures of his family home, Lacock Abbey, imprinted on sensitized paper placed in the back of a small camera obscura. By the 1840s he had also made a wide variety of other types of image. Historians tend to regard most of these images simply as straightforward demonstrations of his process. However, some, like Mike Weaver, argue that at least one or two of them "produced a metaphorical rather than purely descriptive account of reality."[11] I would go even further and suggest that Talbot was an omniverous but never arbitrary image maker; all of his pictures have metaphorical meanings.

A case in point is the series of tiny pictures Talbot made of the inside of the window from the South Gallery of Lacock Abbey. This oriel window is the subject of an often-reproduced image, Talbot's earliest extant negative, taken in August 1835. As Talbot points out in a hand-written inscription next to this negative (perhaps added when it was exhibited in 1839), the number of squares of glass can be counted with the help of a magnifying lens. And if we take his advice and look more closely, we also see that it is a landscape image, for we can just glimpse the silhouetted forms of trees and bushes through the window's transparent panes. Interestingly, Talbot repeats this same basic composition in at least five other negatives, some also made in 1835 and others made perhaps four years later.[12] In all six cases, Talbot's picture shows us nothing but this window; it fills the picture plane entirely, resulting in an abstract blue and white pattern of diamond shapes framed only by the more solid outlines of the latticed window structure itself. (photo 1.1) So why would Talbot make at least six pictures of nothing—of nothing but panes of glass, of a subject with no particular intrinsic interest, either as science or art?

Talbot expert Larry Schaaf implies that a fireplace mantle opposite this window made it an attractive platform for Talbot's primitive camera, allowing him to make a high-contrast negative in favorable environmental conditions.[13] Talbot had rebuilt this particular room as a potential art gallery after he occupied the family home in 1827, completing the job in 1831. The space featured three bay windows, with Talbot choosing to photograph only the

1.1

William Henry Fox Talbot, The Oriel Window, Lacock Abbey, seen from the inside, *c. Summer 1835*
Photogenic drawing negative
Metropolitan Museum of Art, New York

central and smallest example, at a point where the room has narrowed into little more than a wide corridor. He points his camera directly into the light, directly at that feature of the room that is neither inside nor outside but both. What is particularly interesting about these window pictures is that Talbot makes no effort to describe the space of the gallery itself, as he does in a number of later pictures of interiors (*Interior of South Gallery, Lacock Abbey,* November 23, 1839, or March 2, 1840) and their windows. Nor does he allow the window's light to be cast over something else (implying spiritual or intellectual enlightenment), as he does over a bust of Patroclus in a print from November 1839 or over the objects in *Window-seat,* from May 30, 1840. He instead produces an entirely flat, virtually abstract image, an image that emulates the equally flat and already familiar two-dimensional look of the contact print. It is as if he wants to tell us that this window has imprinted itself directly onto his paper, without the mediation of composition or artistic precedent.

This is soon to become a common pictorial option for Talbot; glassware, ceramic vessels, figurines, shelves of books, and even an array of hats all eventually get the same treatment. In each case, Talbot carefully arranged these tiers of objects out in the courtyard of Lacock Abbey in order to exploit the best possible lighting conditions. In other words, he fakes their setting; he asks these objects to perform as if they are somewhere they are not, as if they were sitting indoors. The images that result employ the aesthetic of modern scientific analysis and commercial display. However, it is also a way for Talbot to emphasize the emblematic over the naturalistic possibilities of photographic representation. But emblematic of what?

Could the window picture be read as an emblem of itself, of the very photogenic drawing process that has made its own existence possible? When you think about it, Talbot has set up his camera at exactly the point in the South Gallery where the sensitive paper once sat in his own modified camera obscura. His camera obscura looks out at the inside of the metaphorical lens of the camera of his own house (which he later claimed was "the first that was ever yet known *to have drawn its own picture*").[14] He is, in other words, taking a photograph of photography at work making this photograph. In a letter to Lady Mary Cole about her own photographic "experimentalizing," dated August 9, 1839, Talbot advised her that "the object to begin with is a window & its bars placing the instrument in the interior of the room."[15] So, for Talbot, a picture of the inside of a window is an exemplary photograph—the first

photograph one should attempt, the origin point of one's photography, the origin of all photography. Where Niépce and Daguerre both take pictures *from* their windows, Talbot makes an image *of* his window. He tells us that photography is about framing, and then shows us nothing but that frame; he suggests that photography offers a window onto the world, but then shows nothing but that window.[16] As Derrida suggests, "The time for reflection is also the chance for turning back on the very conditions of reflection, in all senses of that word, as if with the help of a new optical device one could finally see sight, one could not only view the natural landscape, the city, the bridge and the abyss, but could view viewing."[17] This, then, is no ordinary picture. It is rather what Talbot elsewhere called a "Philosophical Window."[18]

But there is still more to this picture. His camera also looks from the perspective of Talbot himself, as if the photographer was leaning up against the wall opposite (literally sitting or standing in the place of the developing photograph). In other words, Talbot's camera obscura acts in place of his own sensitized eye, as a detachable prosthesis of his own body (he himself referred to the "eye of the camera" in his 1844 book, *The Pencil of Nature*).[19] It is a photograph of the absent presence of the photographer. In 1860, George Henry Lewes, in his *The Physiology of Common Life,* suggested that if "we fix our eyes on the panes of a window through which the sunlight is streaming, the image of the panes will continue some seconds after the closure of the eyes."[20] Talbot's serial rendition of his own window demonstrates precisely this afterimage effect, projecting the photographs that result as retinal impressions, retained even after the eye of his camera has been closed.

In effect, this deceptively simple image articulates photography not as some sort of simply transparent window onto the real, but as a complex form of palimpsest. Nature, camera, image, and photographer are all present even when absent from the picture, as if photography represents a perverse dynamic in which each of these components is continually being inscribed in the place already occupied by its neighbor. In Talbot's hands, photography is neither natural nor cultural, but rather an economy that incorporates, produces, and is simultaneously produced by both nature *and* culture, both reality *and* representation (and for that very reason is never simply one or the other).

Talbot offers another, equally complex, articulation of photography in his first published paper on the subject, presented in January 1839 to the Royal Society. The title of this

paper again poses the problem of photography's identity. Photography is, he tells us, "the art of photogenic drawing," but then he goes on to insist that through this same process, "natural objects may be able to delineate themselves without the aid of the artist's pencil." So, for Talbot, photography apparently both is and is not a mode of drawing; it combines a faithful reflection of nature with nature's active production of itself as a picture, somehow incorporating both the artist *and* that artist's object of study. With this conundrum in place, he goes on in his text to posit yet another. Never quite able to decide whether the origins of photography are to be found in nature or in culture (as we have seen, his own early photograms include both botanical specimens and samples of lace and handwriting), Talbot comes up with a descriptive phrase that contains elements of each: "the art of fixing a shadow": "The most transitory of things, a shadow, the proverbial emblem of all that is fleeting and momentary, may be fettered by the spells of our *'natural magic,'* and may be fixed for ever in the position which it seemed only destined for a single instant to occupy. . . . Such is the fact, that we may receive on paper the fleeting shadow, arrest it there and in the space of a single minute fix it there so firmly as to be no more capable of change."[21]

Having decisively abandoned empirical explanation in favor of poetic metaphor, Talbot finds himself speaking of the new medium as a quite peculiar articulation of temporal and spatial coordinates. Photography is a process in which "position" is "occupied" for a "single instant," where "fleeting" time is "arrested" in the "space of a single minute." It would seem he is able to describe the identity of photography only by harnessing together a whole series of unresolved binaries: "art" and "shadows," the "natural" and "magic," the "momentary" and the "for ever," the "fleeting" and the "fettered," the "fixed" and that which is "capable of change." Photography for Talbot is the uneasy maintenance of binary relationships; it is the desire to represent an impossible conjunction of transience and fixity. More than that, the photograph is an emblematic something/sometime, a "space of a single minute," in which space *becomes* time, and time space.

In late 1838, Daguerre circulated a subscription brochure soliciting investors in his new invention. His text finishes with a sentence that in its contradictory convolution of language is surprisingly reminiscent of the description Talbot offered a month or two later. In conclusion, Daguerre says, "The DAGUERREOTYPE is not merely an instrument which serves to draw Nature; on the contrary it is a chemical and physical process which gives her the

power to reproduce herself."[22] Again, photography is something that allows nature to be simultaneously drawn and drawing, artist and model, active and passive (both, and therefore never quite either). During this same period, Daguerre produced three series of daguerreotypes of Parisian street scenes, each comprising three images of the same scene taken at different times of the day. He made two views of the Boulevard du Temple from the window of his studio in the Diorama building, one at 8 A.M. and the other at about midday. He made at least one more of these same views of the Boulevard du Temple, in this case taken late in the afternoon and showing horses that have moved during the exposure. A journalist writing for the *Spectator* reports in the issue of February 2, 1839, that Daguerre made three similar views of the Luxor obelisk in the Place de la Concorde by morning, noon, and evening light. Around the same time he also took a series of views of the Tuileries Palace, "taken at three different times of the day in the summer: in the morning at five, in the afternoon at two, and at sundown."[23] These series surely represent a commentary on the interdependence of appearance and time, even as they visualize time itself as a continuous linear sequence of discrete moments. They also showed that photography was, in the way it brought the present and the past together in the one viewing experience, capable of folding time back on itself. In other words, Daguerre again presents photography as a distinctive temporal articulation of what it, and therefore we, see. Indeed, he, like Talbot, seems to be suggesting that the primary subject of every photograph is time itself.

The work of the various protophotographers is by no means the only source for a discourse of this kind. In the few decades on either side of 1800, we can find increasing evidence of a similar set of aspirations and explorations figured in various other fields of endeavor. As early as 1782, William Gilpin, the English clergyman and famous advocate of picturesque theory, had been moved to express some vexation at not having the means to capture adequately the fleeting visual sensations of a river journey he was undertaking. In his *Observations on the River Wye,* he makes the following comment: "Many of the objects, which had floated so rapidly past us, if we had had time to examine them, would have given us sublime, and beautiful hints in landscape: some of them seemed even well combined, and ready prepared for the pencil: but in so quick a succession, one blotted out another."[24] In 1791 we find Gilpin again wishing for the impossible, this time for the ability to make his mirrored Claude glass "fix" its reflected image: "A succession of high-coloured pictures is continually gliding

before the eye. They are like the visions of the imagination; or the brilliant landscapes of a dream. Forms, and colours in brightest array, fleet before us; and if the transient glance of a good composition happen to unite with them, we should give any price to fix and appropriate the scene."[25]

These sentiments would have been appreciated by English painter John Constable. In 1833, for example, Constable published a book on his landscape painting in which, he claimed, "an attempt has been made to arrest the more abrupt and transient appearance of the CHIAR'OSCURO IN NATURE . . . to give 'to one brief moment caught from fleeting time' a lasting and sober existence, and to render permanent many of those splendid but evanescent Exhibitions, which are ever occurring in the changes of external Nature."[26] Throughout the 1820s and 1830s, Constable sought to produce pictures of this "arrested transience" in the form of a seemingly endless series of painted sketches of the sky. Typical of these, in both pictorial form and the careful empirical exactitude of its title, is his watercolor sketch *Study of Clouds at Hampstead (Cloud Study Above a Wide Landscape, About 11–noon, Sept 15, 1830, wind-W)* (photo 1.2).

At first glance it appears to be a picture of nothing much at all. A thin, horizontal strip of landscape anchors what is an otherwise empty sheet of paper—empty, that is, but for some rapidly applied strokes of paint meant to represent clouds scurrying about in the wind. It is, in fact, a picture of time itself, an attempt on Constable's part to stop time in its tracks, to make time visible. The attempt can never quite succeed of course, as he implicitly acknowledges through the rapidity and insubstantiality of his paint application and his demonstrated need to paint this same subject over and over again. Time, it seems, stops for no one. The picture is about this too. It is about the man who has painted it, and all the people who stand in his metaphorical shoes to look at it now. To a degree foreign to earlier generations of painters, Constable is interested in representing the reality of immediate and momentary perceptual experience. He deliberately shows us this landscape as it is being seen by an imperfect human eye rather than through the ideal, eternal gaze of God. He depicts what a particular person saw standing in a particular place at a particular time, looking upward at the sky under quite particular atmospheric conditions. The picture not only acknowledges and presumes the presence of this viewer; it puts that viewer firmly in place, inscribed as it were within the very fiber of its being.

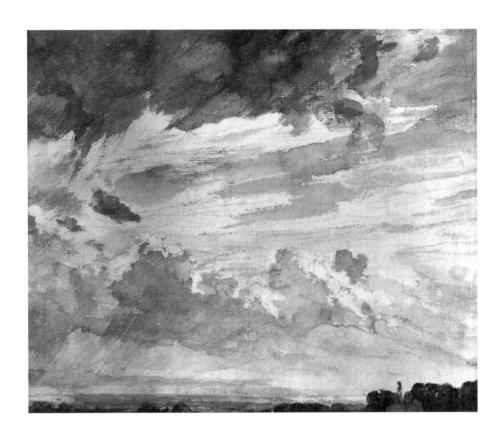

1.2

John Constable, Study of Clouds at Hampstead (Cloud Study Above a Wide Landscape, About 11–noon, Sept 15, 1830, wind-W), *1830*
Watercolor on paper
Victoria and Albert Museum, London

Samuel Taylor Coleridge was another contemporary of the protophotographers (in fact, he was a close friend of three of them) whose work sought to resolve the "time anxiety" we have already seen expressed by Talbot, Daguerre, Gilpin, and Constable.[27] His poetry sought to reproduce in words the lived experience of seeing nature. Like Constable, he tries to capture the instant of perception, that image that is in the eye for only a moment before it changes forever. And, also like Constable, he has the problem of trying to do so through a form of representation (writing) that immediately becomes permanent and fixed in place. How can his writings reconcile eternal nature (the trace of God) and the instant of its actual perception (the presence of humanity)? How can he convey both fixity and transience in the same passage of prose?

In 1817, Coleridge described this poetic ambition with a strikingly photographic metaphor: "Creation rather than painting, or if painting, yet such, and with such co-presence of the whole picture flash'd at once upon the eye, as the sun paints in a camera obscura."[28] In poems like *The Eolian Harp* (1795) and *This Lime-Tree Bower My Prison* (1797) he again compares this "copresence" to the fleeting image stilled by the camera obscura or its equivalent (specifically, an eolian harp, which allows the wind to create its own music, and a leafy bower that projects an image of those leaves onto the ground below). He imagines, in other words, a means of representation that is a direct reflection of nature but also acknowledges the subjective perception of nature experienced by an individual viewer. Stretched out on the side of a hill at noon, he looks upward through half-closed eyes, seeing nothing but "the sunbeams dance." He becomes, he tells us in *The Eolian Harp,* a living camera:[29]

Full many a thought uncall'd and undetain'd,
And many idle flitting phantasies,
Traverse my indolent and passive brain,
As wild and various as the random gales
That swell and flutter on this subject Lute!

Hovering between passive reverie and active thought, the object of Coleridge's vision is nothing less than his own subjectivity. With a certain wonderment, he feels himself becoming "a Self-conscious Looking-glass," as he put it in a note many years later.[30] What else

could Coleridge's "unregenerate mind" be shaping here but the equivalent of a desire to photograph, a desire to take his particular, evanescent vision of nature, and, as Talbot put it, have it "fixed for ever in the position which it seemed only destined for a single instant to occupy"? But he is also fixing himself. Coleridge recognizes that the image he sees is an interaction of nature and his own eye; becoming a camera involves witnessing the spontaneous production of both. In June 1802, Humphry Davy wrote in the *Journals of the Royal Institution* that to copy the images formed by the camera obscura "was the first object of Mr. Wedgwood in his researches on the subject."[31] In November 1802, Coleridge compared the mind of this same Tom Wedgwood to a "miniature Sun seen, as you look thro' a Holly Bush"—in other words, to the visionary copresence of reflection and projection, time and space, viewed object and viewing subject, that makes any camera a potentially *photographic* one.[32]

So we get a sense that the desires, and confusions, of the inventors of photography are shared by many others, that the desire to photograph emerges from a confluence of cultural forces rather than from the genius of any one individual. What a study of this history shows, first and foremost, is that the desire to photograph appeared as a regular discourse at a particular time and place—in Europe or its colonies during the two or three decades around 1800. The inference clearly is that it was possible to think "photography" only at this specific conjuncture, that photography as a concept has an identifiable historical and cultural specificity. Now it might be argued that there had been a number of earlier instances of this photographic desire, like Johann Schulze's experiments with light-sensitive chemicals published in 1727 and Tiphaigne de la Roche's allegorical novel written in 1760. However, what is striking about such possible approximations of photography is how few and far between they are until the 1790s. Much more overwhelming in this regard is the vast *absence,* prior to this period, of talk along the lines I have described. From a virtual dearth of signs of a desire to photograph, the historical archive reveals the onset only in the last decade of the eighteenth century of a rapidly growing, widely dispersed, and increasingly urgent need for that-which-was-to-become-photography.

Indeed by 1839, the desire to photograph was apparently so well established that Arago could confidently assume to speak for all when he claimed that "everyone who has admired these images [produced in a camera obscura] will have felt regret that they could not be rendered permanent."[33] Later that year Arago was again moved to declare that "there is no

one, who, after having observed the nicety of the outlines, the correctness of shape and colour, together with that of the shade and light of the images represented by this instrument, has not greatly regretted that they should not be preserved of *their own accord;* no one that has not ardently desired the discovery of some means to fix them on the focal screen."[34]

Arago's assumption that this once-novel desire is now a universal imperative brings us directly back to the question already posed by the quotation from Gernsheim. Why should the ardent desire Arago described have arisen at this particular time, rather than at some prior or subsequent moment in the long history of European uses of the camera obscura, or indeed in the long history of European image making in general? Given that a basic knowledge of the existence of light-sensitive chemicals had been popularly available since the 1720s, why does the discursive desire to photograph begin to emerge only in the 1790s and not before?

It seems a simple, almost trivial question, and yet this matter of timing is a crucial one as far as the cultural *meaning* of photography is concerned. It is no surprise, then, to find that in recent years, a number of eminent photo historians have sought to provide a satisfactory explanation. Mercifully, few of these historians have centered their explanations on the familiar quest for the medium's first inventor or premier product. Most have instead tried to relate photography's emergence to contemporary developments in other areas of European cultural life. These have included, for example, various developments in art (perspective, realism, modernism), in science (physics, chemistry, mechanization, instrument making), and/or in social and economic formations (the industrial revolution, the rising dominance of bourgeois ideology, the demand from this class for portrait images).

Who could deny that each of these areas of development contributed to (or is it that they themselves arose from?) the same conditions of possiblity from which photography itself was to emerge? However, these explanations still provide only a partial understanding of the significance of photography's timing. Indeed if we had the space here to investigate each of these explanations in detail, and especially to examine them in relation to the available archive of speculations provided by the protophotographers, we might well find that the evidence of their influence on the sudden appearance of photography is relatively slight. For example, it is worth pointing out that the discursive desire to photograph almost always precedes the scientific knowledge needed to do so successfully. Virtually every account of the

invention of photography begins with an "impossible" idea, which is then slowly but surely brought to fruition in the face of constant scientific difficulties and uncertainties. Despite plenty of opportunities, there are no episodes in which this idea arose directly from scientific experiment and discovery itself. Similarly, the archive reveals that portraiture—so often said by historians to be photography's primary aspiration—is only occasionally and belatedly mentioned by its inventors as a possible future use for the medium. What such investigations might suggest in fact is that the evolutionary, percussive, cause-and-effect, base-superstructure notion of historical development that underlies many of these explanations is simply not appropriate to the empirical data we have on photography's emergence.

So how is one to read a desire to photograph against the timing of this emergence? We might well begin by noting the broader implications of this timing, for it soon becomes clear that the epistemological status of all the objects in which the protophotographers want to invest their rhetorical desire—landscape, nature, and the camera image on one hand, and space, time, and subjectivity on the other—is at this same moment in the midst of an unprecedented crisis. Each of these concepts is undergoing a radical transformation, as a nascent modern episteme disrupts the stability of its Enlightenment predecessor. What is particularly interesting about this crisis—this "profound upheaval," as Foucault wants to call it—is that what appears to be at issue is not just the representation of Nature but the nature of representation itself: "In a more fundamental fashion, and at the level where acquired knowledge is rooted in its positivity, the event concerns, not the objects aimed at, analysed, and explained in knowledge, not even the manner of knowing them or rationalizing them, but the relation of representation to that which is posited in it. . . . What came into being . . . is a minuscule but absolutely essential displacement, which toppled the whole of Western thought."[35]

An exemplary demonstration of the effects of this displacement is *Letters from an Exile at Botany-Bay,* a small publication written in 1794 by Australia's first professional painter, Thomas Watling, a Scotsman transported for forgery.[36] Watling himself called his publication "this heterogeneous and deranged performance" and warned his readership, "Not however expecting connection, you must just accept of each wild idea as it presents itself." Throughout his essay, Watling complains of the difficulty of representing, whether by word or image, the unfamiliar and untrustworthy characteristics of the new landscape to which he

had been exiled. His own derangement appears to be a direct consequence of the strangeness of his perceptions (viewer, viewed, and viewing have become as if one): "Whatever flows from my pen, or is laboured by my pencil, affects, in some degree, the tone of mind that possess [*sic*] me at the period of its production." As a consequence, it is his surprise at, and uncertainty about, the veracity of his own observations of nature that are the most striking sentiments to be found in his discourse. As Watling laments, "Never did I find language so imperfect as at present."

In an elegant reading of Watling's publication, Ross Gibson points not only to the author's declared hesitations but also to the text's "uneven" quality as "an unruly and confused dissertation" and to its "enunciative fitfulness." Significantly, Gibson puts this fitfulness down not to incompetence, but to "the pressures that prevailed upon a creative subject attempting to 'methodise' experience at the time of white Australia's inauguration." As Gibson points out, the effects of this pressure are inscribed in the very rhetorical figurations adopted by Watling's prose: "From start to finish a kind of alternating current runs through *Letters,* coursing back and forth between the one pole of expressionist subjectivity and the other of scientific objectivity, between the linguistic figures of metaphor and metonym. . . . His persona thus becomes traumatised; he becomes an effect of his own authorial dilemma."[37] Gibson sees this authorial dilemma—a dilemma apparently involving Watling's very subjectivity—as arising on the one hand from the convict's need to negotiate "an aesthetic crisis that was also inherently theological" and, on the other hand, "as a symptom of the upheaval that was occurring in the history of Western ideas at the end of the eighteenth century." What makes this example so useful is that Watling's text encompasses not only a questioning of representation and the objects posited in it, but also of his culture's prevailing orders of knowledge and subjectivity.

So what do we make of the latent desire that in 1839 will come to be called by the name photography? For contemporary historians informed by psychoanalysis, any pursuit of a desire to photograph "pushes the invention of photography back beyond the nineteenth century," locating it instead within a conveniently universal narrative about the human subject's need to protect itself "against the loss of the object [i.e., the always absent real object of desire], and the loss of identity."[38] Desire, according to this model, is produced in the gap between need and demand. But this kind of explanation, with its continuing emphasis on the

transhistorical constitution of the *individual* human subject, seems unable to account for the specificity of either the timing or the morphology of the generalized photographic desire described here. Even if we accept that photography operates as yet another process of substitution for a lack, we are still left wondering why it should be this solution, and not some other, that arises around 1800, and not some other time, to fill what is supposed to be a perennial gap in our subjectivity. Psychoanalysis, in other words, seems unable to account for either cultural specificity or historical change.

This is no doubt why Foucault speaks of the profound transformations he sees as taking place around 1800 ("something which is undeniable, once one has looked at the texts with sufficient attention"),[39] not as a matter of individual or even collective desire but as a "*positive unconscious* of knowledge."[40] As he puts it, "My problem was to ascertain the sets of transformations in the regime of discourses necessary and sufficient for people to use these words rather than those, a particular type of discourse rather than some other type, for people to be able to look at things from such and such an angle and not some other one."[41] Foucault goes on to make it clear in his later books that any regimentation of what can and cannot be thought at a particular moment in history is as much a question of power as it is of knowledge. Indeed his concept of a "positive unconscious" is soon replaced, via Nietzsche, by the phrase "will to power," and it is in these terms that he subsequently investigates the emergence of a variety of heterogeneous conceptual and social apparatuses around the turn of the nineteenth century: "I understand by the term 'apparatus' a sort of—shall we say—formation which has as its major function at a given historical moment that of responding to an urgent need. The apparatus thus has a dominant strategic function. . . . The apparatus is thus always inscribed in a play of power, but it is always linked to certain coordinates of knowledge which issue from it but, to an equal degree, condition it. This is what the apparatus consists in: strategies of relations of forces supporting, and supported by, types of knowledge."[42]

During his investigations Foucault notices that a "strange empirico-transcendental doublet . . . which was called *man,*" "a being such that knowledge will be attained in him of what renders all knowledge possible," is produced as an integral, indeed necessary, component within each of these apparatuses.[43] This being is, he says, a completely new development, "an invention of recent date . . . a figure not yet two centuries old."[44] Like the viewer

inscribed by and within the gaze of photography, Foucault's "man" "appears in his ambiguous position as an object of knowledge and as a subject that knows."[45] Foucault's discussion of the panopticon, that now notorious system of incarceration proposed by Jeremy Bentham in the late eighteenth century, refigures the emergence of this modern subject in explicitly political terms. For the panopticon is an apparatus that, like photography and as the word's French appellation suggests (*appareil:* apparatus, camera), operates according to a certain system of relations between a light source, a focusing cell, and a directed looking. According to Foucault, it is this same system of relations that extends throughout modern society as "an indefinitely generalizable mechanism of 'panopticism.'"[46]

Foucault's emphasis on the workings of the panopticon has frequently been misread as a description of a static, spatial structure designed to allow an oppressive surveillance of those without power by those who have it. In fact, Foucault is putting an argument that is far more complex than this. His interest is in developing a notion of power as something no longer only possessed and exercised by others. Rather, he proposes power as a productive and interconnected field of forces that creates the conditions of possibility for both pleasure and its repression. We are all complicit in the political economy of this field. To that end, he reiterates Bentham's own point that as the prisoner never knows when he is actually being watched, he must assume that it is always so; thus he necessarily surveys and disciplines himself. As far as the exercise of power is concerned, the prisoner is always caught in an uncertain space of hesitation between tower and cell. He is both the prisoner and the one who imprisons; like the protophotographers, he finds himself to be both the subject and the object of his own gaze. "He inscribes in himself the power relations in which he simultaneously plays both roles; he becomes the principle of his own subjection."[47] The panopticon is, in other words, a productive exercise of subject formation operating such that its participants "are not only its inert or consenting target; they are always also the elements of its articulation."[48] Thus Foucault reads panopticism's reverberating economy of gazes as constituting each of its contributors as a self-reflexive doublet—as both the subject and object, effect and articulation of a netlike exercise of disciplinary power.

We might read photography in similar terms. As we have seen, the desire to photograph is expressed by its pioneers in circular and contradictory terms that are remarkably reminiscent of Foucault's account of panopticism. Think again of the palimpsestic

inscription/erasure of viewer, viewed, and act of viewing that we find enacted in Talbot's early window pictures—or of the first attempts to describe photo-desire, so fraught with problems of nomenclature and articulation, problems that are themselves suggestive of an unresolved philosophical uncertainty. Each of these descriptions maintains a reflexive movement within its rhetoric that comes to rest at neither of the two possible poles (invariably nature and culture or their equivalents) that present themselves. By the early years of the nineteenth century, intellectuals across Europe and its colonies have begun to question the presumed separation of observer and observed, locating all acts of seeing in a contingent and subjective human body. The observer is no longer imagined to be the passive and transparent conduit of God's own eye but now is regarded as someone who actively produces what is seen (and if how one sees determines what one sees, then everyone must be seeing a little differently).[49] To represent this new understanding of the viewing subject, artists and poets had to conceive, as Coleridge put it, "a self-conscious looking-glass" or even "two such looking-glasses fronting, each seeing the other in itself and itself in the other."[50] The camera obscura alone could no longer fulfill this radical new worldview. What had to be invented instead was an apparatus of seeing that involved both reflection and projection, that was simultaneously active and passive in the way it represented things, that incorporated into its very mode of being the subject seeing and the object being seen. This apparatus was photography.

We are given a sense here of the desire to photograph as something appearing on the cusp of two eras and two different worldviews, something uncomfortably caught within the violent inscription of our modern era over and through the remnants of the Enlightenment. It is surely this palpable sense of not being completely in one or the other that motivates the frustrations voiced by Watling, Gilpin, Coleridge, Constable, and the protophotographers. Some historians have tried to argue that photography was in fact a conceptual effort to reconcile these tensions—to resolve prevailing representational uncertainties and provide a positivist confirmation of an objective and discrete outside reality. Strangely, this desire for a positivist certainty is again absent from the discourse produced by the protophotographers (although it certainly appears as a dominant concern among commentators in midcentury and beyond). Consider again the concept-metaphor that the protophotographers conjure up to relieve their frustration: a mode of representation that is simultaneously fixed and transitory, that draws nature while allowing it to draw itself, that both reflects and constitutes its

object, that partakes equally of the realms of nature and culture.[51] It would seem that the desire to photograph is here being projected—as its own nomenclature will later confirm (*photography:* light writing, light writing itself)—in terms of a will to power that is able to write itself even as it is written.[52] Situated within a general epistemological crisis that has made the relationship between nature and its representations a momentarily uncertain one, photography is conceived in these first imaginings as something that is neither one nor the other, being a parasitical spacing that encompasses and inhabits both.

The desire to photograph would therefore seem, at its inception at least, to involve a reproduction of that same empirico-transcendental economy of power-knowledge-subject that has made its own conception possible. This is a process of reproduction that does not operate only at the level of ideology (the "idea" of photography). Nor are its effects confined to the finished photograph and those depicted in it. For the discourse of photo-desire confirms that we must, as Foucault puts it, "grasp subjection in its material instance as a constitution of subjects," and this includes the photographer as much as the photographed.[53] Consider for a moment how the photographer, for whom the camera is, as Niépce put it, "a kind of artificial eye," is constituted by photography as the prosthetic trope around and through which the complicitous economy of photo-desire necessarily turns.[54] This conjunction of photographer, image, and camera produces more than just a surface reorganization of power; it is productive of a total symbiotic assemblage such that "power relations can materially penetrate the body in depth."[55] To put this Foucaultian proposition simply, if photography is a mapping of bodies in time and space, then it is also a production of both those bodies and modernity's particular conception of the time-space continuum.

There may be a danger in following too slavishly the historical path traced here—a danger that one might end up having merely constructed a new beginning, a beginning seemingly more pure and essential, more true to photography's "original identity," than that provided by the account it seeks to displace. However, the greater danger is in assuming that the question of origins, a question one cannot escape even if one would want to, is ever anything *but* dangerous. By shifting the focus of the question from a singular moment of invention to the general appearance of a certain desiring production coinciding with the advent of modernity, photography's emergence is at least made an inescapably political issue. The writing of its history must henceforth address itself not just to developments in optics,

chemistry, and individual creativity, but to the appearance of a peculiarly modern inflection of power, knowledge, and subject, for this inflection inhabits in all its complexities the very grain of photography's existence as an event in our culture. Thus, a beginning that was once thought to be fixed and dependable is now revealed as a problematic field of mutable historical differences. That is not a bad ending from which to begin again. To give Foucault the last word, "What is found at the historical beginning of things is not the inviolable identity of their origin; it is the dissension of other things. It is disparity."[56]

This essay is a revised version of "Desiring Production Itself: Notes on the Invention of Photography," in Rosalyn Diprose and Robyn Ferrell, eds., *Cartographies: Poststructuralism and the Mapping of Bodies and Spaces* (Sydney: Allen & Unwin, 1991), 13–26. Some of its elements have also appeared in *Burning with Desire: The Conception of Photography* (Cambridge, MA: MIT Press, 1997); "Burning with Desire: The Birth and Death of Photography," *Afterimage* 17:6 (January 1990), 8–11; "Orders Profoundly Altered: Photography and Photographies," *West* 1:1 (University of Western Sydney, 1989), 18–21; and "Photography's Haunts," in Stephen Foster, ed., *The Masque,* exhibition catalogue (Southampton: John Hansard Gallery, 2000), commissioned.

+ **2** +

+ + +

+ + +

AUSTRALIAN MADE

The history of Australian photography is an invention of surprisingly recent date. Only in 1988 did that country see the publication of a scholarly history devoted to its photographic production, and then it got two rather than just one. As it happens, one of these emphasizes art, and the other is organized as a social history, therefore presenting a convenient comparison of two different approaches to the writing of photographic history. At the same time, a perusal of these histories offers a welcome opportunity to survey and critically reflect on the photography of a regional culture that normally gets little or no attention outside its own shores. It also allows us to think about what these shores mean. What, we may well ask of these books, is Australian about Australian photography? In asking this question, we must necessarily consider its more obviously difficult corollary: In what ways is any photography informed by its place of production? How do we delimit any photography's identity? So these two histories are about a lot more than just Australian photography; they are about representation, identity, and power—about history itself.

It was back on January 26, 1788, that Captain Arthur Phillip landed a group of convicts and their jailers on an uncharted continent in the South Pacific and thereby established a new English penal colony. Two hundred years later, Australians celebrated this unexpected by-product of the American War of Independence with all the official pomp and ceremony that one now expects to see accompanying such moments of manufactured nationalism. As a consequence, the event was marked not only by an endless series of reenactments, speeches, sporting events, dedications of monuments, visits by the Queen, and so on, but also by an unprecedented rewriting of Australia's history. Gael Newton's *Shades of Light: Photography and Australia, 1839–1988,* and Anne-Marie Willis's *Picturing Australia: A History of Photography* were but one small part of this much larger historiographic project.[1]

About two hundred years seems to be all the history most Australians have to look back on—or at least that is the idea that the bicentenary itself, as a particularly vociferous historical marker, tried to impress on the nation's consciousness. However, the whole identification of Australia's origin with the date of English settlement not only ignores the long prior occupation of the island by Aboriginal groups, but also elides Australia's two-thousand-year history as a motivating concept in the European imaginary.[2] From the Pythagorean perspective of the ancient Greeks, who projected an unknown southern continent as a necessary Antipodean other to their Northern Hemisphere, to the satirical vision of Swift's 1726 *Gulliver's*

Travels, which was strategically set in an unmapped space on the globe near what was eventually to become Adelaide, Australia has been a potent site for the discourses of European desire. As Paul Foss has argued:

Right from the beginning (and do we not endlessly return to this theme?) the antipodal image was nothing but an image necessary for European expansion. It was a simulacrum concealing what it was not. The non-place of the Antipodes, with all its abundance of space and contrarity, only represents a structural reversal of everything which seemed to limit the European ideal: room to grow in, untold wealth, the "opposite earth" whose image dissolves the appearance of a nothing too close to home. In the great leap forth of the European powers, nascent for a time but rapidly to increase thereafter, it is only the counterpart of the threat of territorial restriction.

This is the theatre in which the history of Australia begins to unfold.[3]

Thus do we find that for the first explorers and settlers, Australia had always already been there. Prescribed and preordained, the Australian continent had been endlessly produced and reproduced for centuries in legends, maps, prints, paintings, novels, and other theatrical fictions. These early images and texts are fictions in name only, however, for like all representations, they had real, lived, material effects. One of these, as Foss has already suggested, was the European imperative to "discover" Australia in the first place. With that discovery and the first few penal settlements, a new phase in Australia's representational history was launched. This time it was a phase informed by the conflicting demands of a whole network of different discourses: navigation, empirical science, military strategy, capitalist economics, and global politics, as well as picturesque and romantic aesthetic taste. It is in this sense that Australia could be said to have only ever existed as a space of pure invention. Thus, in 1988, as in 1788, "Australia" continued to be nothing more than a convenient term of location for what has always been a dynamic and productive process of national inscription. Accordingly, Australia's professional inventors, its historians, are faced with a task of Foucaultian proportions: "A task that consists of not—of no longer—treating discourses as groups of signs (signifying elements referring to contents or representations) but as practices that systematically form the objects of which they speak."[4]

There has never been any point, then, in searching for the "true Australia" hidden somewhere beneath its blanket of discursive images. A more useful historical project would seek instead to identify the economies of power within which Australia's representations have periodically been produced and reproduced, and thereby given their particular values, resonances, and effects. In this context it is worth noting briefly that Australia's settlement in the late eighteenth century takes place during what Michel Foucault once described as the "threshold of a modernity that we have not yet left behind."[5] This is that same moment from whence emerged the methods and institutions of disciplinary power (of which the Australian penal colony was certainly one instance). It was also the moment that in Europe first induced a general desire to photograph and ultimately led to the invention of a marketable photographic process in 1839. In this sense one might say that Australia is one of the few national entities that has been from its outset framed by a photo-scopic episteme.

Australia did, however, have to wait a little for the arrival of photography itself. Despite having told the French parliament that they intended to "nobly give to the whole world this discovery," Daguerre and Isidore Niépce had on August 14, 1839, taken out a patent on their daguerreotype process to prevent anyone using it without authorization "within England, Wales, and the town of Berwick-upon-Tweed, and in all her Majesty's Colonies and Plantations abroad."[6] Australia, then being one of "her Majesty's Colonies and Plantations abroad," immediately fell under this legal restriction. As a consequence, and the inevitable delays of distance, the first photograph was not taken in Australia until May 13, 1841, when a daguerreotype was made in Sydney. More important, the earliest continuous production of Australian photographs was not to get under way until December 1842, when the first commercial daguerreotype studio was set up, again in Sydney.

And so here begins what has recently become a familiar story: the development of photography within a small colony far from the world's cultural and economic centers.[7] But why should non-Australian readers be interested in yet another regional account of the history of photography? Australia's photo history is, after all, positioned, when it is thought of at all, as no more than a supplement to The History of Photography as we have come to know it through Helmut Gernsheim and Beaumont Newhall and all their more recent institutional followers.[8] This establishment History, already circumscribed by its monotonous quest for originality, priority, and the heights of artistic sensibility, has by and large confined its

attention to developments in France and Britain in the nineteenth century and the United States in the twentieth. As a consequence, no photographs from Australia are featured in its hallowed lineup of masterworks.[9]

And yet Australian photography, together with that produced by a host of other excluded regional cultures, could well be regarded as the ghostly foundation, the absent presence, upon which the above History rests its ponderous bulk. This History's search for photography's authentic first instances must have it that all parallel and subsequent manifestations are merely derivative and repetitious. Once again we find Australia positioned as the negative reflection of everything that a European-American tradition would hold as unique to itself. However, in such a logic of difference and repetition, the disdained supplement remains absolutely necessary to all claims of authenticity and origin. An apparently secondary term in this One/Other relationship, the supplement, by being made to stand for everything the primary term supposedly is not, takes on an unacknowledged but crucial role as the standard by which an entire structure of values and assumptions is determined.[10] For this reason alone, aside from the interest of their own local idiosyncrasies and achievements, regional histories of photography should be worthy of a greater critical attention among scholars in the United States and elsewhere. These publications from Australia provide that chance. At the same time they represent, along with a number of other indigenous regional histories, a further small displacement in the certainty of that monolithic, singular history of "world" photography with which we are all so tediously familiar.

The first of them, *Shades of Light,* was produced to coincide with the presentation of a massive bicentennial survey exhibition of Australia's photography at the National Gallery of Australia in Canberra. In this institutional environment, it is perhaps understandable that Gael Newton, who was responsible for the exhibition as well as the book, would want to argue that "photography in Australia was from the beginning an art of vigour and pictorial power" (9). Certainly her copiously illustrated book regards "pictorial power" as its central concern. However the absence of any clearer exposition of its own historical method is just one indication of the trouble this book has in fulfilling its author's desire to trace a coherent art history for Australian photography. This is particularly evident in those chapters dealing with the nineteenth century, a period in which artistic merit was seemingly of little consequence to practitioners or commentators. Instead, as Newton's account soon reveals, pho-

tography was principally valued in the new colony for its instrumental and commercial utility. Accordingly Newton finds herself providing a plethora of information on technical and entrepreneurial, rather than artistic, innovations.

These early chapters detail photography's growing involvement in the production of Australian portraits and scenic views by both amateurs and professionals alike, its prominence in public expositions and other promotions of the colony overseas, and its gradual acceptance for the purposes of press reportage and expedition documentation, as well as for geology, astronomy, botany, and a variety of other sciences. It is to her credit that Newton recognizes and acknowledges this photographic diversity through the range of images she reproduces, even though not all of them exhibit the pictorial power or artistic vigor she might have preferred. Among the significant images she reproduces are an early (c.1850) calotype by Joseph Docker of a cricket match at Scone in New South Wales, with the expectant batsman taking guard against an invisible bowler, one whose necessary momentum was obviously beyond the recording capabilities of Docker's primitive camera apparatus.[11] We are also provided with a remarkable portrait by an unknown daguerreotypist from around 1860 of an Aboriginal maid in a pale crinoline dress holding a laughing white child on her knee. As Newton points out, the ease and intimacy of this image, one of a number featuring this Aboriginal woman found in the same family collection, suggests a different kind of relationship between the races than we might perhaps have presumed from other examples of Australia's historical and photographic record in this area. Also surprisingly relaxed is a portrait of John Glen taken by Louisa Elizabeth How in November 1858, one of forty-eight salted paper prints of the Sydney intelligentsia that this amateur photographer produced between 1857 and 1859. Sadly these few assured and impressively composed images make up our only record of her work.

It is not until she gets to the 1890s that Newton is able to report that "photographers were acquiring individual styles" and that "new emphasis on the word 'artistic' appears" (68–69). From this moment on, her exposition concentrates almost entirely on a relatively small number of Australian photographs—those that either at the time of their production or in subsequent years have been recognized as possessing artistic merit or pretension. Australian photography in the twentieth century is consequently made to follow a selective and predictable international pattern: pictorialism, modernism (including a few examples of its

manifestation in fashion and industrial work), and documentary. Like some earlier historians of Australian painting, Newton goes to considerable trouble to trace and acknowledge the periodic influence of overseas developments—mostly by way of foreign magazines—on Australian practice.[12] As a result, insufficient attention is paid to the peculiarly local and ambivalent characteristics of Australian modernism when it does finally begin to appear. Newton, for example, makes a brief reference to the New Vision style of Australian landscape photography produced during the 1920s and 1930s, but reproduces no examples and provides no explanation of its development, disseminations, meanings, or continued popularity.[13] She does, however, both reproduce and briefly analyze Max Dupain's iconic image of Australian modernism, *The sunbaker* (1937). Newton's reading of this now ubiquitious image is a strangely ambiguous one, apparently wanting us somehow to relate the dark skin and relaxed attitude of its featured sunbather to much more recent efforts by Australia's Aborigines to secure guaranteed land rights. Other than this doubtful historical reference, the reading she provides predictably concentrates on the photograph's semiabstract properties and its formal relationship to the New Photography movement with which Dupain was by 1937 distantly familiar. According to Newton then, "its simple geometry and dynamic symmetry had perfectly expressed the energy of Modernist formalism" (125).

This hardly seems an adequate historical approach to the image in question. To engage more usefully with *The sunbaker's* original meanings, one might begin by trying to relate Dupain's photograph to the actual complexities of life in Australia at the time of its production—for example, to Australia's hedonist beach culture, its glorification of masculinity, mythologies of nationalism and egalitarianism and their investment in images of monumental landscape, Australia's mixed response to modernization, and finally its general resistance to modern art. The photograph remained unpublished until 1948, when a version of it appeared with an introduction on modern photography by Dupain himself that called not for abstraction but for "clear statements of actuality." *The sunbaker* could as reasonably fit this documentary formula as Newton's formalist one, providing, as it does, a telling representation of the sweaty sensuality and spatial disorientation of the sunbathing experience. Once considered in this broader context, Dupain's image can be seen as something more than a mere provincial footnote to the international influence of New Photography. On the contrary, it could be said to articulate with considerable visual intelligence the complex nature

AUSTRALIAN MADE

32

of Australia's quite specific engagement with, and production of, modernity between the wars.[14]

While Newton's historical method remains unspoken, that of Anne-Marie Willis in *Picturing Australia* is self-consciously inscribed across her every argument and organizational decision. Indeed her whole book might be said to be about its own processes of formation—about the problems and ramifications of writing a comprehensive history of any culture's photography. The book, for example, deliberately eschews color reproductions and museum-style captions, preferring to do away with art-historical affectations such as these, and begins and ends with chapters devoted to critical analyses of past efforts at the writing of Australian photo history.[15] As she puts it, "Each of these 'histories' provides a very limited and problematic account of the changes in Australian photographic practice, generally working from unstated and unquestioned assumptions about the primacy of photography as fine art, technology or record. The problem is not peculiar to Australia; the local examples have been instances of the three most common approaches to the writing of photographic history" (1). In this context she sees her own book as "a means of opening up new ways of considering photography. . . . not to write a definitive account, but to begin to develop photographic history on different premises" (vii):

There is as yet no survey history of photography in Australia responsive to its multiple conditions and contexts of production. There is a clear need for such a study. This account aims to go some way towards achieving this by mapping the field of photographic practice. It will take existing histories as starting points and, in addition, include new issues and bodies of material in order to reposition those accounts. . . . This account attempts to look at photographs in their original context, to discover the ordinary and the typical and to come to an understanding of the dominant uses of photography in each historical period. (2–3)

The methodological precedent for this kind of an account is Allan Sekula's 1983 essay in *Mining Photographs and Other Pictures,* an essay that Willis in fact describes as "an exemplary model of photographic history" (273).[16] In accordance with Sekula's contextual approach to the work of Leslie Shedden (an approach very much informed by the social history of art), Willis sets out in her book to displace the usual emphasis given in Australian

photo history to exceptional images produced by a few celebrated photographers. She tries instead "to understand the changing character of those institutional forces to which photography is always bound" and thereby to articulate something of the medium's shifting social profile and diversity of uses. This is not to say that individual practitioners are ignored. However, those chosen for discussion and reproduction are valued as much for their typicality, for the way they represent a general tendency, as for their singular achievements as photographers. In her chapter headed "Gentlemen Amateurs," for example, she reproduces no fewer than five images produced during the 1880s by a police inspector of the Northern Territory named Paul Foelsche. No examples of his work appear in Newton's book. So why has Willis chosen this photographer for inclusion in her's? The answer: Because he is so ordinary.

Foelsche's work embodies aspects already encountered: seeking out the exotic, laying symbolic claim to the landscape, taming the unfamiliar, celebrating the familiar transplanted to an alien setting. Because his surviving body of work is much larger than that of the amateurs of the 1850s, these tendencies can be seen more clearly. His work included images of craggy, eroded cliffs rising sheer from pools of flat, clear water, white men taking "masterful actions" in the jungle, settlement, homesteads, shooting and archery parties. There are also images of black and white men together, in which the social relations of power between each are apparent to a viewer alert to issues of race. (36–37)

This last tendency, the depiction of Aborigines by white photographers, becomes one of the most consistent thematic threads running through Willis's history. As early as the 1850s Aborigines had become a popular subject for photographers. As Willis points out, what is extraordinary is the amount of attention paid to them and the relatively varied ways in which they are portrayed. She indicates something of this variety through the twenty-four photographs of Aborigines and Islanders she reproduces in her book. These, along with another seventeen on the same subject to be found in Newton's publication, give a sense of the range of such images that have been produced in Australia over its 130 years—from some relatively sympathetic and intimate portraits made by Antoine Fauchery in the 1850s to several carefully posed tableaux of the exotic native produced in the 1870s by J. W. Lindt and,

more recently, whole series of anthropological photographs taken in the 1930s to record tribal and ceremonial life (photo 2.1). Willis, always concerned with the relations of power inscribed in such images, is right to indicate the complexity of their meanings, meanings that have often changed or become ambiguous as the photographs have come to serve new, unintended purposes.

Another important development around this same time was the introduction of photographic halftone illustrations into the popular press. This development is foreshadowed in J. W. Lindt's remarkable photograph from 1880 of outlaw Joe Byrne's dead body strung up for display at Benalla (photo 2.2). Byrne, a member of the notorious Kelly Gang, had been killed in a shootout with police after a siege at a farmhouse in the countryside outside Melbourne. Newspaper reporters and illustrators were taken out to the scene in a special carriage on the police train and, although arriving after the event, subsequently produced a number of dramatic visual and verbal accounts of the action. Photographers were in a more difficult position, not enjoying the same access to imaginative embellishment as reporters working in other media—hence, the posthumous display of Byrne's body, an early and rather macabre example of the photo opportunity. What makes Lindt's photograph exceptional is that it appears to be concerned with representing precisely this media event rather than with the mere recording of Byrne's body. To this end, Lindt captures not only the activity of his fellow photographer and the unposed movements of the attendant crowd, but also the well-tailored presence of artist and illustrator Julian Ashton, leaving the scene with completed sketchbook under his arm. Although unpublished at the time, Lindt's image contains many of the elements—topicality, spontaneity, narrative interest, and implied violence—that characterize the press photograph as we know it today. At the same time he has been able to embody perceptively the contemporary struggle between photography and illustration as a means of reportage, a struggle from which press photography was to emerge triumphant only at the turn of the century.

Given her interest in Sekula's treatment of Shedden, it is unfortunate that Willis does not find space to discuss the work of James Wooler, official photographer for the *Barrier Miner* newspaper in Broken Hill between 1908 and 1911. During his time with the paper, Wooler not only documented in detail the work practices and daily life of Australia's premier mining town, but also in 1908 and 1909 produced an unprecedented series of images of a

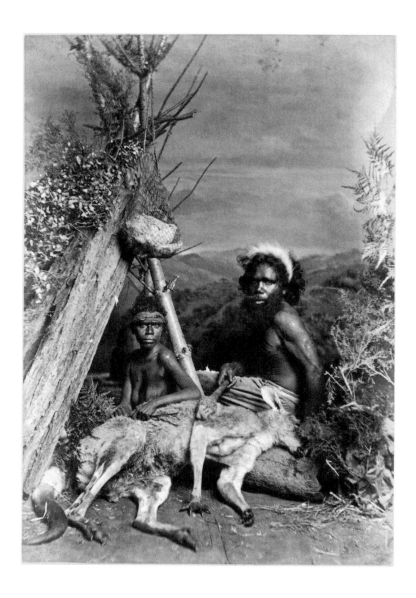

2.1

J. W. Lindt, Portrait of an Aboriginal Man and Woman, *c. 1874*
Albumen silver photograph
National Gallery of Australia, Canberra

bitter strike action. As a union photographer, Wooler was able to capture every aspect of the strike, from protest rallies and the arrival of mounted policemen to the ritual hanging of effigies and the inevitable violent clashes between scabs and picketers. Other would-be photographers were not so lucky. The *Australasian Photo Review* commented in its February 1909 issue, "The feeling against photographers at Broken Hill is still acute." As one of the strikers now remembers it, "They didn't like photographs in the Lockout. Well, put it this way—the slave, if he was out on strike he didn't like his photo gettin' taken. If they took a photo that was evidence against him if it comes to a court case. And rather than have a camera used that way they'd smash the camera up."[17]

In this charged atmosphere, the dramatic composition and comprehensive coverage achieved by Wooler's photographs is all the more remarkable. A pity then that they are not represented or indeed even mentioned in either of these histories. However, it has to be said that, unlike Newton (or indeed Sekula on Sheddon), Willis pays quite a bit of attention to the interpretation of the photographs she does reproduce. As a result she is able to note the local meanings and values of both particular photographs and familiar international genres. A torrent of cartes-de-visite of famous European personalities flooded into Australia during the 1860s, for example, a trade that Willis rightly describes in terms of "the cultural power of Europe" being "given a tangible presence in colonial society": "In the mid-nineteenth century, before the development of Australian nationalism, photographs of and from 'the old country' had a special force of meaning. They were substitutes for the absent culture to which colonists aspired and they contributed to a process in which everyday life was lived through constant reference to somewhere else" (47). By the 1870s this situation had changed somewhat, with a number of intinerant photographers, such as Henry Merlin and Charles Bayliss (working under the auspices of the American and Australasian Photographic Company), making an indigenous living by taking and selling views of regional Australian towns, their streets, buildings, and inhabitants. "The sense that all is on display for the camera—the newly constructed dwellings, the best clothes worn for the occasion, the proud stances, the direct gazes—suggest that these images were icons of pride: pride in new status and newly acquired possessions" (63–65).

These views have become well known in Australia as a complete collection, and this has resulted in what Willis sees as a significant shift in their meanings:

2.2
J. W. Lindt, Body of Joe Byrne, member of the Kelly gang, hung up for photography, *1880*
Gelatin silver photograph
National Gallery of Australia, Canberra

These photographs of the residents and shopkeepers of Hill End and Gulgong have had two
lives, then, first as widely dispersed images with highly personal and localised meanings, and
later as a collection in which it is assumed are deposited certain "truths" about Australian pi-
oneering life. . . . Another factor affecting the way they have been evaluated is that they began
their public life at a time when the documentary aesthetic was gaining favour in Australia.
Thus the images could be valued for their directness, the detail and exhaustiveness of their doc-
umentation. (65, 66)

In some instances Willis is able to point to photographs that were inhabited by this
kind of double meaning even at the time of their production. Charles Kerry's *View, Wolgan
Valley* (c.1890s), for example, is described as masking certain contradictions and conflicts be-
neath its facade of rural calm. The photograph's two featured observers look out not onto an
expanse of natural wilderness, but over a piece of cleared land, fenced and with an established
homestead beckoning in the distance. What would once have been appreciated as an image
of idyllic picturesque landscape has become a seductive advertisement for real estate and pas-
toral opportunity. Thus, the aesthetic form of Kerry's image is caught in an uncomfortable
transition "between the vision of the landscape as scenic view and that of the land as a site of
settlement and development" (80). By means of such analyses, Willis demonstrates that the
idiosyncrasies of Australian culture and history are inscribed in each and every one of its pho-
tographs, even those that seem most obviously to repeat an American or European prede-
cessor. As she shows, every repetition entails a difference, even when this difference is not
always discernible to the foreign eye.

It would be easy simply to see the different accounts of Australian photography pro-
vided by Newton and Willis as neatly complementing one another, the first as an art history
and the second as a social history, and leave it at that. And certainly the two books together
provide a wide and diverse coverage of the available material, frequently giving readers differ-
ent reproductions from the same photographers and thus a sense of the range of Australia's
photographic output. However, it is inevitable and proper that these two books be compared
in more critical terms according to their respective capabilities as histories. I have already in-
dicated some of the many ways in which they diverge in approach. In this context, however,
it is also interesting to see where and in what ways the two accounts intersect.

It is perhaps understandable that their coverage of the early history of Australian photography should be very similar, covering much the same ground and featuring many of the same pioneer photographers. More surprising is the absence in later chapters of any detailed discussion of Australian photography produced during the 1950s and 1960s, a lacuna common to both books. The other strikingly similar chapters are those dealing with the 1970s. For some reason Willis puts aside her concern for the ordinary and the dominant and devotes her chapter on this period to fine art photography, tracing the establishment of photography as an accepted and publicly funded art form. In the process she reverts to the sort of bionarrative style of history writing that is such a feature of Newton's book. As it turns out, Willis's overall view of the 1970s is not a flattering one: "The art photography that was produced and promoted during the 1970s was primarily a shallow brand of international formalism, though it did create a new awareness of photography in general" (250). Newton's book also emphasizes the impact of American models on the art photography produced in Australia at this time. However, the essay on the 1970s and 1980s in *Shades of Light* is contributed not by Newton but by Helen Ennis, then curator of photography at the National Gallery of Australia. Ennis's coverage of the medium is limited to a selection from her own gallery's collection and is therefore another kind of history again to that attempted by Newton and Willis. Nevertheless, it is still wholly confined to photography's manifestation as an art form.

Ennis uses a telling image by David Moore from 1966 to exemplify the undeniably dependent relationship—military, political, economic, as well as cultural—that has existed between Australia and the United States since World War II (photo 2.3). However, her account is keen also to emphasize the 1970s as a time of creative struggle between those Australian practitioners who regarded photography as an art form in its own right and those who used photography as an alternative to established art practices. The latter were often informed by feminist and other social concerns, and allied themselves to the conceptual and counterculture movements then being embodied in other aspects of the art scene. The merger of these two approaches in a younger generation of professionally trained artist-photographers resulted, according to Ennis, in the reassertion of "the individual's private rather than social vision." As she argues, "Postmodernism has become the style of the '80s. . . . It has the voice, in terms of art practice and art discourse" (154).

2.3
David Moore, President Johnson and Prime Minister Holt at Canberra Airport, *1966*
Gelatin silver photograph
National Gallery of Australia, Canberra

Ennis is given an opportunity to develop this argument in more detail in a lavishly illustrated exhibition catalogue, *Australian Photography: The 1980s,* that was also published in 1988.[18] However, the work reproduced in this Kodak-sponsored publication is not confined to that style that she identifies as postmodern. Indeed, this is a catalogue that overtly aspired to be representative of Australia's regional character and ethnic diversity as well as its avant-garde. To that end, it included not only well-known artists like Bill Henson, Anne Ferran, and Julie Brown-Rrap but also younger photographers such as Seham Abi-Elias and Takis Christodoulou, who were then using an unfashionable form of documentary to represent the life of their own immigrant families. The catalogue also featured a strategic placement of images. It was no accident, for example, that in the bicentennial year, Ennis should choose a photograph by Aboriginal artist Tracey Moffatt, itself an ironic transformation of J. W. Lindt's studio portraits of Aborigines from the 1870s, to go opposite her title page. It was also predictable that Ennis would select the left half of a celebrated diptych by Ferran, *Scenes on the Death of Nature I and II,* for her cover image (photo 2.4).

In the complete work, Ferran's daughter and her friends are placed at center stage, confronting us with a presence as large as life itself. Dressed in classical costume, they are arranged in languidly intertwined groups in the style of a high-relief sculptural frieze. One of the girls can be identified in both panels. However, there is no immediately apparent narrative that links one panel with the next, nor do the girls appear to be playing particular roles other than those of generic classical figures. For the artist behind the camera, what seemed to matter more than individual character or storyline was the careful distribution of elements (formal and rhetorical) across the adjoining surfaces. It is clear that Ferran self-consciously orchestrated this distribution to suit the constraints of classical taste. The costumes, lighting, proportions, emotional tone, and general demeanor of the figures all obey the strictures of this most familiar of Western aesthetics. On one level, these photographs speak of a ready compliance with authority and tradition. And yet there is also a disturbing lassitude about the arrangement of these figures, a willful anarchy about the relationship of one to the next that seems to obey individual desire more than noble precedent. If these photographs have adopted the classical tradition, it is not to effect a simple repetition but to rework the grammar of this tradition from the inside.

2.4
Anne Ferran, Scenes on the Death of Nature I and II, *1986*
Two gelatin silver photographs
National Gallery of Australia, Canberra

A memory of the work of Julia Margaret Cameron and Lady Hawarden from the 1860s and 1870s pervades these photographs. We might therefore look for the sources of Ferran's sculptural references not only in the forms of ancient Greece or Rome but also, and perhaps more insistently, in the congealed neoclassical aesthetic of late Victorian public monuments. Drawing directly on the Elgin Marbles and other spoils of British empire building, sculptors of the late nineteenth century were able to use a vocabulary that was already familiar to their audience. Contemporary male heroes and obscure female mythological figures were combined to give imperial power a historical lineage and a facade of civilizing benevolence. Living in what was one of the colonial outposts of the British empire, Ferran has used this public vocabulary to suit her own ends. Muting its confident acclamations with small ironies and ambiguities, she has sought to undermine, and perhaps even to transform, its residual political implications.

At first glance, the girls in these photographs would seem unproblematically to reproduce a masculine ideal of femininity, vestal virgins transported from a bygone age (when, incidentally, such women held a certain power over the affairs of men). And yet the process of photography also works here to reveal mercilessly the flaws of their adolescent skin and homemade costumes, offering these ideal figures to the viewer as both palpable and contemporary. They hover disconcertingly somewhere between an intimate accessibility and a haughty disdain. Their expressionless faces studiously avoid our gaze in a manner reminiscent of funeral guests sharing a well-rehearsed grief. Their flowing hair, the torpor of their bodies (leading, in the case of one figure, to a total collapse), the tender supportive touches of hand and arm: each of these signs hints at a restrained outpouring of feminine emotion on the edge of exceeding conventional codes. The suggestion of mourning is reinforced by the flat, unresponsive, almost somber surface of each print. Roland Barthes has spoken of pleasure as something produced through the loss of preconceived identity. Here that loss, expressed as a protracted and savored melancholy, could conceivably involve the termination of an existing but doomed closeness between mother and daughter.[19]

The *Scenes* are shallow in depth (again echoing the work of the Pre-Raphaelites) but seem to extend in all directions beyond the picture frame, even forward into our own viewing space. So too with their articulation of time. Most traditional photographs appear as a single vertical slice cut through a horizontal passage of time and motion, a passage lived in

AUSTRALIAN MADE

46

the past. The photograph is read as a freeze frame of both historical and real time, always presenting a dead version of that which once lived, a *nature mort* or still life. *Scenes* represents a partial thaw in photography's cryogenic inclinations. Historical time has been compressed into the present even as the normal photo-freeze process is momentarily reversed. What were once static stone figures can here be coaxed by the mind's eye into a glacial animation. One is encouraged to imagine a shiver, an almost imperceptible trembling across the surface of these photographs, as in a living, breathing tableau vivant. The time frame occupied by these figures is therefore infused with life as much as with death; their state of being is irrevocably tied to the viewing experience of the person standing before them in silent contemplation.

My brief traversal of Ferran's work has suggested a number of possible identities for the terminal "nature" of her title: the nature of photography, the nature of a certain representation of femininity, the nature of photographic time and space, the nature of motherhood, and so on. However, it has to be recognized that the companion of death is always birth, just as any end necessarily signals a new beginning. In similar vein, Ferran's work lends itself to provocation and endless conjecture rather than to definitive summary. In this, as in many other aspects, Ferran's work is exemplary of its period.[20]

Ennis's introductory essay to *Australian Photography: The 1980s* argues that "numerous signs indicate that a new era of photographic practice began in Australia in the early 1980s" (7). A very similar claim is made by Willis in one of her few references to the art of the 1980s. So what are the signs of this new era? Ennis identifies several, while admitting that none of them is unique to Australia: the professionalism of a new generation of artist-photographers, the diversity of their backgrounds, the interest of many of these photographers in so-called French theory, the emphasis on grand, studio-induced images that suggest "excess, artifice and decadence," the ability of these images to deny photography's traditional claims to truth and realism. On top of this, Ennis's essay is important in the way it takes care to acknowledge the development in Australia in the 1980s of a substantial art world economy that made such work possible, a supportive network of schools, galleries, museums, magazines, and public funding that had been unknown in that country in previous decades.

The question still remains, though; How are these signs any less dependent on American models than those exhibited by those earlier Australian photographers of the 1970s? The answer lies not only in an affirmation of the quality and local character of Australian cultural

activity, but also in a reconsideration of the issues of influence and dependence themselves. One might begin by looking at the knowing and often ironic way in which some Australian artists, Ferran among them, have engaged with their inescapable position between center and periphery, producing a hybrid, self-consciously appropriative aesthetic that is neither wholly original nor simply imitative.[21] Such an approach has resulted in a photography of seductive ambiguity that in many instances has been able to transform dependency into an aggressive act.

But this is only one small aspect of developments in Australian photography during the 1980s. There is no particular reason to concentrate a historical account of Australian photography in this period exclusively on art production. There were in fact a number of important debates and incidents specific to Australia during that decade in which photography was a central concern, and yet inexplicably they received little or no coverage in any of the above books. Another history of Australian photography in the 1980s remains to be written, one concerned with the medium's social as well as its aesthetic impact. The aim of this other history would be quite specific: to make visible the local configurations of power and resistance within which photography in Australia operated, then as now. What would be in such a history? For the sake of argument, a few selected fragments follow.

One of the most public of these fragments arose out of the attempted introduction of a national identity card system between 1985 and 1987 by Australia's federal government. In September 1985 the minister responsible for this scheme issued a press release defending the function and purpose of the so-called Australia Card, claiming that "our decision not to require a photograph reflects our determination that the Australia Card will not become an internal passport." This "determined" decision was reversed almost immediately afterward, and the card's photographicness subsequently became its most distinctive and contentious feature. It may be difficult for American readers, living in a society in which the surveillance of one's identity is an everyday event, to imagine the widespread opposition that this card induced in the Australian populace. In Australia the furor was such that the government called a general election to decide the issue, placing full-page ads in support of the card in all the nation's newspapers. Public figures from both left and right united in opposition, with the debate focusing not only on the card's potential infringement of civil liberties but also on the government's determination to submit every citizen to the penetrating gaze of the camera.

For the first time it would have been compulsory for every Australian, from outback Aborigines to urban grandmothers, to be inscribed within the isolation cell of the photograph. The card would have meant the formation of a vast network of portrait photographs coordinated by the state, each person's image to be regularly scrutinized by fellow citizens for signs of criminality and deviance. The systematic exercise of disciplinary power, already such a pervasive feature of American life, was about to be firmly established in Australia. Never before in Australia's history has photography itself been the subject of such a heated and politicized public debate.

Despite vigorous opposition to the card, the government was returned (albeit with a reduced majority) in the 1987 election. Ironically, the Australia Card had to be shelved soon afterward when a legal technicality in its legislation was discovered by a retired public servant. However, the card has now been reintroduced through the back door by means of photographic driving licenses issued in each state. These uses of photography by government are part of a tradition dating back almost to the medium's invention, one that regards the camera primarily as a powerful means of social control. As Allan Sekula has shown, this tradition is linked to nineteenth-century assumptions about the relationship between facial features and personal character.[22] That this notion is still alive and well in Australia was continually demonstrated during one of that country's most celebrated legal cases, the trial of Lindy Chamberlain for the alleged murder of her baby, Azaria, at Uluru in central Australia. Caught within the masculine gaze of law and media, Chamberlain was condemned by both for her refusal to conform to the expected photogenic gestures of maternal grief. As one newspaper headline put it in 1986, "The Face Tells the Story." Not quite, as it turns out—for the story in 1989 was that after $20 million worth of trials and appeals, Chamberlain had her conviction quashed and compensation awarded. Most remarkable of all, she has even had her revenge on the media through the formidable surrogacy of Meryl Streep's performance in the 1988 film *A Cry in the Dark.*

As Newton and Willis indicate in their books, Aboriginal Australians have long been familiar with the not-so-tender mercies of photographic surveillance. However, only since the mid-1970s, and the Whitlam government's recognition of land rights, have Aborigines been in a position to resist this surveillance. One place where one might have expected Aboriginal people to be frequently subjected to photography is at Uluru, one of Australia's

premier tourist attractions and under Aboriginal control since 1985.[23] That it is such an attraction suggests that the eighteenth-century desire for the sublime has now fully merged with the modern imperative to photograph one's every experience. It is ironic, then, that about forty tourists die of heart attacks every year after climbing the huge rock to take their necessary snapshots. In this sense, Uluru offers the ultimate photographic sublime. Local Aborigines reportedly call visitors to Uluru *minga juta* ("lots of ants")—people to be pitied rather than scorned. And when those visitors arrive at the rock with their expectant cameras, they are confronted with the following sign:

PHOTOGRAPHS

Traditional owners request that you respect their customs & refrain from photographing local Aboriginal people. Having one's photograph taken is considered culturally innappropriate as the image captured on film, believed to be part of one's spirit, is removed from that person's control forever. Thank you for your co-operation.

Interesting that a group of Aborigines who, as the traditional owners, exercise control over a multimillion dollar attraction would refer to one of anthropology's most hackneyed clichés to prevent visitors from photographing them. Of course, they could well believe that to be photographed is to lose control of part of oneself (after all, many critics subscribe to this same idea). On the other hand, maybe these Aborigines are just cleverly turning the discourse of primitivism against itself in order to secure the privacy that most other Australians would assume to be their automatic right.

In this instance "just saying no" obviously has had its uses as a strategy, but it is by no means the only photographic option taken up by Aboriginal Australians. In the early 1980s, Aboriginal groups employed white photographers to document their struggles against mining companies and produced traveling exhibitions and books to publicize their cause.[24] More recently, individual Aborigines have taken to staging spectacular events that cleverly exploit the media's insatiable appetite for the grand symbolic gesture. In January 1988, Aboriginal spokesman Burnam Burnam set off for England to stand on the white cliffs of Dover (where else?) and read a declaration claiming possession of that land for his own people, promising in the process to bring to the English some much-needed civilization. Dressed in the dis-

AUSTRALIAN MADE

tinctive costume of a Wurundgeri man, his text was based on that read out by Captain James Cook when he claimed Australia as an English colony in 1770. Burnam Burnam's protest, once again intelligently playing off his status as an exotic native, received wide media coverage in the midst of the bicentennial celebrations. In similar style, an Aboriginal protestor intervened during the harborside launch by Australia's prime minister of the official *Penguin Bicentennial History of Australia* and threw a copy of the book into the water in disgust. His action was so sudden that those press photographers who were present, no doubt not expecting anything interesting to happen at this kind of choreographed event, failed to get it on film. So the protestor obligingly threw in another copy and thus ensured his place in the next day's paper. By such means do contemporary Aborigines strategically stake their place in the white man's precession of simulacra.[25]

They are not the only Australians to have managed to stage an effective intervention within the very grain of an established circulation of photographic images. During the 1980s a group calling itself B.U.G.A. U.P (or Billboard Using Graffitists Against Unhealthy Products) regularly terrorized Sydney's advertising billboards, particularly those devoted to the promotion of cigarettes and beer. Ubiquitous urban billboard images were transformed through a judicious and witty application of spray paint such that their naturalized messages of desire and pleasure were made strange, sometimes on a spectacularly grand scale. (photo 2.5). Thus "Marlboro" became "it's a bore," "Sydney draft" became "Sydney drug," and so on, all done so smoothly that one had to look twice to notice that these unauthorized changes were not there on the original. This campaign cost the companies concerned many thousands of dollars in new billboard posters and even more in negative publicity. B.U.G.A. U.P members seemed to be everywhere, indefatigable in their energies and powers of invention. However, when one or two graffitists were finally caught, it turned out that there was in fact no B.U.G.A. U.P organization as such, just an uncoordinated group of concerned activists, many of them articulate young professionals, who had each adopted the catchy acronym as their own. In this form, B.U.G.A. U.P continues to be an active photo-guerrilla force within Sydney's image environment to this day.

The nonurban environment has long attracted the attention of Australian photographers, landscape being a theme that looms large in the historical account provided by the two books I have been considering here. However, it apparently has not been as dominant a

2.5

B.U.G.A. U.P., Sydney Drug, *September 1983*
Altered billboard, Victoria Street, Sydney

concern among the art photographers of the 1980s, with only a few examples of contemporary landscape photography being reproduced in Ennis's catalogue. Among the most telling of these is one from a series by Peter Elliston showing a barren, stony expanse of Australian desert. It stretches out before us into the distance, its monotonous regularity broken only by a pair of mushroom shapes rising organically on the horizon line. For many Australians, these simple white shapes are anything but innocent: they are the architectural signifiers for one of the six U.S. military bases now operating on Australian soil. Elliston's image records their presence with the chilling matter-of-factness peculiar to the documentary photograph. In effect, his otherwise modest photograph has relocated the familiar forms of the Australian landscape within the deadly global geography of American nuclear strategy.

Elliston has produced an undeniably disturbing image, but can any photograph have a discernible impact on public opinion or on the outcome of controversial political debates? In 1982 Australia became embroiled in its most bitterly fought conservation campaign, "Save the Franklin," over the proposed damming of the hitherto untouched Franklin River in Tasmania by that state's conservative government. Photographers were among many other cultural workers and academics who became involved in the effort to stop the construction of the dam, with a number of them contributing to a traveling exhibition devoted to the issue. The photographs on display in this exhibition varied in their approach from panoramic documentations of a devastated landscape to more conceptual efforts to represent the social and media stratification of the protest movement itself.

The most conservative-looking images in the exhibition were some prints produced by Tasmanian photographer Peter Dombrovskis. Lush in color and cloyingly sentimental in style, they would have looked more at home in *National Geographic* or in a glossy calendar than in Sydney's avant-garde galleries. And indeed they did soon appear in calendars, brochures, and a variety of other locations, all in the service of the antidam movement. Of all the photography employed by the movement, these images by Dombrovskis probably contributed more than any other to the eventual transformation of the word *wilderness* from a pejorative to a positive term in the Australian lexicon. Perhaps his most popular photograph was one titled *Rock Island Bend, Franklin River,* a scene featuring turbulent water, all milky and sleek from the extended length of his exposure time, rushing headlong between two rocky crags that rise indomitably from the swirling Tasmanian mists. Get the picture? We are

talking about very familiar, very professional, chocolate-box photography. But imagine this same image appearing in a full-color, double-page spread in every major newspaper in the nation the day before a crucial federal election campaign, with these words writ bold across its lower edge: "Would you vote for a Party that would destroy this?" Well, of course, many could not; the government was changed, and the dam was quickly stopped by federal intervention.[26] Hasn't Jean-François Lyotard suggested that the only artistic sublime possible today must take the form of a realist kitsch?[27] The awful sublimity of this image by Dombrovskis was a significant contribution to the saving of a river, making it one of those few photographs that have made a demonstrable political impact on its viewers. But all this was still not enough to get it, or any of the other photographies I have been discussing, reproduced in one of these survey histories of Australian photography.

And so we return to the question of what implications, if any, Australia's photographic history might have for those interested in the development of the medium in the United States. It should be clear that although the two histories have much in common, sharing, for example, a strong nineteenth-century tradition of itinerant small-town photographers, there are also some significant differences between them. An obvious one is the lack of an Australian equivalent to the massive New Deal programs of the late 1930s. Compared to the United States, documentary photography is a relatively slight tradition in Australia. However, after World War II, such clear historical differences appear to be erased, with American multinational capitalism, and its attendant cultural imperatives, descending irresistibly on Australia as elsewhere. It would be easy to see Australian photography from this point on as no more than a dependent shadow of trends in the United States, and this indeed is the inclination of the authors of each of these three publications.

Of course, such a conclusion can be reached only if the evaluation system one brings to Australian photography is itself uncritically dependent on models formulated overseas. What, however, if one were to develop a distinctively *Australian* historiography, a mode of historical analysis that embodied and reflected on the specific character of Australian life and culture? Willis's admirable book, with its emphasis on Australia's own peculiar "conditions and contexts of production," certainly goes some way in this direction, providing numerous glimpses of subject matter, meanings, and attitudes that could have been produced only by this particular place. And yet, just as she has posited the possibility of a local point of view

(both her own and that of the various audiences for Australian photography throughout its history), Willis abandons it in favor of an art historical model that insists she look from the perspective of the United States and find the provincial product "not original." But as we have heard, a perverse play of origin and copy is precisely what has always made Australia Australian. Australian culture cannot help but be a constitutive intersection of local and international forces, and its cultural products (including its histories) inevitably will be marked by a similar negotiation. The only question is what kind of negotiation this is going to be.

As in the best examples of its art, Australian history writing could conceivably become a self-conscious assertion of interdependency rather than a simple reiteration of subjection.[28] If Australia's photography is ever to challenge its current supplementary status in the world scene, its critics and historians must intervene within the political economy of the supplement itself. They must simultaneously demand that Australian photography's regional qualities be recognized and appreciated in their own terms, even as they dispute the standards by which quality in general has hitherto been determined. This tenaciously double-edged critique of photographic history is the crucial project that still remains to be completed.

This essay incorporates revised versions of "Australian Made: Photographic History in the Antipodes," *Afterimage* 16:10 (May 1989), 12–17; "Ordinary Tendencies: Australian Photographic Practice and Its Uses," *Age Monthly Review* 9:1 (Melbourne, April 1989), 17–18; and "Anne Ferran: Scenes and Scenarios," *Art from Australia: Eight Contemporary Views,* exhibition catalogue (Melbourne: Australian Exhibitions Touring Agency, 1990), 40–42.

+ + **3**

+ + +

+ + +

VERNACULAR PHOTOGRAPHIES

How can photography be restored to its own history? And how can we ensure this history will be both materially grounded and conceptually expansive, just like the medium itself? Well, perhaps we should start by considering what has always been excluded from photography's history: ordinary photographs, the ones made or bought (or sometimes bought and then made over) by everyday folk from 1839 until now, the photographs that preoccupy the home and the heart but rarely the museum or the academy. Elaborately cased daguerreotypes, ambrotype jewelery embellished with twists of human hair, certificates bearing the tintype portraits of those they authorize, enameled faces fixed to metal memorial roundels, image-impregnated pillows and quilts, snapshot albums, panoramas of church groups, wedding pictures, formal portraits of the family dog, lampshades projecting dad's last fishing trip, baby photos paired with bronzed booties, coffee mugs emblazoned with pictures of the kids, snowdomes containing a girlfriend's photogenic smile: this is the popular face of photography, so popular that it has been largely ignored by the critical gaze of respectable history. To these examples could be added a multitude of equally neglected indigenous genres and practices, from gilt Indian albumen prints, to American painted and framed tintypes, to Mexican *fotoescultura,* to Nigerian *ibeji* images. Taken together, these ordinary and regional artifacts represent the troublesome field of vernacular photography; they are the abject photographies for which an appropriate history must now be written.[1]

It is not difficult to understand why vernacular photographies have attracted so little attention in the traditional account of photography's history. Although historical accounts of photography written in the nineteenth or early twentieth century tend to include an eclectic selection of photographies, throughout the late twentieth century, most histories tenaciously focused on the artistic ambitions of the medium, excluding all other genres except as they complement a formalist art-historical narrative.[2] Vernacular photographies resist this kind of classification, tending to be made in vast numbers by anonymous, amateur, working-class, and sometimes even collective hands or, worse, by crass commercial profiteers. Most of these photographic objects have little rarity or monetary value in today's market, and seem to have minimal intellectual content beyond sentimental cliché.[3] Worst of all, their idiosyncratic morphologies refuse to comply with the coherent progression of styles and technical innovations demanded by photography's art history; they muck up the familiar story of great masters and transcendent aesthetic achievements, and disrupt its smooth

European-American prejudice. In short, vernaculars are photography's *parergon,* the part of its history that has been pushed to the margins (or beyond them to oblivion) precisely in order to delimit what is and is not proper to this history's enterprise.

So there is a lacuna in photography's history, an absence. And we are talking about the absence not just of vernacular photographies themselves, but of a cogent explanation for that absence. Jacques Derrida points to a similar gap in Kant's *Critique of Judgment,* a book in which the German philosopher seeks to exclude from "the proper object of the pure judgment of taste" that which "is only an adjunct, and not an intrinsic constituent in the complete representation of an object" (ornamentation, frames of pictures, drapery on statues, colonnades on palaces—what he calls *parerga*).[4] In short, like photography's historians, Kant is against allowing the adjunct to take precedence over or distract from what he regards as the essential—taste's "proper object." His problem, of course, is distinguishing one from the other. The more he tries, the more he finds himself undercutting the entire infrastructure of his philosophy. So too with photography's historians. They have no choice but to ignore the vernacular photograph because to deal with it directly would be to reveal the shallow artifice of their historical judgment, and of the notion of the artwork on which it is based. As Craig Owens has suggested, seeing vernaculars as photography's *parergon* therefore signals a painful necessity, "not of a renovated aesthetics, but of transforming the object, the work of art, beyond recognition."[5]

Some photo historians have already begun this process. Books like Michel Braive's *The Photograph: A Social History* (1966), Camfield and Deirdre Wills's *History of Photography: Techniques and Equipment* (1980), and Heinz and Bridget Henisch's *The Photographic Experience, 1839–1914* (1994) have abandoned the usual art-historical chronology in an effort to encompass a full gamut of photographic practices. To these pioneering efforts could be added the catalogues of omniverous collectors (such as *Reflecting on Photography, 1839–1902: A Catalog of the Cotter Collection* from 1973) and the *Guide to Collections* of relatively enlightened institutions like the California Museum of Photography at Riverside. There have also been occasional specialist studies bringing attention to hitherto neglected vernacular genres, as in the 1983 study of the Shedden Studio photographs, Stanley Burns's 1995 book, *Forgotten Marriage,* on the painted tintype tradition, James Wyman's 1996 exhibition of photo backdrops, and Christopher Pinney's 1997 anthropological study of Indian photo-

graphic culture. Some survey histories of photography have also begun to exhibit the broadening influence of cultural studies. Mattie Boom and Hans Rooseboom, for example, compiled their 1996 study of the photo collections of the Rijksmuseum in Amsterdam under a series of strikingly generic chapter headings: Landscape, Buildings and Cities, The Reproduction of Art, Museums and Monuments, Anthropology and Anthropological Types, Events, Science, and so on. *Nouvelle Histoire de la Photographie,* edited by Michel Frizot in 1995, also goes to considerable effort to extend its coverage beyond the boundaries established by Helmut Gernsheim and Beaumont Newhall, even including an appreciative, if belated, chapter on ordinary photographs.[6]

These are all important contributions to the rethinking of photographic history's purview. Nevertheless, we have yet to see vernaculars being made the organizing principle of photography's history in general, yet to see a *vernacular* theory of photography being advanced. And this is despite the fact that in terms of sheer numbers, they constitute the vast majority of photographs made. (On that basis, of course, art photography should barely rate a mention.) But there are other reasons why this kind of work deserves serious critical attention. As a *parergon,* vernacular photography is the absent presence that determines its medium's historical and physical identity; it is that thing that decides what proper photography is not. Truly to understand photography and its history, therefore, one must closely attend to what that history has chosen to repress. Moreover, by reminding us of the differences within photography, vernaculars insist that there are many photographies, not just one, indicating a need for an equally variegated array of historical methods and rhetorics. In other words, vernacular photographies demand the invention of suitably vernacular histories.

All this is beyond the capacities of any single essay. So I will concentrate here on just one attribute common to many vernacular photographic practices, the creative exploration of the photograph's morphological possibilities, and, on one location, the domestic sphere. And I will do so as part of an ongoing investigation of the complex matter of photography's conceptual, historical, and physical identity.

Morphology is another of those issues that most histories of photography ignore. Indeed, the invisibility of the photograph, its transparency to its referent, has long been one of its most cherished features. All of us tend to look at photographs as if we are simply gazing through a two-dimensional window onto some outside world. This is almost a perceptual

necessity; in order to see what the photograph is of, we must first repress our consciousness of what the photograph is. As a consequence, in even the most sophisticated discussions, the photograph itself—the actual object being examined—is usually left out of the analysis. Vernacular photographies tend to go the other way, so frequently do they exploit the fact that the photograph is something that can also have volume, opacity, tactility, and a physical presence in the world. In many cases, this exploitation involves the subject of the photograph's intervening within or across the photographic act. These subjects make us attend to their photography's morphologies, and thus to look right at rather than only through the photograph. In this sense, vernacular photo objects can be read not only as sensual and creative artifacts but also as thoughtful, even provocative meditations on the nature of photography in general.

An awareness of the physicality of the photograph is an unavoidable feature of photography's earliest processes, particularly the daguerreotype. Dependent on the light sensitivity of a silvered sheet of copper, the daguerreotype image was too delicate and unstable to be touched directly. It was therefore covered by a glass sheet and then packaged in a silk- or velvet-lined leather case like a precious jewel. The daguerreotype case was itself sometimes decorated with embossed designs, painted landscapes, and patterned inserts. Certain examples were disguised as books or covered in expensive materials like mother-of-pearl. Later cases were made from an early thermoplastic, enabling detailed patriotic scenes to be represented in high relief; these stimulated the fingers as much as they delighted the eyes. Although daguerreotypes were obviously conceived by their makers as multifaceted objects, with both an inside and an outside, most histories of photography still isolate and reproduce only the image, excluding much of what made the daguerreotype such a particular experience.[7] As a combination of metal, glass, timber, and leather, daguerreotypes have a distinctive weight when held, a feature that slyly adds the gravitas of gravity to their list of constituent parts. Perhaps that is one reason why so many daguerreotypes feature images of people holding another daguerreotype, even when this is represented by nothing more than a closed case. Sometimes this case is the one we are now holding; we look inside to see the outside, thus collapsing sight and touch, inside and outside, into the same perceptual experience. It is as though these people want to draw our attention not to a particular image but to the brute objectness of photography in general, the comforting solidity of its memorial function.

Most daguerreotypes were made to be viewed in the hand and are scaled accordingly. However, only when we slip the small clasps of a daguerreotype's casing, only when we perform according to the object's prescribed demand, do we get to encounter the actual image inside. Surrounded by a faux-gold mat, this image winks up at us with the flash of a highly burnished mirror. The daguerreotype is simultaneously a negative and a positive, so to become legible as a picture, the silvered plate has to be maneuvered to an angle of forty-five degrees to the light. Hand and eye must work as one if a daguerreotype is to be brought into visibility; the look of the image comes only with the feel of its materiality. Designed to be touched, these photographs touch back, casually grazing the pores of our skin with their textured surfaces. In this mutual stroking of the flesh, we are reminded once again that an image is also an object and that simulation is inseparable from substance. Most important, we are made to behold the *thingness* of the visual—its thickness, the tooth of its grain—even as we simultaneously encounter the *visuality* of the tactile—its look, the piercing force of its perception.

Photography is privileged within modern culture because, unlike other systems of representation, the camera does more than just see the world; it is also touched by it. Photographs are designated as indexical signs, images produced as a consequence of being directly affected by the objects to which they refer.[8] It is as if those objects have reached out and impressed themselves on the surface of a photograph, leaving their own visual imprint, as faithful to the contour of the original object as a death mask is to the newly departed. On this basis, photographs are able to parade themselves as the world's own chemical fingerprints, nature's poignant rendition of herself as memento mori. And it is surely this combination of the haptic and the visual, this entanglement of both touch *and* sight, that makes photography so compelling as a medium. Compelling, but also strangely paradoxical. As Roland Barthes has suggested, "Touch is the most demystifying of all senses, unlike sight, which is the most magical."[9] It is striking how many vernacular photographic objects overtly reflect on this same paradox.

Take framed and painted tintypes, for instance. As Stanley Burns has shown, these objects were produced in large numbers from the 1860s through the 1890s in rural areas of the United States (indeed, this is a practice indigenous to that country), employing framemakers, photographers, and "folk art" painters whose portrait businesses had been

driven into extinction by the cheaper and quicker tintype technology. Individuals and families would sit for a photographic portrait, their heads inevitably supported by a standing metal device to keep them steady for the necessary seconds. Photography insisted that if one wanted to look lifelike in the eventual photograph, one first had to pose as if dead. Not surprisingly, the portraits that resulted have all the animation of a statue or wax effigy. This stiffness is not improved by the subsequent addition of paint, this being limited in color range and usually covering whatever idiosyncratic detail may once have been present in the photograph. As a consequence these portraits exhibit a certain sameness of expression, monotonous to a contemporary viewer but perhaps comforting to a clientele seeking familiarity of genre rather than artistic innovation. This clientele looks out at us from their gray backgrounds with the fixed stare of the blind, their facial and bodily comportment insisting above all on a dignified formality of presentation. Such formality is fitting for a procedure that may have occurred only once in a person's lifetime. Indeed, these otherwise humble portraits declare, "Do not forget me," with as much intensity of purpose as any pharaoh's tomb, a declaration made all the more poignant by the anonymity of the sitters in most examples.

These portraits are also fascinating for what we do not see—the photograph, for example. In many of them, the photographic base has been almost entirely covered by paint or, in the case of some of the backgrounds, erased through the application of acid. The resulting image was then often elaborately framed and matted (giving the final object both pattern and depth) (photo 3.1). We are already talking about a strangely hybrid piece of work then—part photograph, part painting, part etching, part sculpture. A strange practice too. First you take a photographic portrait, indexical guarantor of the veracity of the appearance of the person being portrayed. Then you hide that guarantee beneath a layer of often inexpertly applied paint. The mechanical exactitude of the camera is present—we are aware of its foundational role—but the eye perceives only the traces left by the hand of the painter. Nevertheless, however clumsy the artist, the portrait we witness continues to be supported by the truth value of its photographicness. Indeed, the epistemological presence of the photograph is made all the stronger by its perceptual absence. These images, so simple at first glance, actually exploit a complex form of palimpsest. As Derrida might put it, they offer "an erasure which allows what it obliterates to be read."[10]

3.1

Artist unknown (American), Portrait of a Man, *c. 1860–1880*
Etched and painted tintype, gilt mat, wood frame
Private collection

All sorts of photographs were modified with paint in the nineteenth century.[11] This touch of the brush, often enough only to accentuate jewelry or add a little rouge to a sitter's cheeks, brings a subjective, "artistic" element to the otherwise dull objectivity of a formulaic studio portrait. But it also adds the color of life to the monotones of a medium often associated with death. In many cases, these painted additions provided, with their slender trails of gilt, a welcome illusion of success and prosperity. The paint also helped bring some photographic images—daguerreotypes, for example—under the control of the eye. The polished silver surface of the daguerreotype offers a gestalt experience in which one sees, alternately, one's own reflection and the portrait being examined. The application of paint brought a matte opacity to this gleaming surface, giving it a perceptual tactility that halts the daguerreotype's disconcerting oscillation between mirror and picture. The viewer's eye is thereby able to gain a purchase on the photograph without the discomfort of having to confront itself staring back.

Tactility was evoked in other ways too. Notice the emphasis given to the hand and touching in the pose of many ordinary nineteenth-century photographs. Time and again we see the touch of a hand on the shoulder of another, a physical linking of bodies that suggests affection, reassurance, solidarity, even control. In the case of memento mori, this linkage sometimes comes from outside the picture. In one example, a small tintype of a little girl sitting on what we take to be her father's knee has, after her death, been surrounded by a lovingly embroidered garland woven into a background of black velvet (photo 3.2). The embroiderer's hand (belonging to a mother or sister?) thus remains in tender communion with the photograph of the deceased, itself the residue of an earlier interaction of girl, light, and photographic chemistry. One touch embraces the other in a perpetual enactment of mourning and remembrance. Memory also looms large in a daguerreotype case containing a handwritten inscription and a lock of hair woven into a circle (both once hidden away behind the image): "OCala—Florida—July 20th 1859—'Little things bring back to mind Thoughts of happy bygone times'—Kate—(Dinna Forget)." A portion of Kate's body nestles beneath that same body's photographic imprint, once again bringing touch into the picture and adding a trace of the real (as well as the animation of her presumably Scottish voice) to the simulation of the image.

3.2

Artist unknown (American), Memorial with a Portrait of a Man and his Child, *c. 1860–1880*
Tintype, metal edging, embroidery, elliptical wood frame
Private collection

Similar sentiments are represented in various examples of photographic jewelry, another genre rarely represented in published histories of photography.[12] Here are photographs intended to turn the body into an accessory. One displays one's affections in public, wearing them not on the sleeve but as pendants against the chest or hanging off the ears. This is photography literally put in motion, sharing the folds, volumes, and movements of the wearer and his or her apparel. Often these objects are organized as declarations of love. An ornament might contain portraits of husband and wife on either of its sides, lying back to back, never to be parted (photo 3.3). For the object to be experienced in full, it has to be turned from side to side, a form of caress preordained by its designer. Other examples include photographic lockets in which the man and woman initially lie hidden, kissing each other in the dark until liberated into the light of a loved one's gaze. In the nineteenth century, it was also common for the bonds of matrimony to be confirmed in a framed certificate, complete with tintype or albumen photographs of bride and groom and sometimes even of the responsible minister as well. The photographs presumably add an extra element of indexical weight to the signatures that already authenticate the event. In such artifacts, the photograph finds itself joined to the rituals of both religion and the law, as well as to a plethora of textual admonitions and reminders for the happy couple ("A prudent Wife is from the LORD, Her price is above RUBIES").

Jewelry and marriage certificates are not the only genres where photographs taken on separate occasions are brought together to form a single coherent object. Frequently a number of daguerreotype, ambrotype, and tintype portraits would be gathered in the one frame, declaring themselves to be all part of the same familial genealogy. Organized into geometric grids (rectangles, squares, ovals), these often ornate wall sculptures stress the potential connections between one image and the next. In combining the antinatural, antimimetic order of the grid with the insistent realism of the photograph, these objects also recall the spatial abstractions of optical science that informed photography's invention only two decades before. Their gilt geometries (so solid, so visible, compared to the elusive, reflective images of the photographs they contain) conjure the window that photography claims to provide onto the world, even as they firmly demarcate our separation from that world.[13] But beyond all this, the gridding of photographs provides them with the unmistakable structure of narrative, with the declared capacity to tell a story, always a weakness of individual photographs.

3.3

Artist unknown (American), Portraits of a Man and a Woman, *c. 1850*
Daguerreotypes in silver locket
University of New Mexico Art Museum, Albuquerque
Purchased with funds from the University of New Mexico Foundation, Inc.

This same will to narrative is embodied in photographic albums. As with cased photographs, these books often boast embossed leather covers and enticingly tactile surfaces, creatively decorated with patterns and inserts (or boldly titled with a single self-explanatory word, "Album"). Even the covers of modern, plastic photo albums retain visual hints of this surface tactility, perhaps a memory of the fact that all illustrated books are descendants of medieval liturgical manuscripts and heavily worked and jeweled Bibles. It seems no accident that many subjects in cartes-de-visite or cabinet cards are shown clutching such a book, whether Bible or album it is often difficult to say. In some instances, albums obviously came to be regarded as an essential confirmation of the family unit, proudly displayed in photographic portraits as a substitute, perhaps, for the children or relatives not otherwise present.

Some of these albums were manufactured so that the book itself was built into a decorated stand, from which it folded down to reveal a hidden mirror (presumably allowing viewers to compare their faces to the photographic representations on the page before them). Others open to reveal convenient home altars, once again blurring the distinction between photography's secular and spiritual capacities. In general, albums gave their owners the chance to have a creative input into the way in which photographs were displayed and seen. Images could be sequenced, captioned, and even imaginatively embellished according to individual whim. We usually encounter historical albums today in static form, displayed behind glass in a museum case (they too are rarely discussed or reproduced in survey histories of photography).[14] However, albums are mobile objects and were always experienced as such. Like so many of the photographies discussed here, they demand we add the physical intimacy of touch to the more distanced experience of looking. And when we do touch, by turning an album's pages, for example, we put the photograph back into motion, both literally in an arc through space and in a more abstract, cinematic sense as well. For example, one small album of tiny tintypes (or "gems") shows photographs of the same group of four men arranged in a variety of poses (at one point, three of the group even appear with their backs self-consciously turned to the camera). By appearing on a number of separate pages, these photographs exploit the temporal and spatial possibilities inherent in a book format, playing with small systematic differences between poses to suggest the illusion of animation, an illusion that our hand has just symbiotically produced.

Albums also gave their owners other ways to intervene creatively in the image-making process. The album pages produced by Lady Filmer and other English upper-class women in the mid-1860s are an artful collage of albumen prints and watercolor drawings, sometimes arranged in rigidly symmetrical patterns and sometimes in a seemingly careless profusion of forms that recall contemporaneous trompe l'oeil paintings or even the visionary fantasies of Lewis Carroll.[15] The mechanical exactitude of the photographic portrait is here transformed and elaborated into a personal tribute to these women's friends and family, and the desires and dreams associated with them. As with all other collage practices, attention is drawn to the edges of its constituent images, disrupting the seamlessness of photography's representational claims to fidelity and realism, as well as its role as an inscription of the past (these photographs are harshly located in the here and now of the page itself). In the case of Lady Filmer, one of her symmetrically organized pages demands to be turned on its axis, so that each of its female figures can be momentarily seen standing upright. In other words, this work assumes the hand of the viewer, as well as that of the maker, as an integral part of its representational apparatus.

Although Filmer and others have begun to attract the attention of photography's historians, there has still been little recognition of the creativity demonstrated in twentieth-century snapshot albums. These albums have given ordinary people an opportunity to represent their autobiographies in artful combinations of words, lines, and pictures. The star of these biopics is often designated only as "me." The album's storyline then faithfully follows this frequently photographed but otherwise anonymous person throughout her youth, starting with pictures of family outings, and then gradually including the occasional young man, until one of them is singled out for marriage. The album usually finishes shortly after. One such album begins this story in Michigan in about 1920 and continues through to 1924, "when Norm first bought the pup" (whose photograph is shown outlined by an appropriately doghouse-shaped white line). This particular album is wittily captioned throughout, its owner enlivening its recurring cast of characters with textual teasers ("That crazy summer 1922") or even snatches of musical notation from "When You and I Were Seventeen" (thus including even sound in her multidimensional rendition of life and love). The page presenting "that crazy summer" is festooned with a pink souvenir of a fair and a fanned arrangement of cigarette papers (no doubt the ultimate sign of daring adulthood), as well as

cut-out photos of "Kate" and "Jean" posing in alluring swimsuits (photo 3.4).[16] Once again, we are made witness to the creative efforts of ordinary people who, by exploiting the possibilities of a "demystified photography," are able to express the intricacies of their own social rituals in a tangible, visual form.

The use of photographs as a collage element is not confined to albums. This practice was also extended to domestic interiors, where, for example, we once might have encountered cabinet cards arranged in a dense vertical layer against a floral wallpaper, together with ribbons, a tambourine, and a conveniently supportive tennis racquet. An early Kodak snapshot of such an arrangement also records a small stand holding a photograph, one of a vast number of devices manufactured for such purposes. Late nineteenth- and early twentieth-century homes often demonstrate a pronounced interest in photographs as pieces of domestic architecture, with rooms containing numerous large framed portraits (Charles Eastlake called them Wall-Furniture) and tables and mantels covered in smaller stands or photographic viewing machines.[17] Everywhere a visitor turned, he or she was faced with the insistent presence of photographic objects.

It is still like that in many homes. Walls soon come to be festooned with framed pictures of the wedding ceremony or of the kids, often taken in color by professional photographers. The wedding picture has its own peculiar history, a direct link back to the formal studio portraiture of the nineteenth century and, before that, to the dynastic paintings of the aristocracy. Of course, no wedding would be complete today without photographs being taken to record the event for posterity. These photographs are usually closely orchestrated by a professional photographer (who becomes a key player in the overall wedding event) to ensure the proper conventions are maintained and reproduced. A key historical figure in this practice was the American Rocky Gunn, who introduced both color and romantic narrative into the wedding picture genre. Under his direction, the bride and groom acted out a fantasy courtship ritual (groom on bended knee and so on), retrospectively constructing the imaginary course of events leading up to the wedding itself. The end result is a series of pictures, like stills from an otherwise lost film, in which the formal portrait is but one, climactic element.[18]

Professional photographers also have the task of making otherwise recalcitrant children perform as the "ideal child" in front of the camera. The fantasy image that results (often

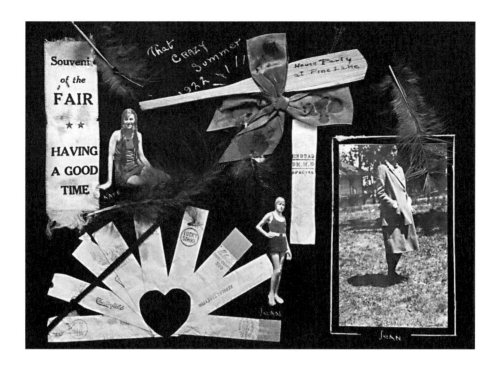

3.4

Mary von Rosen (American), Page from Photo Album: "That Crazy Summer 1922," *c. 1922*
Silver gelatin prints, cigarette papers, ribbon, feathers, string, wood, and ink, on paper
Private collection

enhanced by unearthly lighting and coloring) is again a descendant of a prephotographic painting tradition in which accuracy of representation is less important than the overall message of prosperity and well-being. Sometimes these baby pictures are put into standing wooden frames and combined with the child's bronzed booties in an altarlike tribute to parental memory (photo 3.5). Here is another typical vernacular maneuver, the self-conscious doubling of that indexicality thought to be photography's special attribute. We have seen a similar doubling in those cases where photographs are combined with the subject's hair, a common feature of many examples of photographic jewelry, or in wedding certificates with signatures. Its reiteration in the baby altar suggests that in the parents' minds, at least, the photograph alone is not enough to alleviate the fear of mortality to which this particular object is dedicated.

We might extend this speculation about a memorial function to include certain regionally specific photographic practices found in Africa, Latin America, and Asia, thus taking our study of vernacular photography beyond the restrictive but comfortable boundaries of a Eurocentric worldview.[19] These artifacts necessarily speak to us of difference, of cultural difference but also of photography's own differences from itself. Once again, we find that morphology is a key issue. As Olu Oguibe has told us, in places like Nigeria, photographs have quickly been incorporated into established funeral practices. Since at least the sixteenth century, the Owa of western Nigeria have commissioned a lifelike effigy of the dead as part of their funeral arrangements, dressing it in the deceased's clothes and either interring it or putting it in a commemorative shrine. In more recent years, a photograph is sometimes used as the basis for the making of this effigy. Interestingly, the effigy is itself occasionally supplemented or even entirely replaced by a framed photograph. This is then carried in mourning processions and treated with the same reverence as a three-dimensional object.[20]

So here is a case where context is literally everything (it, rather than the choice of medium, determines something's identity as photography). Stephen Sprague reports that a sculptor from the Ijebu-remo area in Nigeria referred to his own carvings of airplanes as being "like photographs," meaning, Sprague says, "they simply depict the subject but have no spiritual or ritual significance."[21] Sprague also describes the adoption of photography into the *ibeji* rituals of Nigeria's Yoruba. A cult organized around the death of a twin has apparently been in place among the Yoruba since before the nineteenth century. It has resulted in

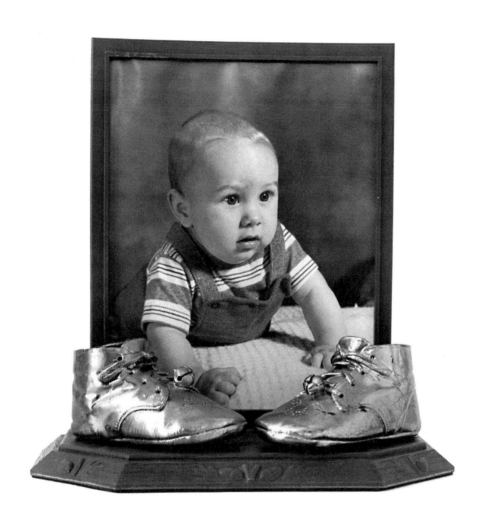

3.5
Artist unknown (American), Baby Shrine for Jayson Hoyt, *1975*
Color photograph, plastic, bronze booties
Private collection

the production of sacrilized sculptural figurines standing in for the dead twin; these are presented at an altar and cared for as if living, and are often passed down through the generations. However, from the late nineteenth century on, photographs, often manipulated in various ways, have sometimes been substituted for this sculptural object (or sometimes a photograph of the carved sculpture is made and then it is venerated).[22] So here among the Yoruba, the photograph is treated as an entirely malleable concept, something to be made rather than simply taken, something that in a certain ritual context has the same concrete significance as a three-dimensional object.

Mexican artisans have also been known to transform photographs into sculptural forms. Although given little or no attention in published histories of photography, many Mexican and Mexican-American homes still own and display a distinctive form of photographic portraiture known as *fotoescultura*.[23] These family portraits, made by collectives of Mexican artisans from the late 1920s through to the early 1980s, combine a photograph, usually an enlarged and hand-colored studio portrait, with a carved bust, elaborate frame, and painted or applied decoration; the final object is sandwiched between two sheets of beveled glass (photo 3.6). The end result is a fascinating and distinctive form of vernacular photography. According to the research of American artist Pamela Scheinman, *fotoesculturas* were commissioned from traveling salesmen for various reasons: to commemorate weddings and *quinceañeras,* memorialize the dead, honor individuals, and even promote the images of celebrities, from Gary Cooper to Richard Nixon.[24] Large numbers were sold not only in Mexico but also among Mexican-American communities in such places as Chicago, Laredo, and Houston. They were particularly popular during and after World War II, when many families were anxious to memorialize their absent sons. Today one finds them in domestic settings, such as home altars, but also in mausoleums. In both cases they are often combined with a profusion of other visual material, both religious and personal.

In a recent essay, Monica Garza argues that *fotoesculturas* exhibit a peculiarly Mexican aesthetic sensibility.[25] She points in particular to their merger of sacred and secular attributes (the double glazing, for example, gives these portraits the distanced intimacy of a reliquary), and to the way they fit a Catholic tradition in which imagery is frequently turned into literal, three-dimensional effigies. As in the Nigerian examples, we find the photograph being treated as a tangible metaphor—as something one looks at rather than through, as an opaque

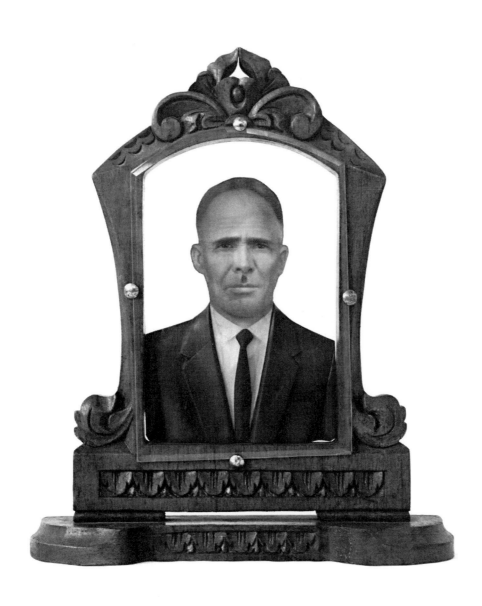

3.6

Artist unknown (Mexican), Hombre/Man, *c. 1950*

Hand-painted photograph over wood, plaster, wood frame, glass

Private collection

icon whose significance rests on ritual rather than visual truth. Where the photograph normally speaks to us of the past, the past in which the photograph was taken, a *fotoescultura* stolidly occupies the eternal horizon of the present. The photograph speaks of the catastrophe of time's passing, but the *fotoescultura* also speaks of eternal life; it posits the possibility of a perpetual stasis, the literal, fully dimensioned presence of the present.

In *Camera Lucida,* Roland Barthes offers the following commentary: "Earlier societies managed so that memory, the substitute for life, was eternal and that at least the thing which spoke Death should itself be immortal: this was the Monument. But by making the (mortal) Photograph into the general and somehow natural witness of 'what has been,' modern society has renounced the Monument."[26] Could it be that in the midst of an age in which, as Marx put it, "everything solid melts into air," *fotoesculturas* and other vernaculars like them are an attempt to restore a certain monumentality to both modern memory and the photograph?[27]

All of this talk of memory returns us to the question of history, to the problem of how to provide an appropriate historical accounting for photography's vernacular manifestations. This is no simple matter. As the proponents of folk art have inadvertently demonstrated, it is not enough to propose yet another, autonomous object of study (the "vernacular photograph"). This merely establishes a new category of collectible, and in the process deliberately reinforces the very distinction between margin and center that should be at issue. Expanding the canon has momentary value, but what is needed here is a rethinking of the whole value system that canonization represents. Why not instead, for example, insist on the vernacularity of the art photograph (its specificity to a particular, regional culture) and include it in our historical discussions as but one type of vernacular photography among many? And why not at the same time explore the artistic qualities of vernacular objects, granting them (as I have here) the same intellectual and aesthetic potential as their more privileged cousins? So we are already talking about developing a history that contests traditional boundaries and disturbs existing oppositional structures.

Perhaps we might do well to take our historiographic clues from the objects themselves. It is interesting, for example, that despite employing photographs, vernacular photographies choose not to declare their own transparency to the world they picture. Where much photography seeks to repress its own existence in favor of the image it conveys, ver-

naculars have presence, both physical and conceptual. Apart from the stress on the dimensionality of the photograph, they also frequently collapse any distinction between the body of the viewer and that of the object, each being made to function as an extension of the other. They produce what Barthes might have called a "writerly" photography, a photography that insists on the cultural density of photographic meaning and assumes the active involvement of the viewer as an interpretive agent.[28] Actually, vernacular photographs tantalize precisely by proffering the rhetoric of a transparency to truth and then problematizing it, in effect inscribing the writerly and the readerly in the same perceptual experience. Although the photograph is obviously an important element of the way they all work, these objects are less about conveying truthful information about their subjects than they are about enacting certain social and cultural rituals through morphological design and object-audience interaction. As you will have noticed, in many of the examples I have examined, conformity to (rather than difference from) established genre conventions is a paramount concern. In other words, making, commissioning, and/or witnessing these objects are all, at least in part, acts of social placement and integration.

This would suggest that material culture, rather than art history, might be a more appropriate place to look for methodological guidance. Certainly traditional art historical categories such as originality, authorship, intention, chronology, and style seem completely inadequate to this kind of material. Genre and morphology, on the other hand, seem more promising as analytical categories; at least they encourage a close attention to the actual photographic object and its physical and functional attributes (and this is certainly an attention such objects deserve and reward). And these categories could also lead to unexpected ways of organizing the material at issue. One might imagine, for example, a historical typology of vernacular photographies organized around the way they deal with their photographs: addition, elaboration, subtraction, erasure, sequencing, masking, framing, inscription, posing, multiplication, and so forth. Or perhaps a more fertile approach would be to trace common themes (death, memory, family, desire, childhood) or social functions (exchange, memorialization, confirmation, certification).

Another key relationship worthy of exploration is the involvement of the body with these objects—both the body of the subject and that of the viewer. This last category of body must, of course, include that of the writer, adding an overt autobiographical element to his

or her history. We are talking about a kind of anecdotal, novelistic approach to vernacular photography, a historical version of Barthes's *Camera Lucida* (which is written in the first person throughout, following the author's early decision to "take myself as mediator for all Photography . . . the measure of photographic knowledge").[29] Michel Foucault's "archaeo-logical" approach to historical analysis is another fruitful model. His examination of modes of knowing (rather than knowledge itself), his concentration on marginal voices (rather than "great masters"), his abandonment of evolutionary cause and effect as an organizing prin-ciple, and his employment of elliptical rhetoric together result in a style of discussion closer to a Borges conundrum than to a traditional history.[30] The advantage of all these kinds of typologies is that they break the linear, progressive, chronological narrative structures of most modern histories of photography, allowing objects from different historical moments to be directly compared (and compared on grounds more pertinent than style or technique) and questioning any presumed distinction between fiction and fact, interpretation and truth. A whole new taxonomy for the study of photography's history needs to be thought out—a pho-tographic *Wunderkammer* fit for our postmodern age.[31]

As I have suggested, this kind of approach may come more easily to scholars already familiar with the study of material culture. Defined as "the interpretation of cultural signals transmitted by artifacts," the analytical focus of material culture rightly reminds us, for ex-ample, that these objects were once (and still are) animated by a social dimension, a dynamic web of exchanges and functions, that gives them a grounded but never static identity.[32] A number of focused studies have been undertaken under the aegis of American studies or an-thropology that seek to recognize and reanimate this social dimension.[33] Such an emphasis necessarily opens up the question of how one determines the meaning of these objects. My discussion of indigenous vernaculars, for example, draws on the anthropological record to suggest that things that look the same or were made in the same way do not necessarily mean the same thing. Photographs never have a singular meaning; neither, it turns out, does photography as a whole. Despite these insights, however, material culture has at least one troubling tendency: the temptation to seek the meanings of objects through a restoration of their original contexts and social settings (in the case of vernacular photographs, now often lost or, at best, a matter of speculation). In this model, the presumed intent of the artist is replaced by that of society as a whole. This desire to replace one first cause with another

VERNACULAR PHOTOGRAPHIES

78

implies that the proper role of history is to search for the true identity of objects, for original or actual meanings found primarily in their past. (A parallel can be found in a brand of semiology that is content to see the sign as simply a bridge between a referent and its meaning.)

But identity (whether of photographs, people, or history itself) is a complex issue that cannot be entirely resolved by a return to origins (even assuming these can be found). As Stuart Hall reminds us, any identity is a matter of becoming as well as of being:

It belongs to the future as much as to the past. It is not something which already exists, transcending place, time, history and culture. Cultural identities come from somewhere, have histories. But, like everything else that is historical, they undergo constant transformation. Far from being eternally fixed in some essentialised past, they are subject to the continuous "play" of history, culture and power. Far from being grounded in a mere "recovery" of the past, which is waiting to be found, and which, when found, will secure our sense of ourselves into eternity, identities are the names we give to the different ways we are positioned by, and position ourselves within, the narratives of the past.[34]

Most histories of photography up to this point have presented themselves as transparent to this past, recreating it not as one of those lived effects of historical writing (a "narrative of the past") but as fact. Any study of vernacular photographies must of course trace the presence of the past, but as an erasure (an absent presence fissured through and through by differences and contradictions) motivating the object in the present. The critical historian's task is not to uncover a secret or lost meaning but to articulate the intelligibility of these objects for our own time.[35] A vernacular history of photography must learn to negotiate the dynamic play of being and becoming that Hall describes, for both itself and the objects it chooses to discuss. Only by this means will it produce a semiology of meaning that can articulate the differences within and between photographies already regarded as excessively different from proper photographs. Just as vernacular photographies themselves implode the presumed distinction between tactility and visibility, and between photography's physical and conceptual identity, so must we produce an equally complex historical morphology for photographic meaning. This vernacular semiology of the photographic (or, more accurately, this *photogrammatology*) is the necessary eruption of photography's history with which I

began, an eruption that promises to transform not just this history's object of study but its very mode of existence.[36]

This essay incorporates a revised version of *Photography's Objects,* exhibition catalogue (Albuquerque: University of New Mexico Art Museum, 1997), as well as elements of "Evidence of a Novel Kind: Photography as Trace," *Camerawork: A Journal of the Photographic Arts* 23:1 (Spring–Summer 1996), 4–7, and "Touché: Photography, Touch, Vision," *Photofile* 47 (March 1996), 6–13. It first appeared in *History of Photography* 24:2 (Summer 2000).

+ + +

4 + +

+ + +

TAKING AND MAKING

When is a photograph made? At what points in its production should we locate its creative and temporal boundaries? Is it when the photographer depresses the camera shutter, submitting a chosen scene to the stasis of framed exposure? Is it when the photographer singles out this exposure for printing, thereby investing a latent image with the personal significance of selection, labor, and, most crucial of all, visibility? Or is it when that image is first exposed to the public gaze, the moment when, if only by adding itself to a culture's collective visual archive, the photograph could be said to enact some sort of residual effect? These questions are of more than academic interest; already a number of exhibitions have been organized that include photographic works never seen by those who are supposed to have "made" them.[1] So my questions immediately impinge on prevailing notions of intention, authorship, and value. But perhaps more important is the way such questions force us to consider how the making of photographs is always caught up in the complex entanglements of their own history.

Take Alfred Stieglitz's *Paula,* for instance (photo 4.1). Stieglitz (1864–1946) is perhaps the most influential American art photographer of the twentieth century and *Paula* one of his most frequently reproduced images. Beaumont Newhall, for example, gives *Paula, or Sun Rays, Berlin* a full-page reproduction in the 1982 edition of his *The History of Photography,* dating it 1889 and using it to open his chapter on Pictorial photography.[2] The sharply focused image shows a young woman (Stieglitz's lover of the time) bent at a table over her writing, her body and its surrounds raked by the parallel striations of strong sunlight projecting through an open window to her left. Before her on the table and above her on the wall are a series of photographic prints (four of them feature this same woman, one is a cabinet card portrait of a young Stieglitz, and two reproduce an identical cloudy landscape scene), some heart-shaped cards with ribbons attached, and a hanging bird cage.[3] Newhall describes the image as one in which "Stieglitz records a new, personal vision."[4]

Rosalind Krauss chose this same work, but now titled *Sunlight and Shadows: Paula/Berlin* (1889), as one of the images she discusses in a 1979 essay about the dangers of any simple essentialist or formalist analysis of photography. Arguing that this photograph demonstrates Stieglitz's "overt concern with the question of definitions," she points to what she calls its "catalogue of self-definition: an elaborate construction through which we are shown what, in its very nature, a photograph is." Having carefully described each of its

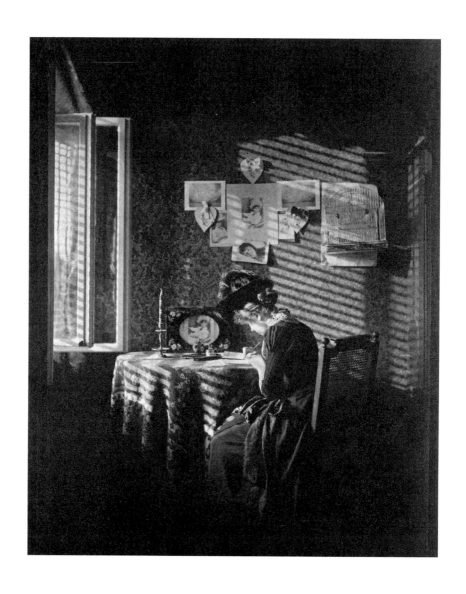

4.1
Alfred Stieglitz, Paula, or Sun Rays, Berlin, *1889 (?)*
Platinum print (1916)
Alfred Stieglitz Collection, National Gallery of Art, Washington, D.C.

iconographic elements, its stress on light, and the framing effects of the window—in particular, its self-conscious display of other photographs—she concludes that *Paula* is "an elaborate demonstration of the fact of reproducibility which lies at the heart of the photographic process." Nevertheless, Krauss then goes on to contrast *Paula* with Stieglitz's later *Equivalents* series of cloud pictures in order to show that the earlier photograph has neglected to include the cut or crop as one of its ontological constellation of signs, and therefore has not yet recognized that the photograph itself is a sign (a form of "radical absence").[5]

A more recent interpretation, by Diana Emery Hulick, calls *Paula* "perhaps the photographer's best known early work": "Its technical virtuosity and modernist sensibility have earned it a well-deserved place in the history of art." Comparing Stieglitz's iconographic and compositional conceits to seventeenth-century Dutch paintings and noting his self-conscious inclusion of other photographs, Hulick concludes that "*Paula* is a turning point in the history of the medium and in the artist's *oeuvre*. . . . It encapsulates the artist's development from narrative to modernist and self-referential photography." Moreover, Hulick repeats what has become a common observation: that "the image also appears to presage Stieglitz's late work."[6]

Strange then that Stieglitz did not repeat this "new personal vision" or "modernist sensibility" in other work from this period. In fact, quite the contrary. In 1892 Stieglitz published an essay, "A Plea for Art Photography in America," in *Photographic Mosaics,* admonishing his countrymen and women to incorporate "exquisite atmospheric effects" in their photographs, an atmosphere that "softens all lines." "The sharp outlines which we Americans are so proud of as being proof of great perfection in our art are *untrue* to Nature, and hence an abomination to the artist."[7] The essay appears to be critiquing precisely the "modernist" attributes of his own 1889 *Paula.* Nor do we find Stieglitz, never adverse to the promotion and advocacy of his "personal vision," producing and exhibiting other pictures in which either *Paula*'s "modernist sensibility" or overt self-referentiality is evident.

Indeed, in the same year Stieglitz took *Paula,* he submitted an entirely naturalistic portrait of a young boy, very much in the spirit of Peter Henry Emerson's aesthetic preferences, to *Der Amateur Photograph,* where it was published in 1890. Work made in subsequent years continued to stress atmospheric effects (as in *Winter on Fifth Avenue,* 1893) or poignant genre scenes caught in differential focus (*The Net Mender,* 1894, which Stieglitz published as

"My favorite picture" in the first, 1899, issue of *Photographic Life*). Although he exhibited many other photographs from this period in his Camera Club Exhibition of 1899, he did not think to include *Paula*.[8] He also failed to include it in his 1913 one-person exhibition at 291 Gallery. Despite ample opportunities, he again neglected to publish *Paula* in either of the magazines under his control, *Camera Notes* or *Camera Work*. Nor did he publish any other examples of the hard-edged modernist sensibility that had apparently become his personal vision in 1889—until, that is, the October 1911 issue of *Camera Work*, which reproduced *The Steerage* for the first time.

When, then, does *Paula* first make an appearance as part of Steiglitz's oeuvre? There is no certain answer.[9] The earliest known examples of this image are owned by the National Gallery of Art in Washington, D.C., and the Museum of Fine Arts in Boston, both platinum prints dated by Stieglitz himself to 1916.[10] In an exhibition catalogue published to accompany *Beginnings and Landmarks: "291" 1905–1917*, an exhibition curated by Stieglitz at An American Place in 1937, he claims to have "introduced" a print titled *Sun Rays* at 291 Gallery in 1905. However, there is no other evidence to support this claim or to verify that *Sun Rays* was the image we now call *Paula*. A more likely introduction was the 1921 retrospective exhibition of Stieglitz's work presented at the Anderson Galleries in New York. Among the 145 prints (ranging in date from 1886 to 1920) that Stieglitz selected, a selection that the artist himself described as the "quintessence" of his photographic development, was a print titled *Sunlight and Shadow* (1889).[11] He also included a gelatin-silver print titled *Sun Rays, Berlin* (1889) in his 1934 retrospective at An American Place. It was in the catalogue brochure for this exhibition that Stieglitz tells the story of coming across twenty-two of his old negatives in the attic at Lake George during the summer of 1933 and printing them: "When I saw the new prints from the old negatives I was startled to see how intimately related their spirit is to my latest work." Newhall repeats this story as fact in the 1982 edition of *The History of Photography*, and it reappears in the interpretations offered by more recent historians, such as Hulick. To complete my genealogical survey, this same image, but now titled *Light and Shadows* and dated 1887, was published for the first time in *America and Alfred Stieglitz*, the anthology of essays and reproductions published in 1934 to celebrate Stieglitz's seventieth year, and then again as *Light and Shadow, Berlin* (1887) in a 1935 issue of the *Magazine of Art* and as *Light and Shadow* (1889) in the September 1938 issue of *Coronet*.

From the tangle of evidence, it seems likely that *Paula* was taken in 1889 (although even this seems to be uncertain in Stieglitz's own mind) but not printed until 1916, and was exhibited for the first time only in 1921. So what has happened in the intervening twenty-seven years between the taking and the making of this image? Why would Stieglitz not consider *Paula* worth printing or exhibiting in 1889 but in 1921 want to claim it as an integral part of his history?

What has happened, of course, is that between about 1907 and 1911, Stieglitz encountered examples of European avant-garde art (by such artists as Rodin, Picasso, Cézanne, and Matisse) and, in concert with others in his circle, began to develop an appreciation of the abstract possibilities of his medium. In 1910, for example, he produced a series of photographs looking across the docks and harbor of New York City in which subject matter seems to be less important than formal relationships (as in *Outward Bound, The Maureta-nia*). As he wrote to a skeptical Heinrich Kuhn in October 1912, "Just as we stand before the door of a new social era, so we stand in art too before a new medium of expression—the true medium (abstraction)."[12] More than that, Stieglitz begins to develop a theory of revelation as the basis of any worthwhile photographic art practice. Eschewing manipulation of any kind, he claims an equivalency between photography and other artwork because of their common vision of the world's formal values; henceforth, the *art* of photography is to be found in the receptivity of the photographer's eye to that play of form. His friend Marius de Zayas articulates this theory in a 1913 essay in *Camera Work:* "[The idea photographer] tried to get at that objectivity of Form which generates the different conceptions that man has of Form. . . . [The idea photographer] puts himself in front of nature, and without preconceptions, with the free mind of an investigator, with the method of an experimentalist, tries to get out of her a true state of conditions."[13] Stieglitz's *Equivalents* series of the 1920s was perhaps his most sustained exploration of this "idea photography," but it is equally influential on the extensive reinterpretation of his own career in which he was engaged for the last thirty years of his life.[14]

Much has been written about the history of *The Steerage* within this context, recounting how Stieglitz exposed the image in 1907 but failed to recognize its significance until 1910 (when it was rediscovered by friends), after which he published it in a 1911 issue of *Camera Work* and exhibited it in his one-person show of 1913.[15] Thirty-five years later, in 1942,

Stieglitz projected his theory of revelation back onto the production of this now-famous image, remembering not this inconvenient lag between its taking and making but an immediate and spontaneous vision of "shapes and underlying that a feeling I had about life."[16] His reminiscence stresses that he had seen the image complete in his mind's eye before he even had his camera in his hand. For the mature Stieglitz, photographing was merely the capturing in pictorial form of what had already been seen by the artist as Form—not just the surface appearance of things but what lay hidden underneath. Ignoring subject matter (in this case, the articulation of class difference), Stieglitz's reading of *The Steerage* established the parameters of the formalist approach to photographic history that continues to dominate, especially in art museums, up to the present day.[17]

The historical resurrection of *Paula* belongs to this same pattern. Inconsequential in 1889, by 1921 its sharp contrasts of light and dark (enhanced by the shift from the warm tones and paper textures of the platinum version to the starker and more highly detailed gelatin silver print) suit the artist's desire to claim retrospectively an early grasp of his later modernist principles.[18] Having gone to the trouble of reprinting *Paula,* Stieglitz must have been gratified by John Tennant's review of the 1921 exhibition: "In the Stieglitz prints, you have the subject itself in its own substance or personality, as revealed by the natural play of light and shade about it, without disguise or attempt at interpretation, simply set forth with perfect technique."[19] Tennant ignores the iconographic narrative Stieglitz sets up in images like *Paula;* for him, as for Stieglitz himself, this is a work encountered *after* 1910 and therefore to be read in formal terms only. More than that, in presenting *Paula* as an image prescient of his later career, Stieglitz once again claims for himself the eye of the seer; apparently he recognized significant form back in 1889, even when he was not conscious of it (even when he *could not* be conscious of it).

This example tells us something not just about Stieglitz and *Paula,* but about the problems that attend the history of any photograph. Max Dupain's *The sunbaker* (photo 4.2) represents a similar and equally instructional dilemma, although for slightly different reasons. Dupain (1911–1992) remains Australia's most celebrated twentieth-century photographer, and *The sunbaker* his most famous and frequently discussed picture. Indeed, it is often referred to in that country's press as an "Australian icon."[20] Even now, despite a familiarity born of repeated reproduction, it remains a fascinating image. A young man lies before

us, beaded with water droplets and encrusted with sand, a lone, anonymous body stretched out on the beach at Culburra, New South Wales.[21] In fact this particular sunbaker has been partially disembodied by Dupain's camera, for all we can see here are his head, shoulders, and cushioning arms. The combination of a fortuitous play of shadows and our low angle of vision presents these limbs to the eye as a single pyramidal form. This form has often been described as monumental, and its brooding intensity compared to everything from the Sphinx to Uluru.

But this is only part of the story. Notice how the foreground field of unfocused sand can barely be distinguished from the sky above. This gives us the sensation of rushing toward the sunbaker's embracing arms as if from a great distance, while also leaving the central form hovering ambiguously on a horizontal boundary between heaven and earth. Moreover, the symmetrical division of the picture plane produces a strange mirroring effect along this same boundary. One consequence is that the gestalt shape of the sunbaker is made to fold in on itself, as if caught in a perpetual act of self-reflection. At the same time, this symmetry works to draw the viewer's eye irresistibly into the black void at the center of the picture, adding a menacing sexuality to its sense of dynamic implosion. In short, *The sunbaker* is one of those images that fascinates precisely because of its ability to attract and repel the gaze simultaneously.

The sunbaker is thought to have been taken in 1937; this is the date ascribed to it in every Australian art museum and photographic history. Based in part on its timing, this image is often seen as exemplifying a move within Australian culture from an insular provincialism toward a more modern (and by that is usually meant "more international") sensibility. Gael Newton, the current curator of Australian photography at the National Gallery of Australia, has argued, for example, that *The sunbaker*'s "simple geometry and dynamic symmetry had perfectly expressed the energy of Modernist formalism."[22] As further evidence, she refers us to Dupain's enthusiasm for Man Ray and his distanced familiarity with the New Photography movements in Europe and the United States.[23] Certainly *The sunbaker*'s lack of anecdote and acute angle of vision self-consciously draw attention to its mode of production, a characteristic typical of Bauhaus-inspired photography of the time. However, this photograph also has a lot to say about the regional specificities of Australian life between the world wars and obstinately remains, despite its formalist affectations, a plausible

4.2

Max Dupain, The sunbaker, *1937/1975*
Gelatin silver photograph
National Gallery of Australia, Canberra

4.3

Max Dupain, Sunbaker, *1940/1948*

from Max Dupain Photographs *(Sydney: Ure Smith, 1948)*

representation of the sweaty sensuality and spatial disorientation of the sunbathing experience. Perhaps what we are seeing here, then, is the formation of a vernacular Australian modernism that conjoins a number of competing visual codes, without entirely adhering to any one.

Then, as now, beach culture was a distinctive aspect of Sydney life. Australia's most prominent photographer, Harold Cazneaux, had photographed a number of beach scenes in the late 1920s, and Charles Meere, who for a time worked in the same building as Dupain, was to paint his pseudoclassical *Australian Beach Pattern* between 1938 and 1940.[24] By Australia's sesquicentenary celebrations in 1938, the figure of the surf lifesaver was regarded as a personification of Australia itself. In Dupain's case, the sunbaker theme allows a glorification of the body in general and of the masculine body in particular. This is in keeping with his father's professional involvement in health and physical exercise, and links *The sunbaker* to other male and female nudes by Dupain, many of them photographed reclining on the beach. It also has to be recognized that both desert/beach scenes and idealized images of the masculine body had a particular resonance in Australia after World War I, powerfully conjuring the myth of the Australian soldier and its attendant nationalist rhetoric.

In this context it is interesting to note how the formal devices employed in *The sunbaker,* specifically the symmetrical placement of the horizon line, are reminiscent of those found in famous Australian paintings like *Land of the Golden Fleece* (1926) by Arthur Streeton and *Morning Light* (1930) by Elioth Gruner.[25] Such paintings, together with photographs by Cazneaux (one thinks of his muscular *Autumn Landscape,* c.1935), were regarded, to use the phrase coined by *Art in Australia* in 1926, as a "New Vision of Australian Landscape." This New Vision, involving a "simplification and reduction to essentials," was interpreted by contemporary commentators as an effort to represent Australian life in the "curt speech of the present day."[26] The same might well have been said of Dupain's *The sunbaker.*

Of Dupain's other work from the 1930s, images like *Sharks at Blackhead Beach* (1937) and *Bondi* (1939) come closest to *The sunbaker* in their knowing manipulation of our point of view and their reduction of human figures to a singular, signifying form. However neither of these pictures is able to match *The sunbaker*'s complex intercourse of the local and the international, or its disturbing compositional and thematic ambivalence. *Bondi* (photo 4.4), recently given national prominence by its reproduction as an Australian postage stamp, is

particularly notable for its coincidence of premeditated camera angle and chance gesture. Two seemingly gigantic figures, one male and one female, stand before us on Bondi Beach, intent on staring at something going on slightly to their left and out to sea (perhaps looking for the shark whose presence has been signaled by an alarm). This sea forms an unusually low horizon line, running exactly parallel to the picture plane at the level of their ankles. The man, whom Dupain later identified as a professional wrestler, looks completely immovable, with legs planted widely in the sand and hands permanently parked on hips. His heavy stance is reiterated in the deep imprint of thumb on darkened flesh. The woman seems less sure of herself, with her right leg slightly bent up on her toes, leaning her body over to the left so that her shoulder crosses behind her companion's elbow. Her leftward lean neatly complements the angle of his left leg, fusing their bodies as a single pyramidal shape. However, the formal gravity of their pose is brought down to earth by what she is doing with her hands. Apparently unaware of the camera behind her, the unfortunate woman has been caught reaching back and delicately emptying sand from the bottom of her bathing suit.

For Australian viewers, it is a strangely familiar and endearing action, but one that also underlines this picture's modern sensibility. Only the mechanical wizardry of the camera could take this fugitive moment and freeze it forever in this way. Only photography could plausibly juxtapose these giants and their lilliputian companions within the same picture plane. Only photography could flatten that picture plane to make these figures appear not as human individuals but as a sculptural frieze set into a vast two-dimensional sky. *Bondi* is in this sense an entirely *photographic* picture, one that is as anxious to show off its own picture-making operations as it is to document what is there before us. It is a picture, in short, both of and about modernity itself.

"Modernity" was of course an auratic quality much valued by those operating within the burgeoning Australian consumer culture of the time. *The sunbaker* should not be left out of this culture. Its formal structure proffers the advertisement's allure of value-added significance but without the option of acquisition or the panacea of literal explanation. Here, then, is an aspect of Dupain's work still to be fully explored.[27] The purpose of such an exploration would not be to denigrate Dupain's art with the taint of commerce, but to articulate the mixed and uneven development of modernism within Australia between the wars. For we have to recognize that what inhabits the conception of an image like *The sunbaker* is a peculiar weave

4.4

Max Dupain, Bondi, *1939/1975*
Gelatin silver photograph
National Gallery of Australia, Canberra

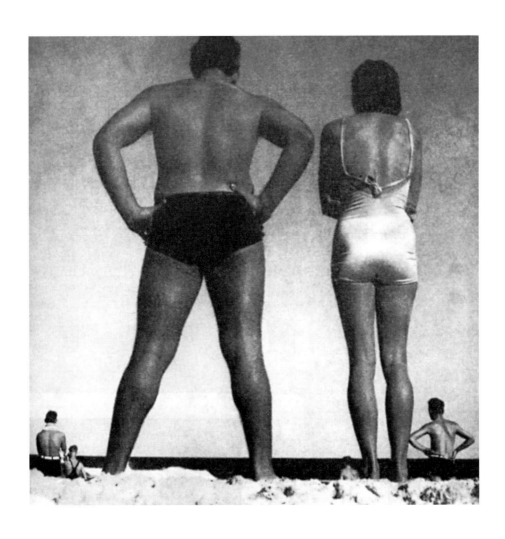

4.5
Max Dupain, Form at Bondi, *1939/1948*
from Contemporary Photography *(July–August, 1948)*

of a modernity that was happily promoted within mass culture, a modernist rhetoric suspected and even feared by the fine arts establishment, and a New (hence, modern) Vision seen by this same establishment as nationalist and therefore acceptable. It is this telling intersection of many different modernisms, rather than some faithful adherence to overseas trends, that makes this image so special within the history of Australian photography.

The sunbaker is supposed to have been taken in 1937. However, it first appeared in public only in 1948, when it was published as part of a Sydney Ure Smith monograph devoted to Dupain's work. Actually this is not quite true. The image reproduced in the monograph is titled *Sunbaker* (photo 4.3), but it is not the same picture that we now know as *The sunbaker.* Apparently Dupain had recognized the possibilities of the general composition offered by the man lying on the sand and taken a number of exposures.[28] In *Sunbaker,* the man's skin is still wet, so no doubt this shot was taken within seconds of its better-known sibling. However, in this version of the composition, the young man has a clenched fist and a jagged shadow, and one can see the surf more clearly through the gaps between arms and head. Evidently Dupain has raised his Rolleiflex camera an inch or two. The result is a less monumental and forbidding depiction of the sunbathing figure. A few unruly hairs now stick up to break the smooth curve of his shoulder line, and the foreground sand remains in sharp focus. Most important, the proportions of this print are quite different from its fellow, and it reads differently as a result. Here the triangular form of the sunbaking figure rests stolidly near the bottom of the picture plane, confirming its mass and adherence to gravity and allowing an expanse of sky to dominate the scene. All in all, it is a more comfortable image to look at, without the oscillation effect that so animates *The sunbaker.* We are thus allowed to enjoy a sense of contemplation and casual intimacy denied in its more famous counterpart.

Sunbaker was probably printed in 1947, especially for the Ure Smith publication. Unlike most of the other images in the book, this reproduction is signed and dated on the front, as if it was intended for exhibition at some time (although there is no record of such an exhibition).[29] But the date we see there is not 1937, when it was supposedly taken, but 1940. The discrepancy suggests that Dupain's memory of the moment of shooting has become a little hazy after a decade's pause. Or perhaps it just was not that memorable a moment in the first place. *Sunbaker* is, after all, but one of the fifty-one photographs that Dupain described

in his introduction to this book as "a cross section of that which I consider to be my best work since 1935."[30] What is interesting about its appearance here is that in 1948, when faced on his proof sheet with a choice between *Sunbaker* and *The sunbaker,* Dupain picked the former rather than the latter as one of his "best works." Interestingly, he included among his best work none of the modernist pictures from the 1930s for which he is now most renowned. *Sharks at Blackhead Beach* is there, but we do not get to see such celebrated images as *Eggs* (c.1932), *Kerosene lamp* (c.1932), *The post* (c.1932), *Industrial landscape* (1935), *Pyrmont silos* (1935), *Silos through windscreen* (1935), *Two forms* (1939), or, for that matter, *Bondi.* Also missing are *Dart* (1935) and any examples of Dupain's experiments with surrealist montage, both of which had featured in an earlier portfolio of his work published in the November 1935 issue of *Art in Australia.*

What we do tend to get in this 1948 monograph are documentary-style pictures, including such classics as *The meat queue* and *Baby protesting* (both 1946). But we also get images of Aborigines from Kirrawina, men eating in hostels, beach scenes, nudes, landscapes, and portraits of personalities from the arts. This apparent shift in emphasis from modernist experimentation to documentary realism can be traced to the instrumental demands of World War II. It is also informed by Dupain's personal contact with Australian filmmaker Damien Parer and, through him, the documentary creed of Britain's John Grierson.[31] Encouraged by Parer's example, Dupain had read Forsyth Hardy's *Grierson on Documentary* in 1947. As a consequence, Grierson is approvingly quoted and paraphrased in Dupain's introduction to the 1948 book—but then so are a number of the sources of his earlier ideas about photographic practice.

In his 1935 feature in *Art in Australia,* Dupain had quoted from an essay by G. H. Saxon Mills as a way of explaining what his own photography was about. Saxon Mills's essay, "Modern Photography: Its Development, Scope and Possibilities," had been published in a 1931 issue of the British art journal, *The Studio,* an issue that Dupain first encountered in 1933. The editor's introduction to this particular issue, which was devoted entirely to modern photography, argues that photography "supplies a public need from the pictorial point of view." And according to this introduction, it does so by utilizing the two aspects of the camera that Dupain was soon to combine to such good effect in his own work: "First, by a

realism which is much more satisfying than the average subject picture. Second, by its adaptability to unaccustomed angles and view-points which lend an exciting novelty to the world we know."[32]

Much of what Saxon Mills says in his essay coincides with Dupain's own thinking on photography during the 1930s. Examining photography as "a new art-form," Saxon Mills defines "modern photography" as something "whose aim is partly or wholly aesthetic, as opposed to photography which is merely documentary and representational." Seeking to broaden his definition beyond the boundaries of a "distorted" and sometimes "unintelligible" modernist art practice, Saxon Mills suggests that "it is in the halfway between subjective and objective that the camera finds its true *métier*."[33] The photographs reproduced in this issue of *The Studio* confirm the value of such a balanced view. Gathered from all over Europe and the United States, they exhibit the unexpected angles, self-conscious framing, mildly abstracting close-ups, and technical experimentation soon to be identified with "modern" photography in general. At the same time, very few of these featured images stray from a defiantly realist style. In a number of different ways, this issue of *The Studio* offered Dupain an influential model for his future work. Indeed, many of his own photographic projects can be found prefigured here. Just as important is the way the journal happily mixes artistic and commercial photography, seeking apt expressions of the modern in both. It was in support of these values that we find Dupain enthusiastically contributing to a 1938 Contemporary Camera Groupe exhibition in Sydney that promoted itself as "prophetic in its modernity." Earlier that same year, Dupain had written a protest letter to the *Sydney Morning Herald* about another international survey exhibition, complaining that by concentrating on pictorial photography, it showed no evidence of "the surge along aesthetic lines" or of "modern adventure and research."[34]

However, by the time of his monograph ten years later, Dupain's attempts to represent modern life in Australia had extended beyond this concentration on "adventure" and the "wholly aesthetic." The year before, in 1947, Dupain had written an article about himself for the Australian magazine *Contemporary Photography*. He argues there against any kind of studio fakery or manipulation, claiming that "photography is at its best when it shows a thing clearly and simply":

The photograph is concerned with showing actual life often beyond the scope of the human eye, the painting is a symbol of life and fused with the spiritual interpretation of the painter. The former is objective, the latter subjective and never the twain shall meet. The more akin a photograph is to a painting or manual work of art, the more it diverges from its main and most potent quality, and vice versa. It is necessary to develop photography with particular reference to its mechanistic form. Let it be automatic as much as possible, the human element being selection of viewpoint and moment of exposure, subsequent technicalities being performed skilfully and scientifically.

Dupain finishes his article with what was to become a lifelong appeal for the development of a specifically Australian approach to photographic practice, an approach that he hoped would combine his country's distinctively harsh sunlight with the immediacy of the documentary style:

One hopes that the new generation of photographers in Australia will graduate to the outdoors and make naturalness and spontaneity the underlying qualities of their work rather than a superficial pleasantness which characterises so much of it today. It is so necessary to learn from other countries but forever keeping in mind that a national photography will contribute greatly to Australian culture. Let one see and photograph Australia's way of life as it is, not as one would wish it to be. It is wasting the dynamic recording capacity of the camera to work otherwise.[35]

In the same year that his monograph appeared, Dupain published his third article in *Contemporary Photography*. Titled "The Narrative Series," it provided Dupain with yet another opportunity to rail against pictorial affectations in photography (which he called "a gutless pseudonym for painting") and to reinforce his conviction that "the purpose of the photograph is to reveal things clearly." He concludes by arguing that "to develop the narrative series is to make one more step towards a realisation of the inherent faculties of pure photography."[36] It is in this context that we find him writing the introduction to his Ure Smith monograph and, in the process, attempting to define what he believed these "inherent faculties" were. The resulting text is a contradictory amalgam of aspirations such that

photography is asked to provide both the "new aesthetic experience" of the machine age as well as imagery that "must incite thought and, by its clear statements of actuality, cultivate a sympathetic understanding of men and women and the life they create and live." This amalgam of modernist and documentary ideas explains the catholic mix of images we get in the 1948 book. It also points to a central, motivating paradox within Dupain's photographic practice as a whole.

In 1991, Dupain was given a retrospective exhibition at the National Gallery of Australia. The photograph titled *The sunbaker* that was shown in it was signed and dated 1937. However, it was actually printed in about 1975, the year in which Dupain was accorded his first retrospective at the Australian Centre for Photography (ACP) in Sydney. In fact, it seems likely that this was the first time any version of *The sunbaker* had been put on public exhibition. No vintage print has yet come to light, and, surprisingly, Dupain did not include the image in the promodernist Contemporary Camera Groupe show of 1938. Nor was it reproduced in the only history of Australian photography published prior to this time, Jack Cato's 1955 book, *The Story of Australian Photography*.[37] Previously unknown, *The sunbaker,* along with the rest of this 1975 retrospective, had an immediate impact in Australian photography circles. This was not only due to the unfamiliarity of Dupain's work to a later generation of photographers but also because of the way this kind of work so aptly answered the needs of the moment. Art photography was just struggling to its feet in Australia, aided by Prime Minister Gough Whitlam's support for the arts and manifested in the formation of the ACP in Sydney and the Photographers' Gallery in Melbourne (both in 1974) and the appointment of specialist photography curators for the first time in the state galleries of Victoria (1972) and New South Wales (1974). Dupain's work provided a ready-made genealogy, an extended history as well as an avant-garde tradition, on which an argument for Australian art photography could be built. Suddenly, after years of comparative obscurity, Dupain (and more particularly *The sunbaker*) was everywhere: on the 1975 ACP exhibition poster, on the 1976 acquisitions list of the Art Gallery of New South Wales, on the front cover of *Light Vision* magazine (1978), in *Creative Camera* (1978), in James Mollison's exhibition *Australian Photographers* (1979), and as the star turn within yet another Dupain retrospective exhibition organized by Gael Newton for the Art Gallery of New South Wales in 1980.[38]

These last two appearances are worthy of further comment. Coming at the end of the decade and representing the work of eighty-eight practitioners, *Australian Photographers* was described in its catalogue foreword as a "comprehensive survey of contemporary Australian photography." And there, reproduced on both page 47 and on the back cover, is *The sunbaker,* dated 1937! It is obviously clear to Mollison at least that this is an image of the 1970s, whatever the moment of its original exposure in Dupain's camera. Newton's retrospective was organized around a similar intuition. Paying scant attention to his documentary pictures, she herself picked out images such as *Eggs, The post,* and *Silos through windscreen* from the vast archive of negatives at Dupain's studio and encouraged him to print them up for the show. These last two, together with *The floater* (1939), were especially appealing to the formalist 1970s sensibility that then prevailed. *Silos through windscreen,* with its arbitrary framing and two-way vision (via a rear-view mirror), seemed like an uncanny prophecy of John Williams's earlier (1977) series of fragmented Sydney vignettes. The "natural abstraction" and infinite field of *The floater* was similarly in keeping with the 1970s work of younger practitioners like Marion Hardman and Christine Godden. Visitors to Dupain's retrospective were therefore faced with an apparent conjunction of early and late modernism in the same exhibition and the same practice; *The sunbaker* and *The floater* were even printed opposite each other in the catalogue. Whether intended or not, their pairing represented a conundrum that exactly mirrored the character of Australian art photography during the 1970s.

This double vision of Dupain's photography, a historical enfoldment of *The sunbaker* into *The floater* and 1930s into 1970s, recalls his own complex convolution of modernist and documentary conventions. It also encourages us to remember the multiple manifestations of *The sunbaker* and to look for evidence of a similar multiplicity in other aspects of Dupain's output.

Such evidence is not hard to find, for it turns out that *Bondi* is yet another of Dupain's early exposures that was printed only in the 1970s. However, a companion image, taken from the same strip of negative as its better-known counterpart, was again published back in 1948. It appeared in the July–August issue of *Contemporary Photography* as *Form at Bondi* (photo 4.5), a title chosen by the magazine's editor, Lawrence Le Guay. Like *Sunbaker,* this rogue version of *Bondi* has never been subsequently reproduced or promoted by Dupain or his historians. Perhaps this is because both these images undermine the modernist formalism that Dupain's

4.6

Max Dupain, The floater, *1939/1976*
Gelatin silver photograph
National Gallery of Australia, Canberra

4.7

Max Dupain, The floater, *1939/1986*
Gelatin silver photograph

work is now presumed to legitimate. In *Form at Bondi,* for example, the standing figures no longer turn their heads but instead look straight out to sea. The stolid stance of the man is otherwise unchanged. However, the woman is quite differently configured, having moved away from her companion and crossed both arms across the front of her body, as if to ward against the cold. This clear separation of their bodies, together with the absence of any spontaneous movement on the woman's part, dissolves that conjunction of accidental and self-conscious pictorial unity that characterizes the better-known version. It also changes the whole mood of the image. Where once it was the processes of photography and the dynamic formal interplay of the two bodies that drew our attention, now we are directed to ponder the nature of the relationship between these people and the prolonged narrative of their act of looking. Thus, despite this photograph's adopted title, its principal concern is with anecdote rather than form.[39]

We get a sense from this history that at least from 1940 on, whenever Dupain had the opportunity, he always chose the less abstracted image from whatever negatives he had at his disposal. Only in the 1970s did his preferences seem to change. Only then did his choices as a printer fall in step with the historical desires of the museums and curators eager to purchase examples—albeit only certain examples—of his "old" work. However, when this institutional pressure was absent, he did sometimes revert to a preference for the "clear statements of actuality" he had called for in 1948. In 1986, for example, he published a self-selected collection of his work under the title *Max Dupain's Australia.*[40] In it we find the familiar 1970s versions of *Bondi* and *The sunbaker.* But we also find a previously unseen version of *The floater.* The National Gallery of Australia had bought another *Floater* in 1976, an image that Gael Newton later compared positively to a picture on the same theme by Edward Weston.[41] But the NGA's *Floater* is not the one that Dupain chose to reproduce in his book. Instead, he picked another image from the same shooting session.

Once again, the difference between these two photographs is instructive. The 1939/1976 *Floater* (photo 4.6) has its small female figure drifting aimlessly into the middle distance of the picture plane. Centrally located and pointing almost vertically upward within the photograph's expanse of opaque watery ripples, her body becomes a pictorial element as abstracted as the leaves that float with her. The picture's modernist credentials are guaranteed by this partial abstraction, as well as by the way the scene is framed—its spatial and tempo-

ral coordinates are entirely self-referential, a product of the arbitrary cropping of camera vision. The 1939/1986 *Floater* (photo 4.7), on the other hand, uses the camera lens to bring us in much closer to the swimming figure. Here she fills a substantial portion of the picture plane, and we can see the slight smile playing on her face; the woman herself, as a feeling individual person, is now the principal subject of the picture. A similar, if not quite so dramatic, change takes place elsewhere in this book. *At Newport,* shot in 1952, is another of Dupain's most famous images. However *Max Dupain's Australia* chooses to reproduce this same picture with an extra young girl in place on the right. She is shown gazing in wonder, just as we outside viewers do, at the graceful movements of the other figures in this fortuitous tableau.[42] Dupain enjoyed a late career in the 1980s as an opinionated newspaper critic of Australian art photography, and he frequently condemned studio manipulation of any kind. It is ironic, then, that we find him willing to crop his own work in this way. Apparently, when necessary, "actuality" can be creatively adjusted, at least to this extent.[43]

As we have seen, Dupain's photographs, his "clear statements of actuality," are not as clear as one might have first imagined. Although frequently lauded in recent years as the genealogical source of modernist photography in Australia, Dupain himself consistently exhibited a preference for anecdotal, documentary-style versions of many of his most famous compositions. In the 1940s in particular, following a period of eclectic experimentation, Dupain developed a concept of "the modern" that merged aspects of both the New Photography and documentary techniques, seeking its expression through explicitly Australian subjects and settings. The result was a vernacular modernism that in many ways embodied his country's complex and quite specific engagement with modernity in all its forms during this period. In other words, Dupain's own hesitation as an image maker between *The sunbaker* and *Bondi* on the one hand and *Sunbaker* and *Form at Bondi* on the other, has much to tell us about the peculiar history of Australian visual culture in the twentieth century.

The point of this analysis is not to accuse Dupain of revising his own past; this, as we have seen with Stieglitz, is typical of ambitious photographers who are given the opportunity to reorganize their careers later in life.[44] The point is to raise questions about the kind of history that accepts such retrospective re-creations without comment, a history that is content simply to reproduce *The sunbaker* and date it 1937 and to present *Paula* as a work from 1889. Such histories thereby privilege the moment of taking over that of making, the private

moment over the public, the origin over the journey, the aesthetic decisions over the social. At the same time, these histories deny their own role in the making of photographs (and photographers), in the establishment of certain meanings and values and the exclusion of others. In this, they are guided by the art historical model provided by Beaumont Newhall's *The History of Photography,* and especially by the version published in 1949. Dedicated to Stieglitz and very much informed by that artist's understanding of the photographic medium (such that even scientific photographs are presented as art, as "experiments in abstraction"), this publication establishes a canon of masterworks and an emphasis on formal qualities and stylistic analysis that has been imitated ever since.[45] The approach is repeated, for example, in the various art histories of Australian photography that have valorized a 1937 *The sunbaker.*[46] In these and many other cases, we find that a mode of avant-garde art practice, Stieglitz's theory of revelation, has been blithely repeated as historical method.

What this method represses, apart from the complications of actual historical evidence, is the schizophrenic identity of all photographs. As a system of representation dependent on reproduction, the photograph is capable of having many distinct physical manifestations. It is simply not appropriate for historians to treat photographs as if they are unique objects like paintings or sculptures. More than that, any particular photograph has an infinite range of possible meanings, depending on the contexts in which we find it and the changing significances it accrues. Once again, the semiotic mobility of photography surely requires an equally mobile historicization. Neither *The sunbaker* nor *Paula* has a stable moment of origin; like all other photographs, they exist only as a state of continual fabrication, constantly being made and remade within the twists and turns of their own unruly passage through space and time. The question is, Can we now develop a history of photography that acknowledges this same complexity? Can we at last abandon our investment in originary moments and dare to articulate instead the temporal and ontological convolutions that make photography the strange and fascinating phenomenon that it is? Well, can we?

This essay is a revised version of "Creative Actuality: The Photography of Max Dupain," *Art Monthly Australia,* no. 45 (November 1991), 2–5, and "Max Dupain: Sunbakers," *History of Photography* 19:4 (Winter 1995), 349–357.

+ + +

+ **5** +

+ + +

POST-PHOTOGRAPHY

It used to be said that photography was tormented by the ghost of painting. Used to be said. For now photography is the one that is doing the haunting. Where once art photography was measured according to the conventions and aesthetic values of the painted image, today the situation is decidedly more complicated. Over the past two decades, the boundary between photography and other media like painting, sculpture, or performance has become increasingly porous. It would seem that each medium has absorbed the other, leaving the photographic residing everywhere, but nowhere in particular. A number of critics have also lamented the loss of photography's "truth effect" under the pressure of new photographic simulation technologies. These critics draw a distinction between photography as a direct inscription of a referent in the world and the photographic as a practice dependent on the re-circulation of already existing codes and images. The suggestion is that a diminution of our collective faith in the photograph's indexical relationship to the real will inevitably lead to the death of photography as an autonomous medium.[1] The irony of this scenario is that photography as a separate entity might well be on the verge of disappearing forever, even as the photographic as a rich vocabulary of conventions and references lives on in ever-expanding splendor. In short, it appears we have already entered a "post-photography," that moment after but not yet beyond photography.

The implications of this moment are perhaps most vividly expressed in work that reflects on the "objectness" of the photograph. Such work begins by miring the presumed distinction between taking and making, and goes on to undermine photography's claim to a privileged relationship to a real world outside itself. In a number of works by Mike and Doug Starn, for example, the photograph has been twisted and shaped into a sculptural element. *Yellow and Blue Raft of the Medusa* (1990–1991) turns a reproduction of Gericault's famous painting into a series of translucent planes that contemptuously curl off the wall to show us their edges. The photograph's thickness, the part of its existence that is usually thought of as mere support, is made one of its primary features. In similar fashion, Jennifer Bolande co-opts a strip of lurid landscape that one day rained down on her from a Kodak light-box billboard above the Marriott Hotel in New York. Her *Orange Photograph* (1987) is this same strip hung from the wall, cascading down across the floor to exhibit itself as a three-dimensional object (it folds, it bends, it occupies the gallery). Kodak's high-tech sublime is

brought down to earth, and with it the equally overwrought rhetoric of photography. What was once thought to be a window onto the world is transformed into an opaque, resistant surface volumetrically unfolding in space. In each of these cases, we are forced to look at photography rather than through it. As a consequence, the photograph's two-dimensionality is revealed as a fiction that always requires the suppression of a third term. At the same time, this displacement of the photographic from one set of dimensions to another draws our attention to, among other things, the problematic identity of the photographic medium. It is precisely this sort of questioning that makes post-photography a phenomenon worth investigating further.

Peter Bunnell signaled this questioning among photographic artists as early as 1969, first in a short essay in *Art in America* (in which he identified a body of work that he said was "calling attention to the photographic artefact") and then in a 1970 exhibition, *Photography into Sculpture,* staged at the Museum of Modern Art (MoMA) in New York.[2] A subsequent article of the same name stressed his twenty-three chosen artists' "commitment to the physical object," a commitment that Bunnell claimed "exploits the properties unique to photography itself." Nevertheless, he also conceded that works by featured artists like Robert Heinecken and Jerry McMillan make it hard to sustain this formalist claim, precisely because in the presence of their work, it is "exceedingly difficult to state just what the [photographic] medium is."[3] Bunnell traces this difficulty back to both photography's earliest manifestations—for example, to those cased daguerreotype photo objects that rest heavily in one's hand and have to be manipulated into visibility each time they are examined—and to such formative twentieth-century art phenomena as constructivism and pop. But as more recent exhibitions have made clear, the major influence on this bleeding of photography into other media came from the broader conceptual art movement of the 1960s.[4] Indeed, the showing of *Photography into Sculpture* at MoMA briefly overlapped with this same museum's installation of *Information,* its overview of the emerging conceptual moment.[5] Many of *Information*'s artists made use of photography not as a fine art medium but as a means of deadpan documentation that also happened to be a convenient building material. Edward Ruscha's concertina-book *Every Building on the Sunset Strip* (1966), for example, was often exhibited standing upright in extended form, zigzagging its way across a floor or fanned out to fill a Perspex case.

While this generation of artists extended the photograph out into space, later practitioners pursued the spatiality *within* the photograph. David Hockney's various cameraworks of the early 1980s, large collages constructed from Polaroid and color snapshots, turn looking at photographs into a temporal experience. Each snapshot represents a distinct moment in time; seen collectively, they mark the passage of time lived by the artist during the making of the overall image. We witness duration. But we also move through space, questing through a given scene in concert with Hockney's own eye. Unlike any single photograph, his otherwise banal and decorative images convey a sense of depth and dimension, of multidimension. Abandoning the singular perspective recommended by the camera, Hockney draws with his photographs, once again making the edge of the photograph a prominent feature and the ground of his image, its negative unoccupied space, a vital part of our visual experience.[6]

Post-photography takes these various permutations of the photograph as a given. Like photography itself, they have been consigned to the toolbox of history. Now any number of artists practice a form of transmutation in which photographic imagery reappears as solid apparitions of glass, timber, graphite, stone, paint, paper, vinyl, or wax. Turned into an artifact, the photograph has become just one more reference point to an industrial age already rapidly passing us by. Photography has become "photography," eternally framed by the quotation marks of historical distance and a certain awkward self-consciousness (that embarrassment one feels in the presence of the recently deceased). In short, for these artists, photography has taken on a memorial role, not of the subjects it depicts but of its own operation as a system of representation.

Consider the work of Seattle-based artist Ellen Garvens, for example. The first thing you notice is the sheer size of it. *Hidden Fish* (1989) comes in at four feet high and over five and a half feet wide. It is the sort of work where you need to walk back and forth to take everything in. This includes its depth, for *Hidden Fish* has a literal extra dimension provided by the addition of chunks of weathered marble (which throw shadows back into the work) and the layering of images and surfaces over each other. Generated from a single negative, the images in *Hidden Fish* are strikingly noncommittal as pictures, although loaded with significance as signs. These signs include two examples of coelacanth, the living fossil fish, their stolid photographic facades fissured and fractured with tears and abrasions, only to be stuck back together over sheets of roughly painted plywood. The other half of the image, equally

divided and scarred, gazes down onto the checked floor of the natural history depository where these fish have been found and photographed.

A later work, *Hourglass* (1991), almost seven and a half feet tall, features a photograph of the wrinkled neck and chin of an older woman (in fact, she suffers from a skin disease) laid over a skeletal gathering of angle iron (photo 5.1). One piece of this angle iron continues down behind the photograph to poke out the bottom of the picture directly in line with an artery in the woman's neck. The upper portion of the work consists of a sheet of bent steel, dulled by use and inscribed with scratches and seemingly arbitrary patterns of lines. Like the piece of steel, the photograph curves forward into space, declaring itself as volume and making its materiality an overt part of our perceptual experience. In similar fashion, *Egyptian Ibex* (1992) combines two silver gelatin photographs of mummified animals with steel and crumpled graphite-coated paper. Duct tape helps twist the paper together to mimic the leg form of the ibex in one of the photographs, or at least to echo it in some way. Unremittingly industrial in tone, all of Garvens's photographs tend to drift lazily in and out of focus, refusing the spatial and temporal certainty of a consistent gaze.

There is something calligraphic, perhaps even alchemic, about Garvens's choice and use of materials. They are, after all, the primary "content providers" of her work. These materials are almost always found objects, often broken and abused, their surfaces (like her photographs) scarified by use and the passing of time. Starting from a theme suggested by a particular photograph, she builds around and onto it using the found materials as complementary elements, inevitably achieving a near-symmetrical balance not only of her various components, but also of the organic and the inorganic, abstraction and order, image and metaphor. Often her materials are orchestrated into curvilinear clusters suggestive of bodily organs such as skeletons, arteries, or intestines (yet another example is the bundle of rubber tubing tightly bound with wire that is a part of 1998's *Brooklyn Mosquito*). In such cases, the negative space is as significant as the actual objects, with the wall (and the shadows cast on it) becoming an integrated component of the viewer's visual experience. Indeed, Garvens's work always clings to the wall as its ground and support (thus remaining a drawing more than a sculptural practice). At the same time, the strange morphologies of her objects disrupt the rectangular expectations we usually bring to the photograph; having broken these boundaries, photography is here rendered in more ways than one.

5.1

Ellen Garvens, Hourglass, *1991*
Gelatin silver print, steel
Courtesy of the artist

In his 1981 book, *A New Science of Life,* Rupert Sheldrake proposes a provocative hypothesis about morphogenesis, the process whereby things come to embody particular structural morphologies. He suggests the possibility of a "morphic resonance" between forms and across space and time, a kind of interactive, multidimensional pattern of vibrations.[7] Garvens's work suggests something similar. The easy slippage between one substance and the next, in particular from shards of photographic image to equally fragmentary pieces of metal, stone, or glass, makes materiality—specifically, the matter of photography's physical identity—a central issue. A tension is proposed between the photograph's function as a transparent window onto another world and its opacity as an object, sitting before us in the here and now. The photograph is revealed as two kinds of object then—as simultaneously image and thing (a schizophrenia equally enjoyed by Garvens's nonphotographic materials).

With her consistent references to archaeology, preservation, aging, and mortality, Garvens's work presents photography as one transient entity within a history of such entities. Photography, she implies, is today as much a mummified effigy as the falcons and shriveled hands she borrows from Egyptology; it is something properly housed in a museum. Could it be that the photograph is just another of Garvens's living fossils, still endlessly reproducing itself but notable today primarily for the mere fact of its survival, for still obstinately embodying a certain attitude to the act of representation that is already two centuries old? One of Louis Daguerre's earliest photographs featured three ordered rows of fossilized shells, examples of nature exactly replicating itself in and as stone (just as his daguerreotype process allowed it to do the same in metallic form). Garvens's work brings photography's historical self-consciousness full circle, preserving its identity, but only as a fading memory, as but one morphic vibration even now being passed on from our modern epoch to its successor.

One finds a similar resonance in the work of Pennsylvania-based artist Lynn Cazabon. Cazabon starts by videotaping certain image sequences, sometimes of herself (or at least of her body) and sometimes off her television screen, and then refilms them in black and white with a Super 8 movie camera. In most cases, this film is processed by hand as a negative, toned with colored dyes, and then printed (thus reversing the color tones and leaving her with positive images). The processed film is cut into smaller strips and woven together into various patterns before being taped at the edges onto thick pieces of glass or directly into glass negative carriers. Two types of prints are made from this raw material, photograms (direct con-

tact prints of the woven film strips) and photographs (enlargements of particular sections), both produced on RA color photographic paper. The process is labor intensive, laborious even. But it results in certain effects that seem important to the look of the final prints (our look at them, their look at us).

The Large Plaid (1997) is typical in this regard (photo 5.2). When seen from a distance (as demanded by its sixteen-foot width), it appears as a dense textile of these interwoven film clips, a simultaneously regular and yet uneven grid of black, green, yellow, and blue image strips. The grid, that sign of culture (mathematical, regulated, antinatural, antimimetic), that marker of obsessive, almost neurotic repetition, is imposed on the assumed naturalness, the accidental contingency, of the photograph.[8] Each interrupts the neutrality of the other, undermining the autonomy of both. The fissure that results itself implies a certain kind of erotic encounter (Barthes: "Neither culture nor its destruction is erotic; it is the seam between them, the fault, the flaw, which becomes so.")[9] The extravagant repetition of forms (not only in this work but in all the others that accompany it) suggests yet another such encounter: the dangerously intoxicated reiteration of bodily action that does not so much satisfy desire as threaten its recipients with extinction.

Certainly, at this stage, from this distance, the abstraction of *The Large Plaid*'s form overwhelms the "content" of its individual photographs (in the earliest prints in this series, the component photos are so small that they cannot be discerned, having become nothing more than a stream of visual data). Not that this form is ever particularly stable. *The Large Plaid* shivers and shimmers, flashes and winks at us, even as we stare at it. These flashes occur at those points where two strips of film have overlapped and blocked out most of the light in the printing process. Like the pops and crackles in an old record, such spots interrupt the gridded flow of images and make us acutely aware that we are looking at an object—*at* the photograph rather than *through* it. It also makes us aware of us, of our own looking, of the extent to which our look (or, more precisely, the exchange of looks between us and this surface) is what brings the image to life. It seems we are part of this image, whether we like it or not.

Cazabon teases us with another kind of animation as well, with the possibility of stitching these sequences back into motion, at least in our mind's eye. The restitution of linear space and time is actually quite elusive in *The Large Plaid,* given all those flashes and fissures, given

5.2

Lynn Cazabon, The Large Plaid, *1997*
60 RA color photographs
Courtesy of the artist

that we are looking at absence as much as presence, at spaces as well as images. Only with the repression of these spaces, only by passing over them at a speed sufficient to no longer see them, can our eye enjoy the unfolding of space through time that is cinema. To succeed in this endeavor we must become *The Large Plaid*'s surrogate tailor (vision must become a form of imagined touch, of *suture*); we must turn our eye into a tracking camera (into a machine).[10]

Everywhere we look in Cazabon's work, we see the determined weave of photo-textiles, the splicing together of video/film/photography as a single surface, the visualization of an artist's labor. We are reminded of a history of such labors, of what was once women's work—not just the labor of birth, but also of weaving and the production of textiles. Freud even speculates that women may have been the inventors of "plaiting and weaving," an invention of culture that, for reasons of his own, he wants to collapse into the specificity of women's biological "nature" (they are apparently inspired by "the growth at maturity of the pubic hair that conceals the genitals").[11] An enticement to the look, a concealment beyond which one would like to see, that appearance-as-disappearance that generates the anxieties of sexed subjectivity—weaving, it seems, is at the very heart of our being.

As Sadie Plant has argued, it is also at the heart of virtually every other aspect of modern culture: "For weaving is the fabric of every other discovery and invention, not the least those of Freudian analysis itself. . . . Hidden in history as the fabric of his world, weaving threads its way from squared paper to the data nets of artificial memory and machine intelligence."[12] The mechanical loom of Joseph Marie Jacquard, which had replaced the creative decisions of the weaver with a train of punched cards, was adopted by Charles Babbage as the model for his planned Analytical Engine of 1836, commonly regarded as the first step toward the computer culture within which we all live today. As Ada Lovelace wrote in 1843, Babbage's Analytical Engine "*weaves algebraic patterns* just as the Jacquard-loom weaves flowers and leaves."[13] In confronting us with an eroticized consummation of modern photo media (video/film/photography) using a metaphor of weaving, Cazabon's work simultaneously conjures the specter of the dissolution of all three into an electronic ether. The threat of the digital is present even when absent, leaving Cazabon's photography neither dead nor alive, but rather a kind of haunting of one by the other.

The same might be said of the work of Californian artist Rachel Stevens. She is another who makes dimensioned manifestations of photographic images, in this case, snapshots of

herself taken by her divorced father in the early 1970s during their periodic visits with one another. In *Kodak 1974* (1998) Stevens transfigures a pixelated fragment of one of these portraits into a large panel of coffee-stained sugar cubes (photo 5.3). Memory (of her girlhood but also of her father's caffeine consumption) is painstakingly evoked as image (digital, and therefore simultaneously material and immaterial) and sensory experience (a smell so pungent one can taste it). In another case, *Kodak 1972: Smile* (1998), she induces a similarly pixelated detail of her smile from the painted end-grain of a stack of lumber. These are pixels that have mass as well as length and depth (a state of being antithetical to their electronic existence as pure surface). At the same time her photogenic "wooden smile" masquerades as a form of neominimal sculpture, recalling the 1960s stacking sculptures of Carl Andre and others.

A lot of the work Bunnell featured in *Photography into Sculpture* incorporated photographs within built structures, and this tradition has been continued by any number of more recent artists, from Bill Barrette to Dennis Adams. Equally ubiquitous has been the practice of constructing tableaux and then photographing them. What should we make of this? What should we make of a photography that induces the production of things? In one recent case, the things in question are simulations of various kinds of prison architecture, constructed and photographed by New York artist James Casebere. Two sets of things, then, models and photographs of models, each produced by the demands of the other. Strange as it may seem, this equation again immediately takes us back to photography's beginnings. As one writer claimed in *Gazette de France* in January 1839, "Inanimate nature, and architecture, are the triumph of the apparatus."[14] In similar fashion, Henry Talbot, announcing his invention of photogenic drawing in this same month, designated the photographing of architecture as "perhaps the most curious application of this art." Speaking of pictures of his own house inscribed in a camera obscura, Talbot called the building "the first that was ever yet known *to have drawn its own picture*."[15] His phrasing is awkward, but how else is he to describe photographs of objects seemingly made by those objects themselves, an architecture that draws even while being drawn? How else is he to render photography *as* an architecture (as an "archiwriting")?[16] Casebere's 1992–1995 *Prison Series* provides a similarly complex articulation of the photographic, but also adds another element: the brooding demeanor of the penitential.

5.3
Rachel Stevens, Kodak 1974, *1998*
Coffee-stained sugar cubes
Courtesy of the artist

Casebere's images present a variety of styles of prison and include both enigmatic interiors and external views of historically specific buildings, as well as a number of aerial shots of speculative "prison typologies" generated on a computer. It is hard not to think of Michel Foucault's commentaries on the development of the panoptic prison in the late eighteenth century (a development that coincides with that of photography).[17] As Maurice Berger has suggested, Foucault's interest is not so much in the architecture of the prison as in the organization within modern culture of "invisible power in the service of subtle coercion."[18] Casebere's *Prison Series* reenacts this history as visual rhetoric. For example, although not restricted to panoptic designs, Casebere's overall project is itself panoptic; we are placed simultaneously inside and outside the penitentiary, seeing through the eyes of both prisoner and prison designer. In other words, when we witness Casebere's series in its entirety, we find ourselves enmeshed within a disciplinary economy of precisely the kind described by Foucault: "Power has its principle not so much in a person as in a certain concerted distribution of bodies, surfaces, lights, gazes; in an arrangement whose internal mechanisms produce the relation in which individuals are caught up."[19]

The same could be said of photography. Indeed, some of Casebere's interiors (*Empty Room,* photo 5.4) are eerily reminiscent of the inside of a camera, as if we are looking from the inside out, as if the architecture we are viewing is that of the photographic apparatus. Reminiscent of Talbot's negative images of the windows of his country home, these *cameras,* these rooms, are all illuminated by a single blinding source of light. As viewers, we appear to be looking from the back wall of the space, standing in for (perhaps even becoming) the photographic image being projected there. This lighting modulates the stark whiteness of the surfaces and desultory objects that comprise these otherwise empty interiors. Actually, the whiteness of these rooms is something of an assumption on our part, for Casebere's prints come tinted with a gray-blue pallor. Prisoners have this pallor, but so do monks confined to their cells (and photographers who spend too much time in the darkroom or computer lab). It is the color of incarcerated skin, of confession and repentance. This ecclesiastical aura adds to the impression of silence (some types of photograph are noisy, but certainly not these). Moreover, the selective lighting, minimal furnishings, and sepulchral tone of these images call to mind not only prisons and monasteries, but also art galleries—the very spaces where one might reasonably expect to encounter these photos in the flesh. It is as if cell, camera,

5.4

James Casebere, Empty Room, *1994*
Cibachrome print
Courtesy of Sean Kelly Gallery, New York

and gallery (viewer, viewing apparatus and view) can do no more than endlessly reproduce one another. We are faced with the prospect of a photographic architecture that is continually in the process of turning itself inside out, with a photography building and demolishing its own parameters with equal fervor.

In this sense, Casebere's work is not so much a photography of spaces as it is about photography as *spacing* (about, in Jacques Derrida's words, "the impossibility for an identity to be closed on itself, on the inside of its proper interiority, or on its coincidence with itself").[20] Such a photography necessarily haunts its own conceptual armature, insists on acting as its own medium. No wonder these images exhibit such a ghostly presence (the sort of presence that is inevitably a remarking of absence, the residual absence that makes any presence possible). Once again we find Casebere broaching the very architectonics of photography. This time it is the traditional orders of sign and referent that are threatened, that is, the separation of real and representation on which the presumed veracity of the photograph has for so long been founded. In Casebere's *Prison Series,* there is a constant referencing from one to the other, but no longer any originary outside source, no absolute ground.[21] Real and representation, presence and absence, thing and photograph, are instead seen to share the sort of promiscuous complicity that calls all identity into question. Like Talbot, Casebere leaves us with that most troubling of apparitions: photography's architecture as a site of deconstruction.

Other artists have effectively disintegrated this architecture altogether. Australian Jacky Redgate is one of several who make work that is all about photography, even when no photograph is actually present.[22] In her 1990 installation, *Untitled (from Fox Talbot 'Articles of China' plate 3 and 'Articles of Glass' plate 4, in 'The Pencil of Nature', 1844–46),* we find her bringing back into being a number of objects once photographed by Henry Talbot for his promotional book *The Pencil of Nature.* Apart from these tiers of china and glassware, Talbot also made a number of photographs of other sculptural objects, including no fewer than thirty of a bust he called "Patroclus," bought in 1839 specifically for this purpose. Two different pictures of this bust were, for example, included in *The Pencil of Nature,* with Talbot remarking on "how very great a number of different effects may be obtained from a single specimen of sculpture."[23] One of these effects, according to a recent essay by Mary Bergstein, is to drain the sculpture of physical presence: "Sculpture (precisely because of its photogenic

properties) may be the plastic art most deflated, most deprived of its substance in photographic representation."[24] This is no doubt why both Talbot and Hippolyte Bayard often photographed the same object from different angles and under different lighting conditions, thus restoring to it some measure of temporal and morphological complexity. Bayard went one step further, posing himself in one picture as a piece of relief sculpture and therefore momentarily bringing this sculpture back to life (only to consign it immediately again to the two-dimensional half-life of the photographed).[25]

This play between two and three dimensions was in fact something of a preoccupation for nineteenth-century photography. Like Talbot and Bayard, Daguerre (along with his assistant Eugène Hubert) also frequently photographed pieces of sculpture, usually arranged in complex (and as yet undeciphered) iconographic arrangements. These pictures were then sent, suitably inscribed, to usefully influential persons such as politician François Arago, the director of the Louvre, Alphonse de Cailleux, and Germany's Prince Metternich. Remarkable for the unfettered cornucopia of statuary they represent (including memorial busts of such historical personages as Homer, Augustus, and the recently deceased French architect Charles Percier; statuettes of cupids and other Greek and Roman mythological figures; architectural moldings; embossed shields; copies of Greek and Roman relief friezes as well as one by French Renaissance sculptor Jean Goujon; and carved Gothic roundels), Daguerre's still lifes also include artfully placed reproductions of paintings and prints. Indeed, reproduction seems to be a primary theme throughout. An 1839 still life commonly attributed to Hubert, for example, features a small copy of the *Venus de Milo*. Around 1836, Frenchman Achille Collas had introduced a sculptural reducing and copying machine and three years later demonstrated its capabilities by producing a two-fifths-size version of this same canonical statue. As Robert Sobieszek tells us, "The Collas machine was the primary vehicle for the proliferation of serial sculpture and sculptural editions of various sizes beginning in the late 1830s and 1840s."[26] Thus, in these still lifes daguerreotypy copies what has already been copied, in the process linking its own mechanical aptitude for picture making to a three-dimensional analogue. It was not long before this shift from three dimensions to two was reversed. In 1859, François Willème proposed a photo-sculpture process in which photographs of people or objects, no matter how elaborate, could be accurately transformed into terra-cotta, biscuit, bronze, alabaster, or plaster figurines.[27] Ironically, the success of

these likenesses in part depended on their invisible but overt reference back to the presumed veracity of the "insubstantial" photograph from which they were spawned.

So there is a long and complex history being conjured by Redgate's seemingly obtuse photo objects. Taking her cue from two plates found in Talbot's *The Pencil of Nature,* she commissioned craftspeople to make conjoined pairs of glass and ceramic objects based on those found in these canonical pictures. Like a scientist coaxing living dinosaurs from fossilized traces of DNA, Redgate conjures faithful three-dimensional replicas of Talbot's photographic object lessons for our contemporary consideration. Due to the difference in their luminosities, Talbot had been unable to photograph white china and glass together. In making this work, Redgate is confronted with another incommensurable: the impossibility of joining glass to ceramic. A difference in luminosity is repeated 150 years later as a difference in matter. Like Talbot's book, Redgate's ongoing explorations of the possibilities and constraints of photography (which also include her production of, for example, a set of five unphotographable objects, black ceramic vases mounted in front of black perspective screens) are no less than, as Ross Gibson has suggested, "subtle inquests into what can be perceived, known and communicated."[28]

Subtlety is not a quality often ascribed to the work of Jeff Koons. However, he too has chosen to exhibit contemporary photo sculptures—in this case an edition of large polychrome wood sculptures, *String of Puppies* (1988), made on his direction by Italian workers from an earlier postcard image by Art Rogers, a California photographer. Koons no doubt intended the resulting objects, in which banal pictorial sentiment is transformed into a pseudo-Catholic monument, to be read as an ironic commentary on contemporary consumer culture (he has claimed he gave the source image "spirituality, animation and took it to another vocabulary"). A federal appeals court in Manhattan refused to see the joke, or the difference. In 1990 this court found that Koons had violated the copyright of Rogers, arguing that "the essence of Rogers's photograph was copied nearly in toto," and pointing out that in copyright law, "the medium isn't the message."[29] Such a ruling merely repeats what postphotography takes as a given: that photography is now a message rather than a medium, a message that can be conveyed and endlessly repeated even in the absence of any actual photograph.

Koons's *String of Puppies* was produced in the same year that spawned a similar but much more interesting photo sculpture, Jennifer Bolande's *Milk Crown* (1987–1988, photo 5.5). A. D. Coleman has described this piece, a porcelain reproduction of Harold Edgerton's famous 1936 photo of a milk splash, as "essentially a one-liner."[30] But there is a lot at stake in this singular line, even when we leave aside the copyright issue. Edgerton's photograph, which he titled *Milk Drop Coronet,* gives us an image made visible only by the high-speed workings of the camera apparatus. It is a case of the truth of the eye being replaced by that of a machine. In making the invisible visible, Edgerton also reveals photography's peculiar calibration of space and time. Photographs depict a set of fixed spatial relations at a given moment in time, that instant lived by the subject or object before the camera. And yet photography figures time itself as a progressive linear movement from past to future. The elegant geometry of Edgerton's frozen milk drop is but one archaeological slice through what is presumed to be an extended series of movements and potential images.

This notion of time—diachronic, evolutionary, cinematic, or, more properly, photographic in nature—is in fact an invention of the late eighteenth and early nineteenth centuries. In other words, its introduction exactly coincides with the conception of photography. Barthes described photographic time as involving a "revolutionary" and "unprecedented" type of consciousness. He speaks of the "stigmatum" of the "having-been-there" of the thing photographed. Photography, he says, gives us a "this will be" and a "this has been" in one and the same representation. He looks at an 1865 portrait, for example, and observes that the subject depicted there is dead and is going to die. "Whether or not the subject is already dead, every photograph is this catastrophe." Indeed, this future anterior tense is the source of photography's realism. According to Barthes, the reality offered by the photograph is not that of truth-to-appearance but rather of truth-to-presence, a matter of being (of something's irrefutable place in space and time), not of resemblance.[31]

Bolande's work could be taken as another of these meditations on photography and the real. Edgerton's image, that quintessential cliché of the photographic, has here induced the production of a three-dimensional analogue. Of course, his photograph still hovers somewhere between us and this sculpture, an apparition at once present and absent. And yet there is a profound difference between Bolande's sculpture and Edgerton's photograph. This

5.5

Jennifer Bolande, Milk Crown, 1987–1988
Cast porcelain
Courtesy of Alexander and Bonin, New York

difference has little to do with appearance and everything to do with space and time. Edgerton's *Milk Drop Coronet* resonates with the catastrophe of the future anterior. Bolande's *Milk Crown* stolidly occupies the eternal horizon of the present. We look into the photograph to witness the past and imagine the future. We circle around a ceramic object that occupies the same space-time coordinates as we do. The photograph speaks of death. The sculpture speaks of life. Where the photograph insists on a diachronic notion of time, Bolande's post-photography posits a perpetual stasis, the presence of the present.

While the photograph confirms the separation of past and future as a natural fact, Bolande's multidimensional citation returns time (and with it photography) to artifice and the prospect of change. Neither sculpture nor photograph, more a movement between the two, *Milk Crown* is an equally undecidable staging point between past and future. The distinction between these temporal markers—the difference that makes photography possible—has become a question rather than a statement. If nothing else, the advent of post-photography is an uncomfortable reminder that the present we all embody, the photographic presence that is the very guarantee of our being, is no more than one ephemeral effect within history's own ongoing and inexorable processes of reproduction and erasure.

This essay incorporates revised versions of "On Post-Photography," *Afterimage* 20:3 (October 1992), 17; "Post-Photography: After But Not Yet Beyond," *Photofile,* no. 39 (July 1993), 7–10; "Post-Photography," Chinese translation by Huang Shaohua, *Chinese Photography* (April 1995), 8–9; "Reflexions: Life and Death in the Age of Post-Photography," in Stuart Koop, ed., *Reflex,* exhibition catalogue (Melbourne: Centre for Contemporary Photography, 1993), 32–39; "Penitential: James Casebere," *Creative Camera,* no. 340 (June–July 1996), 14–21; "Morphic Resonance: The Work of Ellen Garvens," *Creative Camera,* no. 354 (October–November 1998), 30–35; "The Pleasures of the Textile," in *Rushes: The Work of Lynn Cazabon,* exhibition catalogue (Lewisburg, PA: Bucknell Art Gallery, 1999).

+ + +

+ + **6**

+ + +

ECTOPLASM

Faced with the invention of photography, French painter Paul Delaroche is supposed to have declared, "From today, painting is dead!"[1] Now, a little over 150 years later, everyone seems to want to talk about photography's own death. Tim Druckrey, for example, has claimed that the "very foundation and status of the [photographic] document is challenged." Fred Ritchin speaks of the "profound undermining of photography's status as an inherently truthful pictorial form." Anne-Marie Willis speculates about the possible disappearance of photography "as a technology and as a medium-specific aesthetic." And William J. Mitchell has asserted that "from the moment of its sesquicentennial in 1989 photography was dead—or, more precisely, radically and permanently displaced."[2]

This sustained outburst of morbidity appears to stem from two related anxieties. The first is an effect of the widespread introduction of computer-driven imaging processes that allow "fake" photos to be passed off as real ones. The prospect is that, unable to spot the "fake" from the "real," viewers increasingly will discard their faith in the photograph's ability to deliver objective truth. Photography will thereby lose its power as a privileged conveyor of information. Given the proliferation of digital images that look exactly like photographs, photography may even be robbed of its cultural identity as a distinctive medium.

These possibilities are exacerbated by a second source of concern: the pervasive suspicion that we are entering a time when it will no longer be possible to tell any original from its simulations. Thing and sign, nature and culture, human and machine: all these hitherto dependable entities appear to be collapsing in on each other. Soon, it seems, the whole world will consist of an undifferentiated "artificial nature." According to this scenario, the vexed question of distinguishing truth from falsehood will then become nothing more than a quaint anachronism—as will photography itself.

So photography is faced with two apparent crises: one technological (the introduction of computerized images) and one epistemological (having to do with broader changes in ethics, knowledge, and culture). Taken together, these crises threaten us with the loss of photography, with the "end" of photography and the culture it sustains. But exactly what kind of end would this be?

It should not be forgotten that photography has been associated with death since the beginning. Some early onlookers, for example, associated the daguerreotype process with

black magic. Nadar tells us with some amusement that his friend Balzac was one person who had an "intense fear" of being photographed:

According to Balzac's theory, all physical bodies are made up entirely of layers of ghostlike images, an infinite number of leaflike skins laid one on top of the other. Since Balzac believed man was incapable of making something material from an apparition, from something impalpable—that is, creating something from nothing—he concluded that every time someone had his photograph taken, one of the spectral layers was removed from the body and transferred to the photograph. Repeated exposures entailed the unavoidable loss of subsequent ghostly layers, that is, the very essence of life.[3]

An excess of life was actually a bit of a problem for those early photographers trying to make portraits. Due to the slowness of exposure times, only a slight movement of the subject's head was enough to result in an unsightly blur. Even when this could be avoided, some critics complained that the strain of keeping steady made the subject's face look like that of a corpse. However, a simple solution was soon available: those wanting their portrait taken simply had to submit to having their head placed within a constraining device, which ensured a still posture for the necessary seconds. This device worked, in effect, to transform the lived time of the body into the stasis of an embalmed effigy. In other words, photography insisted that if one wanted to appear lifelike in a photograph, one first had to act as if dead.

Portrait photographers soon took this association a step further, developing a lucrative trade in posthumous photographs, or memento mori. Grieving parents could console themselves with a photograph of their departed loved one, an image of the dead *as* dead that somehow worked to sustain the living. This business was taken to another level in 1861, when a Boston engraver announced that he had found a successful way to photograph ghosts. Thousands of photographs were produced that showed the living consorting with the dead, a comfort for those inclined toward spiritualism and a financial bonanza for those who were prepared to manipulate the photographic technology of double exposure.[4]

But not everyone benefited from photography's business success. As Delaroche had predicted, photography's introduction into the capitals of Western Europe spelled doom for many established image-making industries. Miniature painting, for example, was quickly

ECTOPLASM

130

made extinct by the magically cheap appearance of the daguerreotype's exact, shiny portraits. As N. P. Willis, the first American commentator on photography, warned in April 1839, other art practices were also under threat from the new apparatus: "Vanish equatints [sic] and mezzotints—as chimneys that consume their own smoke, devour yourselves. Steel engravers, copper engravers, and etchers, drink up your aquafortis and die! There is an end of your black art. . . . The real black art of true magic arises and cries avaunt."[5]

But it was not only individual reproductive practices that found themselves having to face a photographically induced euthanasia. Walter Benjamin argued in his famous essay on mechanical reproduction that photography, by inexorably transforming the aura of authenticity into a commodity would hasten the demise of capitalism itself. As a mechanical manifestation of the capitalist mode of production, photography, he argued, necessarily bore the seeds of capitalism's own implosion and demise. In his complicated tale of sacrifice and resurrection, aura would have to die at the hand of photography before any truly authentic social relations could be brought back to life. As Benjamin put it, "One could expect [capitalism] not only to exploit the proletariat with increasing intensity, but ultimately to create conditions which would make it possible to abolish capitalism itself."[6] Capitalism is therefore projected as its own worst nightmare, for its means of sustenance is also its poison. And, for Benjamin at least, photography enjoys this same dual character. Like the daguerreotype, it is a force that is simultaneously positive and negative.

Photography's flirtation with life and death does not end there. It could be argued, for example, that the very idea of photography repeats the theme. As Benjamin reminds us, the beginnings of this idea remain obscured by a "fog" of uncertainties.[7] Frequently cited but seldom seen, the photograph exercised a hallucinatory presence well before its official invention, being conceived by at least twenty different individuals between 1790 and 1839. The manner and timing of photography's conception is in fact a complex historical question. Why didn't previous generations of scholars come up with the idea? Why does it appear only in European discourse around 1800? And this appearance is itself a strange phenomenon, one perhaps best described as a palimpsest, as an event that inscribed itself within the space left blank by the sudden collapse of natural philosophy and its Enlightenment worldview.[8] As Michel Foucault says of this moment, "What came into being . . . is a minuscule but absolutely essential displacement which toppled the whole of Western thought."[9] In other

words, photography's birth pangs coincided with both the demise of a premodern episteme and the invention of a peculiarly modern conjunction of power-knowledge-subject; the appearance of one was made possible only through the erasure of the other.[10]

A life born of death; a presence inhabited by absence: photography's genealogy is repeated in each of its individual instances. Henry Talbot's earliest contact prints, for example, also hovered somewhere between life and death; perversely, the very light needed to see them proved fatal to their continued visibility. In a sense, Talbot's struggle to overcome this shortcoming was a struggle with mortality itself. Even after he had learned how to arrest his wraithlike apparitions (or at least to delay their departure), Talbot still had to explain the nature of their conjuring. What exactly were these lingering presences, these spectral traces of an object no longer fully present?

In his first paper on photography in 1839, Talbot called his process the "art of fixing a shadow," conceding that the capturing of such elusive shades "appears to me to partake of the character of the marvellous": "The most transitory of things, a shadow, the proverbial emblem of all that is fleeting and momentary, may be fettered by the spells of our 'natural magic,' and may be fixed for ever in the position which it seemed only destined for a single instant to occupy. . . . Such is the fact, that we may receive on paper the fleeting shadow, arrest it there and in the space of a single minute fix it there so firmly as to be no more capable of change."[11]

Photography is, for Talbot, the desire for an impossible conjunction of transience and fixity, a visual simultaneity of the fleeting and the eternal. It is an emblematic something, a "space of a single minute," in which space *becomes* time, and time space. Louis Daguerre explicated his process in similarly temporal terms. In March 1839, Daguerre made three identical views—at morning, noon, and in evening light—of the Boulevard du Temple outside his studio window. This series not only calibrated the passing of time in terms of changing shadows and degrees of legibility, but also presented time itself as a linear sequence of discrete but interrelated moments. By bringing the past and the present together in the one viewing experience, Daguerre showed that photography could fold time back on itself.

In stopping or turning back time, photography appeared once again to be playing with life and death. No wonder, then, that *necromancy* (communication with the dead) is a term used by a number of contemporary journalists to describe the actions of both Daguerre's and

Talbot's processes. Some also noted photography's peculiar engagement with time. *The Athenaeum,* for example, commented in 1845 that "photography has already enabled us to hand down to future ages a picture of the sunshine of yesterday."[12] Photography allowed the return of what had come before—and with it a prophecy of future returns. Whatever its nominal subject, photography was a visual inscription of the passing of time and therefore also an intimation of every viewer's own inevitable passing.

Over a century later, Roland Barthes found himself describing photography in remarkably similar terms. In the process, he shifted his own analysis of the medium from a phenomenology of individual images to a meditation on the nature of death in general. He speaks in *Camera Lucida* of the "stigmatum" of the "having-been-there" of the thing photographed. Photography, he says, gives us a "this will be" and a "this has been" in one and the same representation. Every photograph is therefore a chilling reminder of human mortality. Pondering the recent death of his own mother, Barthes looks at an 1865 portrait of a condemned man and observes that the subject depicted there is dead, and is going to die: "Whether or not the subject is already dead, every photograph is this catastrophe." On further reflection, he takes the temporal perversity of this future anterior tense to be the ultimate source of photography's plausibility. For, according to Barthes, the reality offered by the photograph is not that of truth-to-appearance but rather of truth-to-presence, a matter of being (of something's irrefutable place in time) rather than resemblance.[13]

Given this historical background, what does it mean to speak of the death of photography by digital imaging? There is no doubt that computerized image-making processes are rapidly replacing or supplementing traditional still-camera images in many commercial situations, especially in advertising and photojournalism. Given the economies involved, it probably will not be long before almost all silver-based photographies are superseded by computer-driven processes. Eastman Kodak, for example, is putting increasing research and advertising emphasis on its electronic imaging products, worried that it will soon be left behind in the ever-expanding digital industry. As a financial analyst told the *New York Times,* "Film-based information is a dying business."[14]

Bill Gates has certainly come to this conclusion. In 1989 the world's richest man established a company specifically to buy and sell the electronic reproduction rights to an array of pictures so extensive that they "capture the entire human experience throughout

history."[15] This company, Corbis Corporation, acquired the Bettmann Archive in 1995, and with it came control over one of the world's largest private depositories of images—sixteen million in all. Corbis's principal business involves leasing these images, in the form of data stored on digital files, to those who are willing to pay for specified electronic "use rights." Thousands of new images are being added to the Corbis collection every week, drawn from both individual photographers and institutions such as art museums and the Library of Congress. According to its fall 1996 catalogue, Corbis was able to offer its customers over 700,000 digital images to choose from. It is worth noting that when, in April of that same year, Corbis struck an agreement with the Ansel Adams Publishing Rights Trust regarding Adams's photographs, they bothered to acquire only the *electronic* reproduction rights (the traditional rights remaining with the trust). It seems that the basic assumption behind Corbis is that in the near future, digital images are the only kind that are going to matter.[16]

The dissemination of photographs as data raises a number of issues, not least of which is the question of image integrity. The fact is that, whether by scanning in and manipulating bits of existing images or by manufacturing fictional representations on screen (or both), computer operators can already produce printed images that are indistinguishable in look and quality from traditional photographs. The main difference seems to be that whereas photography still claims some sort of objectivity, digital imaging is an *overtly* fictional process. As a practice that is *known* to be capable of nothing but fabrication, digitization abandons even the rhetoric of truth that has been such an important part of photography's cultural success. As their name suggests, digital processes actually return the production of photographic images to the whim of the creative human hand (to the "digits"). For that reason, digital images are actually closer in spirit to the creative processes of art than they are to the truth values of documentary.

This is perceived as a potential problem by those industries that rely on photography as a mechanical and hence nonsubjective purveyor of information. Anxious to preserve the integrity of their product, many European newspapers at one point considered adding an "M" to the credit line accompanying any image that has been digitally manipulated.[17] Of course, given that such a credit line will not actually tell readers what has been suppressed or changed, it simply casts doubt on the truth of every image that henceforth appears in the paper. This is no doubt why American publishers have been reluctant to adopt such a standard

designation (*Time* magazine, for example, describes various covers it published between 1993 and 1996, all digital images, as either illustrations, photo-illustrations, digital illustrations, or digital montages). But this whole dilemma is more rhetorical than ethical; newspapers and magazines have always manipulated their images in one way or another. The much-heralded advent of digital imaging simply means having to admit it to oneself and even, perhaps, to one's customers.

Or perhaps not. The history of commercial digital imaging thus far is a seemingly endless litany of deceptions and unacknowledged manipulations. Many of these, such as the notorious *National Geographic* cover from February 1982 in which the pyramids were moved closer together or the even more notorious *TV Guide* cover from August 1985 which merged the head of Oprah Winfrey and the body of Ann-Margret, were no doubt conceived by their editors as "illustrative" and therefore not beholden to the same standards of truth as properly journalistic images.[18]

Time magazine has continued this tradition, regularly employing digital imaging to produce catchy cover art for articles on everything from the conflict between the two Koreas to what it called the "new face of America" (photo 6.1).[19] In each case, the resulting illustration is clearly just that: an overtly manipulated or invented image. However, the same magazine stumbled into more controversial waters when it chose to grace the cover of its June 27, 1994, issue with a digitally darkened Los Angeles Police Department mug shot of O. J. Simpson. Although the extent of this manipulation was not mentioned by *Time,* it was made plain by the fact that *Newsweek* chose the same mug shot for its cover that week, but unadulterated, thus allowing a direct comparison on the newsstand. In the face of considerable public criticism, *Time'*s editor was forced to print a full-page letter in the July 4 issue to explain the reasoning behind the magazine's apparent racism and its decision to alter "the facts." Arguing that the digital alterations "lifted a common police mug shot to the level of art," the editor claimed that such interventions had always been allowable within journalism as long as "the essential meaning of the picture is left intact."[20] Of course, this double appeal—to art and to essence—could be used to justify silently changing virtually any image in the magazine.

Incidents such as these continue to occur at regular intervals. The November 1996 issue of *LIFE* magazine contained a quiet apology (hidden away on page 36 at the foot of another story) for having reproduced a digitally manipulated image of a bullfight (in which an

6.1

Time *(artist: Kin Wah Lam), The New Face of America, Fall 1993*

inconvenient matador's arm had been removed) in the August issue. The magazine told its readers that "such electronic manipulation of news photographs is against our policy, and *LIFE* regrets the lapse." But if the editors themselves didn't know that the image they used had been altered, one wonders how many other such images they and similar magazines are inadvertently printing.

In a different kind of case, the *New York Times* reported on page 17 of its October 13, 1996, issue that an election race for the U.S. Senate had been "shaken up" by the revelation that the media consultant for Senator John Warner had electronically placed his political opponent's head on the body of another man. The combination image had been used in an advertisement that accused the opponent of cavorting "with the nation's most liberal politicians." The *Times* quotes an expert in political advertising as saying that this example was "particularly egregious because it's undetectable to the average viewer." When questioned, one of Senator Warner's campaign aides dismissed the head-swapping exercise as "a technical adjustment." However, under pressure from the press, Warner later fired his media consultant and canceled the advertisement. Other examples show that the Oprah/Ann-Margret merger is not an isolated case. The January/February 1994 issue of *American Photo* magazine featured a cover picture of a diaphanously clad Kate Moss (photo 6.2). However, fearing that Southern-based distributors would refuse to handle the issue, the magazine chose to digitally erase any sign of her nipples. This sort of quiet adjustment to pictorial truth is no doubt going to be an increasingly common practice among newspapers and magazines. The November 1996 issue of *Ladies Home Journal,* for example, featured an image of a smiling Cher on its cover. Or was it? Cher maintains that everything below the chin in the cover photo belongs to someone else. The magazine's marketing director admitted only that "we used technology to change the dress and remove the tattoo, to make the cover more appealing to our readers." Perhaps Cher should consult her lawyers. On January 22, 1999, a judge ordered *Los Angeles* magazine to pay actor Dustin Hoffman $1.5 million for publishing without permission a computer-altered image of him in an evening dress and high heels.[21]

But all this can hardly be blamed on digitization. The history of photography is already full of images that have been manipulated in some way or other. In fact, it could be argued that photography is nothing but that history. And I am not speaking here of just those notorious images where figures have been added or erased in the darkroom for the convenience

6.2

American Photo, *Kate Moss, January/February 1994*

of contemporary politics.[22] I am suggesting that the production of any and every photograph involves practices of intervention and manipulation of some kind. After all, what else is photography but the knowing manipulation of light levels, exposure times, chemical concentrations, tonal ranges, and so on? In the mere act of transcribing world into picture, three dimensions into two, photographers necessarily manufacture the image they make. Artifice of one kind or another is therefore an inescapable part of photographic life. In that sense, photographs are no more or less "true" to the appearance of things in the world than are digital images.

This argument returns us to the dilemma of photography's ontology, to the analogical operations that supposedly give photography its distinctive identity as a medium. Remember that Barthes has already discounted resemblance to reality as a way of defining photography. In his terms, a given person may not look exactly as the photograph now portrays him or her, but we can at least be sure he or she was once there in front of the camera. We can be sure that person was at some point present in time and space. For what makes photographs distinctive is that they depend on this original presence, a referent in the material world that at some time really did exist to imprint itself on a sheet of light-sensitive paper. Reality may have been transcribed, manipulated, or enhanced, but photography does not cast doubt on reality's actual existence.

Indeed, quite the opposite. Photography's plausibility has always rested on the uniqueness of its indexical relation to the world it images, a relation that is regarded as fundamental to its operation as a system of representation. As a footprint is to a foot, so is a photograph to its referent. Susan Sontag says that the photograph is "something directly stencilled off the real," and Rosalind Krauss describes it as "a kind of deposit of the real itself."[23] It is as if objects have reached out and touched the surface of a photograph, leaving their own trace, as faithful to the contour of the original object as a death mask is to the face of the newly departed. Photography is the world's memento mori. It allows that world to become its own photographer. For this reason, a photograph of something has long been held to be a proof of that thing's *being*, even if not of its truth.

Computer visualization, on the other hand, allows photographic-style images to be made in which there is potentially no direct referent in an outside world. Where photography is inscribed by the things it represents, it is possible for digital images to have no origin

other than their own computer program. These images may still be indexes of a sort, but their referents are now differential circuits and abstracted data banks of information (information that includes, in most cases, the *look* of the photographic). In other words, digital images are not so much signs of reality as they are signs of signs. They are representations of what is already perceived to be a series of representations. This is why digital images remain untroubled by the future anterior, the complex play of "this has been" and "this will be" that so animates the photograph. Digital images are *in* time but not *of* time. In this sense, the reality the computer presents to us could be said to be a virtual one, a mere simulation of the analogically and temporally guaranteed reality promised by the photograph. And, of course, when people seek to protect photography from the incursion of the digital, it is this reality that they are ultimately defending.

But how is it, or photography for that matter, threatened? It should be clear to those familiar with the history of photography that a change in imaging technology will not, in and of itself, cause the disappearance of the photograph and the culture it sustains. For a start, photography has never been any one technology; its nearly two centuries of development have been marked by numerous, competing instances of technological innovation and obsolescence, without any threat being posed to the survival of the medium itself. In any case, even if we continue to identify photography with certain archaic technologies, such as camera and film, those technologies are themselves the embodiment of the idea of photography or, more accurately, of a persistent economy of photographic desires and concepts. The concepts inscribed within this economy would have to include things like nature, knowledge, representation, time, space, observing subject, and observed object. Thus, if we do have to define it for a moment, we might say that photography is the desire, conscious or not, to orchestrate a particular set of relationships between these various concepts.

While both concepts and relationships continue to endure, so surely will a photographic culture of one sort or another. Even if a computer does replace the traditional camera, that computer will continue to depend on the thinking and worldview of the humans who program, control, and direct it, just as photography now does. While the human survives, so will human values and human culture—no matter what image-making instrument that human chooses to employ.

But are both "the human" and "the photographic" indeed still with us? Technology alone will not determine photography's future, but new technologies, as manifestations of our culture's latest worldview, may at least give us some vital signs of its state of health. Digitization, prosthetic and cosmetic surgery, cloning, genetic engineering, artificial intelligence, virtual reality—each of these expanding fields of activity calls into question the presumed distinction between nature and culture, human and nonhuman, real and representation, truth and falsehood—all those concepts on which the epistemology of the photographic has hitherto depended.

Back in 1982, the film *Blade Runner* looked into the near future and suggested that we will all soon become replicants, manufactured by the social-medical-industrial culture of the early twenty-first century as "more human than human," as living simulations of what the human is imagined to be. Deckard's job as a Blade Runner is to distinguish human from replicant, a distinction that, ironically, is possible only when he allows himself to become prosthesis to a viewing machine. At the start of the film, he thinks he knows what a human is. But the harder he looks, the less clear the distinction becomes. (Like him, the replicants have snapshots, triggers for memories planted by their manufacturer, memories just like his own.) Eventually he has to abandon the attempt, unsure at the end as to the status of even his own subjectivity.[24]

The twenty-first century is upon us. And already there is no one reading this who is a "natural" being, whose flesh has not been nourished by genetically enhanced corn, milk, or beef and whose body has not experienced some form of medical intervention, from artificial teeth to preventive inoculations to corrective surgery. Zucchinis are being "enhanced" by human growth hormones. Pigs are now bred to produce flesh genetically identical to that of humans (replicant flesh).[25] Who can any longer say with confidence where the human ends and the nonhuman begins?

Not that this is a new dilemma. Like any other technology, the body has always involved a process of continual metamorphosis. What is different today is the degree to which its permeability is a visible part of everyday life, a situation that surely insists on a radical questioning not only of the body but also of the very nature of humanness itself. We have entered an age in which the human and all that appends to it can no longer remain a stable site

of knowledge precisely because the human cannot be clearly identified. And if "the human" is under erasure, can photography and photographic culture simply remain as before?

If this be a crisis, then its manifestations are all around (as well as within) us. Contemporary philosophy, for example, would question the conceptual stability of the index on which photography's identity is presumed to rest. As we have already heard, photographs are privileged over digital images because they are indexical signs, images inscribed by the very objects to which they refer. This is taken to mean that whatever degrees of mediation may be introduced, photographs are ultimately a direct imprint of reality itself. The semiotician who devised this concept of the index was the American philosopher Charles Sanders Peirce.[26] However, as Jacques Derrida points out in his own examination of semiotics, the whole Peircean schema "complies with two apparently incompatible exigencies." To summarize Derrida's argument quickly, Peirce continues to depend on the existence of a nonsymbolic logic, even while recognizing that such a logic is itself a semiotic field of symbols. Thus, "no ground of nonsignification . . . stretches out to give it foundation under the play and the coming into being of signs." In other words, Peirce's work never allows us to presume that there is a "real world," an ultimate foundation, that somehow precedes or exists outside representation ("signification"). Real and representation must, according to Peirce's own argument, always already inhabit each other. As Derrida points out, in Peirce's writing "the thing itself is a sign. . . . From the moment there is meaning there are nothing but signs."[27]

So those who look to Peirce for pragmatic evidence of an extraphotographic real (the "thing-itself"), will, if they look closely enough, find in its place "nothing but signs." Accordingly, if we follow Peirce to the letter and rewrite photography as a "signing of signs" (and therefore, it should be noted, recognizing that photography too is a *digital* process), we must logically include the real as but one more form of the photographic. It too is the becoming of signs. It too is a dynamic practice of signification. Any extended notion of photography's identity must therefore concern itself with the how of this "becoming," with the "tracing" of one sign within the grain of the other. In other words, photography must be regarded as the representation of a reality that is itself already nothing but the play of representations. More than that, if reality is such a representational system, then it is one produced within, among other things, the *spacings* of the photographic.[28]

This shift in photography's conception obviously has ramifications for the entire epistemological edifice on which our culture is built. As Derrida puts it, "This concept of the photograph *photographs* all conceptual oppositions, it traces a relationship of haunting which perhaps is constitutive of all logics."[29]

Photography, it appears, is a logic that continually returns to haunt itself. It is its own "medium." Accordingly, each of my examples has been part of a photographic ghost story. Each has pointed to the enigmatic quality of photography's death, or, more precisely, each has posed the necessity of questioning our understanding of the very concepts "life" and "death." Given the new imaging processes, photography may indeed be on the verge of losing its privileged place within modern culture. This does not mean that photographic images will no longer be made, but it does signal the possibility of a dramatic transformation of their meaning and value, and therefore of the medium's ongoing significance. However, it should be clear that any such shift in significance will have as much to do with general epistemological changes as with the advent of digital imaging. Photography will cease to be a dominant element of modern life only when the desire to photograph, and the peculiar arrangement of knowledges and investments that that desire represents, is refigured as another social and cultural formation. Photography's passing must necessarily entail the inscription of another way of seeing—and of being.

Photography has been haunted by the spectre of such a "death" throughout its long life, just as it has always been inhabited by the very thing, digitization, that is supposed to be about to deal the fatal blow. In other words, what is really at stake in the current debate about digital imaging is not only photography's possible future but also the nature of its past and present.

Versions of this essay have been previously published as "Post-Photography: Digital Imaging and the Death of Photography," and "Post-Fotografie: Digitale Bilderstellung und der Tod der Fotografie," *BE Magazin,* no. 1 (Berlin, May 1994), 7–13; "Phantasm: Digital Imaging and the Death of Photography," *Aperture,* no. 136 (Summer 1994), 47–50; "Post-Photography: Digital Imaging and the Death of Photography," *Chinese Photography* 15:5 (Beijing, May 1994), 10–12 (Chinese translation by Huang Shaohua); "Ghost Stories: The Beginnings and Ends of Photography," In N. W. M. Ko ed., *Art Catalogue of the First International Conference on Flow Interaction* (Hong Kong: Fung Ping Shan Museum, University of Hong Kong, September 1994), 5–13; "Ghost Stories: The Beginnings and Ends of Photography," *Art Monthly Australia,* no. 76

(December 1994), 4–8; "Ghost Stories: The Beginnings and Ends of Photography," *Sajinyesul: The Monthly Photographic Art Magazine,* no. 74 (Korea, 1995–96), 62–66 (Korean translation by Keun-Shik Chang); "Ectoplasm: Photography in the Digital Age," in Carol Squiers, ed., *Over Exposed: Essays on Contemporary Photography* (New York: New Press, 1999), 9–23. Portions of it also appear in my book *Burning with Desire: The Conception of Photography* (Cambridge, MA: The MIT Press, 1997).

+ + +

+ + +

7 + +

PHOTOGENICS

This essay was prompted by an exhibition of the past decade's photography acquisitions at the Art Museum of the University of New Mexico in Albuquerque.[1] Not that the work in the exhibition was particularly exceptional. As one might expect in a museum already well known for its photography holdings, it featured a broad range of different photographic approaches, functions, and techniques (from an anonymous 1865 portrait of an amputated leg made for an Army Medical Corps to an illustrated fan by contemporary Japanese photo-artist Yasumasa Morimura) and exemplary prints by some well-known names (Carleton Watkins, George Seeley, Erich Salomon, Dorothea Lange, Lee Friedlander). An impressive collection, especially for a university museum. But what caught the attention was not the work itself but the way in which it was presented. Hung on the usual tastefully colored walls, the display was organized in a roughly chronological fashion—that is, as a kind of history, a history of photography.

Nothing exceptional here either, except for the way the exhibition chose to begin and end its chronology. The exhibition's curators began their historical exposition with one of photography's earliest products, an 1850 cyanotype contact print by Anna Atkins, and ended with another much larger cyanotype work made in 1977 by American artist Barbara Kasten. The exhibition thereby seemed to be presenting photography's history, as one of the wall texts explicitly told us, as a "full circle."

To repeat, this otherwise unassuming exhibition chose to represent photography's history as a movement that is now turning back on itself, almost consuming itself, certainly repeating certain motifs and self-understandings in a kind of cannibalistic homage to itself. It is as if the exhibition wanted to tell us that photography's history has reached a point not of no return, but of nothing but returns. This sense of photographic history as a narrative constituted by "forward motion through endless return" was made all the more poignant by a recent phenomenon that the exhibition excluded from its story: the displacement of traditional photographs by computer-generated digital images.[2] Continuing in the spirit of the UNM Art Museum curators, my essay therefore seeks to place the digital phenomenon back into this exhibition's intriguing historical circuitry.

On April 2, 1996, Corbis Corporation, owned by American billionaire Bill Gates, announced that it had signed a long-term agreement with the Ansel Adams Publishing Rights Trust for the exclusive electronic rights to works by photographer Ansel Adams. This

followed an earlier announcement from Corbis regarding its acquisition of the Bettmann Archive, one of the world's largest image libraries.[3] In this one purchase, Gates gained reproduction rights to over sixteen million photographic images. And this is only the beginning. Thousands of new images are being added to the Corbis collection every week, drawn from a multitude of individual commercial photographers as well as institutions such as NASA, the National Institutes of Health, the Library of Congress, the National Gallery of Art in London, the Seattle Art Museum, the Philadelphia Museum of Art, and the Hermitage in St. Petersburg.[4] Selected images are scanned into the Corbis computer banks, promoted via Web site, CD-ROMS, and catalogues, and then leased, in the form of digital files, to those willing to pay for specified electronic "use rights." According to its 1996 catalogue, Corbis is able to offer its customers over 700,000 of these digital images to choose from.[5]

Even the *New York Times* felt the need to refer to Marxist critic Walter Benjamin when trying to describe the potential consequences of this new industry (for Corbis is but one company in a rapidly expanding trade in electronic images).[6] Benjamin's 1936 essay on the effects of mechanical reproduction tells a rather complicated tale of sacrifice and resurrection.[7] According to this tale, authentic social relations are depleted by their technically induced commodification, in the process creating the conditions for the phoenix-like return of these relations in a postcapitalist economy. His central point was that the shift from production to reproduction, one of the "basic conditions" of capitalism, would also be the source of this system's downfall. Technological manifestations of this shift, such as photography, therefore embodied the potential for both oppression and liberation. This explains Benjamin's strange ambivalence about technical reproducibility. Interestingly, it is an ambivalence that has been repeated in many of the commentaries on its electronic version. These commentaries often combine utopian predictions of unfettered democratized access to the world's visual archives with a fear of the potential trivialization of meaning and history produced by this same access.

There is also a certain nervousness about the prospect of one man, none other than the world's wealthiest capitalist, gaining so much power over the very process, reproduction, that Benjamin saw as crucial to capitalism's demise. This nervousness is understandable when one puts Gates's sudden interest in images into a bigger picture. All sorts of expensive multi-

national mergers have been taking place in which communication, entertainment, and computing companies have enthusiastically interbred in order to spawn gigantic media conglomerates. One of the phenomena at stake in these business wars is the Internet. Indeed, the Internet is on the verge of becoming an essential part of daily life, providing a vast, competitive electronic marketplace in which virtually anything can be bought and sold. Microsoft, another Gates company, has made great efforts to achieve dominance over the means of access to this market. For example, Microsoft is spending millions to develop search and navigation software that will make it possible for any interested subscriber, from schoolchildren to industry executives, to locate, download, and automatically pay for the images owned by Corbis. The consequence of all this is that Gates may soon control not only the vehicle but also a major portion of the visual content being conveyed over the information superhighway. To really cash in, all he needs to devise now is the right sort of electronic toll gate. Here we have the ultimate goal of this whole exercise, and Gates obviously plans to make considerable profits on his investments. But will this new enterprise also accelerate the alienation of his subscribers from their own culture, thereby hastening what Benjamin saw as that culture's inevitable implosion and transformation? Only time will tell.

While we wait, there are a number of more immediate concerns to ponder. One of these is censorship. In November 1995, America Online declared that *breast* was an indecent word and cut off access to any user groups that identified themselves with it. The decision was later reversed in the face of complaints from enraged subscribers interested in information on breast cancer. In December 1995, Compuserve temporarily denied 4 million users of the Internet access to more than two hundred discussion groups and picture databases after a federal prosecutor in Munich said the material contained in them violated German pornography laws. On February 8, 1996, American legislators, keen to capture the moral high ground in the lead-up to an election, introduced laws designed to outlaw electronic traffic considered "indecent."[8] The Microsoft Network, like the other companies offering access to the Internet, already warns its subscribers against exchanging what it deems "offensive" speech.

It remains to be seen whether Corbis chooses to exercise a similar level of control over its ever-expanding image empire. At this stage, the company claims to have no formal policy on the matter, using the undefined criterion of what a spokesman called "good taste" as a way

of assessing images offered to them (resulting, for example, in their rejection of an offer of images of "babes"). Presumably the company eventually will have to monitor the range of pictures made available to its school-age market. But to what degree will this censorship be extended to its adult customers? No policy has yet been announced. However, on one level, a selection process of some kind or other is already taking place: only about 5 percent of the company's holdings have been converted to digital form. Perhaps certain pictures will simply never see the (electronic) light of day.

By dominating the market in electronic reproductions, Gates has also acquired a measure of control over what many might have naively thought to be a public resource: history. Remember that image of Truman holding up the premature issue of the *Chicago Daily Tribune* declaring his defeat by Dewey? It is in the Corbis catalogue. Remember Malcolm X pointing out over his crowd of listeners, the airship *Hindenburg* exploding in the New Jersey sky, that naked Vietnamese child running toward us after being burned by napalm, Churchill flashing his V-for-victory sign, Dorothea Lange's *Migrant Mother,* Patty Hearst posing with her gun in front of the Symbionese Liberation Army banner, LBJ being sworn into office aboard *Air Force One* beside a blood-spattered Jackie? Corbis offers to lease us electronic versions of them all. It offers to sell us, in other words, the ability to reproduce our memories of our own culture, and therefore of ourselves.

The company's objective, according to its chief executive officer, is to "capture the entire human experience throughout history."[9] Notice that experience and image are assumed to be one and the same thing, as are image and reproduction. The 1996 Corbis catalogue reiterates its CEO's ideal by dividing the company's offerings into an exhibition of digestible themes: historical views, world art, entertainment, contemporary life, science and industry, animals, nature, travel and culture. In the world according to Corbis, human experience is defined by the needs and demands of commercial publishing. More than anything else, the Corbis catalogue is full of generic images of the kind desired by busy picture editors: human faces from across the globe, plants and animals of every stripe, cityscapes from Agra to New York, human activity in all its varieties. Want an image of a biracial couple? Want a shot of rosary beads and a Bible? Want the view from across the handlebars of a speeding mountain bike? Want to see a welder working on a high-rise building? Corbis can supply any of these and many more like it, all in glossy, saturated color, perfect for magazine reproduction and

company brochures. Human experience comes suspended in the sickly sweet amniotic fluid of commercial photography. And a world normally animated by abrasive differences is blithely reduced to a single, homogeneous *National Geographic* way of seeing.

All this talk of capturing things brings us to another question: What exactly is Corbis buying and selling? What is a digital image? It is notable that in the case of the work of Ansel Adams, it has not bothered to acquire any actual prints (although Gates could obviously afford them). It does not even own the copyright to any of the photographs by Adams (this has been retained by the Adams Trust). All that Corbis owns are the electronic reproduction rights to certain of Adams's images. The assumption is that in the near future, *electronic* reproduction is the only kind that is going to matter. The other assumption in play here is that *reproduction* is already the only aspect of an image worth owning. The world's richest man has declared in no uncertain terms that the original print—always a contradiction in terms for photography in any case—is of absolutely no interest. He does not want to accumulate photographs; he just wants to be able to sell endless reproductions of them. He seeks to control not photography but the total flow of photo data.

And that is just what he is going to do. *Moonrise, Hernandez, New Mexico,* a photograph taken by Adams in November 1941, has been transformed through the wizardry of the computer into a series of digits that take up somewhere between 20 and 50 megabytes of an optical disk (depending on the quality of the reproduction wanted).[10] After the required fee is paid, Corbis removes its electronic watermark and allows temporary use of a certain system of coded numbers. These numbers, when transposed through a computer program and printer, will reproduce an image that resembles the photograph taken by Adams. If we go back to Benjamin's commentary for a moment, we might conclude that capital has here finally reached the limits of its own logic. It has erased the aura of authenticity from its system of values and replaced it, once and for all, with the glitter of reproducibility.

In effect, what a customer is leasing from Corbis are the performance rights to a digitized Adams score.[11] But this otherwise useful musical analogy is also a little misleading, for what Corbis actually seems to want to bring to photography is the logic of a certain kind of science. After all, the Corbis catalogue is insistent that "we bring you all the beauty of the original work in a convenient digital format." In positing a faithful one-to-one correspondence between original and copy, code and image, Corbis claims to go beyond mere

performance, inviting us instead to associate digitization with the precise replication practices of something like genetic engineering.

What are the consequences of such an association? For a start, Corbis's photogenics runs against the grain of photography as Adams understood and practiced it. When one orders, for example, *Moonrise, Hernandez, New Mexico* from Corbis, one gets a quite particular reproduction. No matter how many times a customer might order this title from Corbis, she or he is guaranteed exactly the same image, one precisely cloned from the genetic code that is the new identity of this picture. However, I have seen at least half a dozen different versions by Adams based on this particular negative, some with virtually no moon visible and others with varying degrees of cloud and foreground detail brought out in the printing process (photo 7.1).[12] Indeed, Mary Street Alinder's 1996 biography of Adams details the complex history of this picture, which she suggests is "for many . . . the greatest photograph ever made."[13] Alinder argues that *Moonrise* is an early product of his Zone System of photography, a differentiation of visible light Adams devised to allow the practitioner to previsualize the entire gamut of values that will appear in the final print. Thus, the image comes before the photograph (which is merely its reproduction), and the film is already inscribed with a picture before it is ever exposed to light. Adams took this particular exposure under difficult circumstances on the side of a road in failing light; a recalcitrant negative was the result. He made his first print from it in late November 1941, now in the collection of the Museum of Modern Art. In 1948 he attempted to intensify the foreground of the negative and made further prints in December of that year. By 1980, when he stopped printing from it, Adams had made at least thirteen hundred original prints from that negative, dodging and burning selected areas of the print in an evolving interpretation of its tonal possibilities.

The complication of photography's physical identity (and we are not even talking here about the added complexities of contextual or historical determinations of a photograph's meaning) has always been that there is no fixed point of origin; neither the negative nor any one print can be said to represent in its entirety the entity that is called *Moonrise, Hernandez, New Mexico*. And if there is no "original work," then there can be no "faithful copy" either. To borrow a phrase from Ferdinand de Saussure's description of language, in photography there are "only differences *without positive terms*."[14] As a consequence, photography is produced within and as an economy that Jacques Derrida calls *différance;* any particular photo-

7.1
James Alinder, Ansel Adams with a Straight and a Fine Print of *Moonrise, 1981*
Gelatin silver print
Courtesy of James Alinder

graphic image is "never present in and of itself" but "is inscribed in a chain or in a system within which it refers to the other, to other [images], by means of the systematic play of differences."[15] The irony haunting Corbis's electronic reproduction business is that cloning obeys this same [il]logic. In biology, a clone is a copy of another organism produced by implanting an unfertilized egg with a "differentiated" sample of that organism's DNA.[16] The clone is genetically identical to its donor (its DNA code is a replication of the donor's), and yet the clone is not the same being; it is younger (a lamb is produced from the mammary cell of an adult sheep) even while, at the same time, its genetic material carries the history of that donor alongside and within its own. *Moonrise* has an equally complicated identity, produced by differentiation and further dividing itself from itself in each and every one of its clones (which are always the same but different, even if this difference is not immediately discernible to the eye).

Bill Gates does not see this proliferation of reproductions as a problem. In his book *The Road Ahead,* he argues that "exposure to the reproductions is likely to increase rather than diminish reverence for the real art and encourage more people to get out to museums and galleries."[17] This is the hope of museums and historians alike, many of whom now offer Web sites as an enticement to potential visitors or as an archival resource for scholars. But what is interesting about the new archiving is that everyone who has access to the data can curate their own museum or devise their own history. Gates, for example, has commissioned a series of large electronic screens to be installed in his $30 million house in Seattle, and these will be linked to the Corbis database: "If you're a guest, you'll be able to call up on screens throughout the house almost any image you like—presidential portraits, reproductions of High Renaissance paintings, pictures of sunsets, airplanes, skiers in the Andes, a rare French stamp, the Beatles in 1965."[18] The eclecticism of his proposed choices—choices so kitsch they are sublime—suggests a further element of digital imaging.[19] Classification, once the closely policed art form of the librarian, is now as potentially idiosyncratic as the famous entry from "a certain Chinese encyclopedia" that so amused both Borges and Foucault.[20] Participants who follow the Gates lead can surf an image archive as arbitrarily as people already surf art museums, happily jumping from Rembrandt to ancient Egyptian sculpture to Japanese armor, or from sunsets to stamps to Nobel Prize winners, as the whim takes them.[21] With electronic reproduction, no one has to care about history as a linear sequence any more. His-

tory instead becomes a matter of individual invention, a conjuring of talismans of the not-now as a way of confirming our own fragile presence in time and space. History, in other words, takes on something of the poignantly personal character of the photographic (at least as this is described by Roland Barthes in *Camera Lucida*).[22]

Imagine this future. You will venture (electronically, of course) into the global super-market and find offered for sale, side by side on your screen, digital files for an Adams pho-tograph, an improved heart valve, and a disease-resistant zucchini. Impossible? Actually, that future is already here. In 1994 Calgene, a California-based biotechnology company, put a tasty, genetically engineered tomato on the market, a programmed vegetable that *Newsweek* magazine playfully called "DNA on a plate." The human body is already on that same plate. The Human Genome project, for example, presumes that *Homo sapiens* too is no more than manifest data. At least four firms are racing to produce a genetically modified pig whose DNA, having been rendered identical to that of humans, will allow rejection-free organ transplants to take place. In 1995 the U.S. Department of Health and Human Services re-ceived a patent (No. 5,397,696) for a virus-resistant cell line found in the blood of Hagahai tribespeople in New Guinea.[23] The list could go on. The point is that Corbis and other com-panies like it are intent on taking photography into a well-established economy, an economy all about the distillation and exchange of the world's most valuable commodity: data. And within the logic of that (electronic) economy, the identity of an image is no longer distin-guishable from that of any other piece of datum, be it animal, vegetable, or "experiential" in origin. Indeed, given the rhyzomatic structure of the electronic universe, the point of origin is no longer of consequence. All that matters (in every sense of this word) is the possibility of the instant dissemination and exact reproduction of data.

Here we have one of the major consequences of the advent of the age of electronic reproduction. The old, familiar distinctions between reality and its representation, original and reproduction, nature and culture—the very infrastructure of our modern worldview—seem to have collapsed in on each other. More specifically, the substance of an image, the matter of its identity, no longer has to do with paper or particles of silver or pictorial appearance or place of origin; it instead comprises a pliable sequence of digital codes and electrical impulses.[24] It is their configuration that will decide an image's look and sig-nificance—even the possibility of its continued existence. It is their reproduction and

consumption, flow and exchange, maintenance and disruption, that already constitute our culture (that now constitute even our own flesh and blood).

This meditation on the current state of photography's identity brings me back to my essay's beginning, just as the UNM Art Museum's exhibition layout had suggested it would. For it might well be argued that much of what I have just identified with the digital phenomenon can already be found in the work of the medium's earliest practitioners—in the work of Anna Atkins (1799–1871), for example. The cyanotype that opened UNM's exhibition, *Hymenophylum Wilsoni*, comes from a systematic series of 389 such images that Atkins produced between October 1843, when she issued the first part of her pioneering photographically illustrated book (titled *Photographs of British Algae: Cyanotype Impressions*) and 1853 (when it was completed) (photo 7.2). Thus the inspiration for this image was the science of botany, a discipline in which Atkins's father was an established expert (and to whom her book is dedicated).

As Larry Schaaf has demonstrated in his many invaluable publications on Atkins, her close relationship with her father, John George Children (1777–1852), was crucial for her photographic work.[25] Children was a friend of Humphry Davy, John Herschel, and Henry Talbot, a respected scientist in his own right, and a fellow and secretary of the Royal Society. He was an editor of the *Zoological Journal* and a founding member of the Zoological Club of the Linnaean Society, as well as the keeper of the zoological collections at the British Museum (working there for twenty-four years until his resignation in March 1840). Most important, Children was a vice president of the Botanical Society of London, an organization to which Atkins was also elected a member in 1839. Through Children, Atkins was able to have contact with, among other notables, the leading British botanist William Hooker. She was obviously familiar with the leading scientists and natural philosophers of her day. Children was also a persistent, if not particularly gifted, poet. After his death, Atkins reproduced some of these poems in the various books she prepared in honor of his memory, with one of these being his 1841 effort titled "On Failing to Take the Calograph Portrait of a Beautiful Young Lady."[26] This last piece of verse commemorated Children's own experiments with photography, specifically with the calotype process Talbot patented in 1841.[27]

Children had chaired the meeting of the Royal Society on February 21, 1839, when Talbot first disclosed the details of photogenic drawing. In September 1841, Children

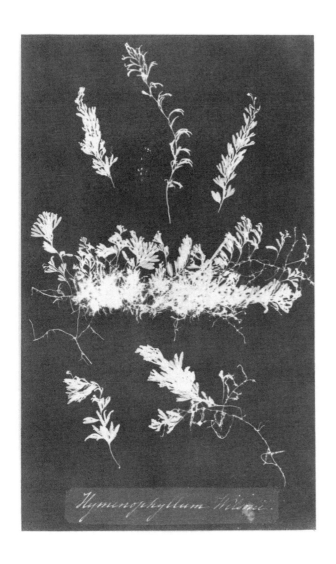

7.2

Anna Atkins, Hymenophyllum Wilsoni, *c. 1850*
Cyanotype photograph
University of New Mexico Art Museum, Albuquerque; Beaumont Newhall Collection, purchased with
funds from the John D. and Catherine T. MacArthur Foundation

bought a camera for Atkins from Andrew Ross and had his own portrait taken by Henry Collen. Schaaf suggests that "it is almost certain" that Children and Atkins were also present at the meeting of the Botanical Society on March 1, 1839, when John Thomas, Jr., showed members "numerous figures of Mosses and Ferns produced by the Photogenic process of Mr Talbot."[28] Talbot sent Children twelve examples of these "figures" in September 1841, with the latter sending Henry a letter on the fourteenth of that month declaring that "my daughter and I shall set to work in good ernest [sic] till we completely succeed in practicing your valuable process."[29] Children had already received some earlier photogenic drawings from Talbot in 1839. However, the only known photographs by either Children or Atkins were made not with calotype or photogenic drawing, but using the cyanotype process Herschel announced in 1842. As had Talbot before him, Herschel immediately sent Children a copy of his paper on this process, which used ferric ammonium citrate and potassium ferricyanide and resulted in deep blue permanent contact prints. It was the ideal photography for Atkins's purpose, the making of exact reproductions of botanical specimens.

The visual design of Atkins's book followed the lead of an established botanical genre in which actual specimens of seaweed were mounted in bulky, annotated albums or botanical specimens were transformed into engravings, silhouettes, or "cut flower mosaics."[30] Using William Harvey's unillustrated *Manual of British Algae* of 1841 as her guide, Atkins tells us in her introduction to Part 1 of *British Algae* that she was attempting a "systematic arrangement," trying to represent photographically "the Tribes and Species in their proper order." In Atkins's own schema, then, the photogram titled *Hymenophylum Wilsoni* is but one typical example of a genus; it was made to be representative of a group of images thought to have common structural properties. It should be remembered that each image was printed about fifteen times for the different editions of the book, usually reusing the same botanical specimen for each print. So each page always contains the same basic visual information but always with slight variations in the arrangement of that information between each edition, as befits a hand-made contact print. In short, like Gates, Atkins presents her images as data, as precisely repeated, invariably differentiated information derived from a common master code and disseminated in image form. Accordingly, to refer to the original print of *Hymenophylum Wilsoni* would be a nonsense; for Atkins, photography is a processing of data that produces nothing but reproductions.

There is some confusion as to how this reproduction was achieved. In *Sun Gardens,* Larry Schaaf suggests that "the evidence is that she printed most of her specimens 'nude', not mounted on any surface. This can be detected from the fact that identical specimens were sometimes printed in different positions, including as a perfect mirror image."[31] A little later in a caption for one of these mirrored pairs, he claims that their existence "prove[s] that Atkins printed many of the plates by placing the unmounted dried-algae original directly on the cyanotype paper."[32] But if the two images are mirror versions of each other, surely this verifies that she cannot have simply placed them directly on the prepared paper? To get an exact mirror copy, surely she must have sandwiched them between two sheets of glass or mica, as Schaaf elsewhere suggests, and then flipped the sheets over as she went from one print to the next.[33] The existence of a mirror version of certain images implies a desire for an exact, even if reversed, copy of a particular specimen. But it also suggests a fledgling effort toward a system of mass production, a gesture toward the possibility of that endless reproduction of images now being engineered by Corbis.

The close contact between Atkins and Talbot (she sent him a copy of *British Algae* and he later reciprocated with a copy of *The Pencil of Nature*), suggests that they may also have discussed this particular problem. As early as 1835, Henry Talbot apparently employed a small frame that sandwiched a botanical specimen between a sheet of glass and his light-sensitive paper. By March 1839 he was using, he tells us in his notebooks, an "air cushion, or bladder with a little air in it to keep the plants etc., tight against the glass: or India rubber in sheets."[34] In his January 1839 paper, "Some Account of the Art of Photogenic Drawing," Talbot mentions "flowers and leaves" as "the first kind of objects which I attempted to copy." Having studied botany since the age of twelve, he continued to use botanical specimens as a primary subject for his photogenic drawing experiments. He even imagined a book of photograms devoted exclusively to these sorts of images. On March 26, 1839, Talbot wrote a letter to fellow botanist William Hooker, suggesting they work together on a publication "on the plants of Britain, or any other plants, with photographic plates, 100 copies to be struck off, or whatever one may call it, taken off, the objects."[35] He enclosed a photograph with the letter, seemingly made along with some others in November 1838, "representing Camp. hederacea from bog on the summit of a mountain, Llantrissent Glamorgan."[36] Talbot presented another fifteen botanical photogenic drawings to the Italian botanist Antonio Bertoloni

between June 1839 and June 1840. These included at least one sample of seaweed (a stalk of Wrack). He also sent a negative version of a specimen of heliophilia. Interestingly, Talbot employed exactly the same specimen to make two further negatives, probably on the same day in the opening months of 1839.[37] With these various experiments and aspirations behind him, it seems unlikely that Talbot would not have had an intense interest in and practical suggestions for Atkins's 1843 project.

The particular example in the UNM exhibition repeats the major visual attributes of all the others Atkins made (a repetition that itself works to give the project some "scientific" credence). Notice how she has carefully centered the image on her page, leaving the plant form to float in an appropriately blue sea of cyan. This symmetry gives the image both a pleasing aesthetic order and the reasoned geometry of a scientific illustration. A desirably scientific character is enhanced by the addition of an appropriate Latin name, a photographic facsimile of Atkins's own handwriting, along the lower edge of each print.

What more could be said about these images? What further possible relation could they be said to have to the logic of electronic reproduction? Atkins herself described these images as "impressions of the plants themselves." She thus conjures up that direct indexical relationship between an object and its representation that is presumed to be photography's special privilege. As Allan Sekula puts it, photographs are "physical traces of their objects."[38] This raises the whole question of the relationship between photograph and object, and necessitates some investigation of "tracing" in general. Talbot tells us in 1839 that he showed a contact print of a piece of lace to some friends and asked them whether it was a good representation. The friends replied, he tells us with some pride, "that they were not to be so easily deceived, for that it was evidently no picture, but the piece of lace itself."[39] The philosophical dimensions of the blurring of this distinction must surely have occurred to Atkins as she or her servants laboriously made each of her own botanical contact prints.

To make a contact print or photogram, objects such as specimens of seaweed are placed directly on a material made sensitive to the difference between the presence and absence of light. Here object and image, reality and representation, come face to face, literally touching each other. Indeed the production of a photogram requires real and representation to begin as a single merged entity, as inseparable as a mirror and its image, as one and its other. These objects have to be removed before their photographic trace (the articulation of a differential

exposure to light) can be seen. By this means, photography allows botanical specimens to be present as image even when they are absent as objects. This continuous play between presence and absence provides, as Talbot put it, "evidence of a novel kind."[40] The photogram's persuasive power depends on precisely a lingering spectre of the total entity, a continual re-presentation of this coming together of image and object on the photographic paper. This is the prior moment, that something other than itself, to which the photogram must always defer in order to be itself.

The photogram (which Rosalind Krauss has argued "only forces, or makes explicit, what is the case of *all* photography") therefore could be said to mark what is set aside from itself.[41] It is a marker of the space between the object and its image, but also the temporal movement (the *spacing*) of this object's placement and setting aside—the very condition of the image's production. So we are actually talking about a surprisingly complicated maneuver here, one that simultaneously circumscribes and divides the identity summoned by the photogram. Sekula is obviously right to describe the essence of photography as "trace," for the word itself simultaneously designates both a mark and the act of marking, both a path and its traversal, both the original inscription and its copy, both that which is and that which is left behind, both a plan and its decipherment. To call photography a form of trace is therefore to recognize an activity that, as Derrida puts it, "produces what it forbids, making possible the very thing that it makes impossible."[42]

To reiterate, the photogram could be said to incorporate a kind of spacing that Derrida has described as "the impossibility for an identity to be closed in on itself, on the inside of its proper interiority, or on its coincidence with itself."[43] The contact print, then, like the digital image, represents a visible convolution of the binary relationship of absence/presence, nature/culture, real/representation, inside/outside, time/space, that seemingly constitutes the very possibility of photographing of any kind. So with Atkins's prints we witness not just the beginnings of photography but also that same collapse of oppositional terms (original/reproduction) that I have already identified with electronic reproduction. Moreover, this investigation of the photogram once again reveals not a simple correspondence of object and photograph, code and image, but what Derrida calls "an infinite chain, ineluctably multiplying the supplementary mediations that produce the sense of the very thing they defer: the image of the thing itself, of immediate presence, of originary perception."[44]

I have tried to show that the model adopted by UNM's exhibition, its presentation of photographic history as a "full circle" comprising a paradoxical play of continuities and differences, absences and presences, differences and deferrals, is repeated wherever one looks—in the work of Anna Atkins and in the logic of electronic reproduction, at the beginnings of photography and at its ends. In that context, I hope I have also been able to present a way of thinking photography that persuasively accords with the medium's own undeniable conceptual and historical complexity.

This essay is a revised version of "Manifest Data: The Image in the Age of Electronic Reproduction," *Art Monthly Australia,* no. 96 (December 1996), 4–6; "Manifest Data: The Image in the Age of Electronic Reproduction," *Afterimage* 24:3 (November–December 1996), 5–6; "Manifest Data: The Image in the Age of Electronic Reproduction" (translated into Russian by Gia Rigvava), *Moscow Art Magazine,* nos. 19–20 (February 1998), 83–85; "Photogenics," *History of Photography* 22:1 (Spring 1998), 18–26; "Photogenics," *Camera Austria* 62/63 (1998), 5–16.

```
+    +    +

+    +    +

+    8    +
```

OBEDIENT NUMBERS, SOFT DELIGHT

Numbers, high powers, and humble roots, give soft delight. Lo! The raptured arithmetician!
. . . To calculate, contents his livliest desires, and obedient numbers are within his reach.
—E. de Joncourt (1762), quoted by Charles Babbage, *Passages from the Life of a Philosopher*

Much has been made in recent years of the potential and actual impact of computing on the practice of photography. In most cases, critics have concentrated their anxieties on the computer's ability to manipulate and fabricate images that look like photographs and then disseminate them electronically to all corners of the globe.[1] The inference is that the widespread introduction of computing represents a turning point in photography's history—that computing may even spell photography's doom. But what if it can be shown that these two technologies actually share a common history and embody comparable logics? What if the cultural and social conditions that made photography conceivable were the same as those from which emerged computing? What, indeed, if the representational desires, and therefore the political challenges, of the computer are also those of the photograph?

It is not difficult to establish the chronological and personal links between the inventions of computing and photography. Historians like to trace the development of modern computing back to the pioneering efforts of English philosopher and mathematician Charles Babbage (1792–1871). Babbage conceived the first Analytical Engine or mechanical computer in 1833 (based on his 1822 Difference Engine). He was also a close confidant of Henry Talbot and John Herschel and a professional associate of Humphry Davy, Thomas Young, François Arago, and Jean Baptiste Biot, all closely involved with photography's invention or promotion. So close was he to Talbot that in February and May 1839, the English inventor of photography sent Babbage a copy of his privately printed *Some Account of the Art of Photogenic Drawing,* and then, as if to illustrate its arguments, eight examples of his prints. Babbage went on to display Talbot's photogenic drawings and calotypes at his famous London soirées ("for the decoration of my drawing room and the delight of my friends"), intellectual gatherings that Talbot and his family occasionally attended in person.[2] Between 1833 and 1842, among the other entertainments at such gatherings was a working model of a portion of Babbage's first computing machine, the Difference Engine. It seems likely, then, that visitors to Babbage's drawing room encountered photography and computing together, for the first time at the same time.

Given their close relationship, Talbot and Babbage would surely have discussed the Difference and Analytical Engines and their conceptual and mechanical complexities;[3] indeed, it appears that Babbage even invited Talbot, also an eminent mathematician, to contribute to the design of the later apparatus.[4] For his part, Babbage continued to take an active interest in photography; he arranged to have a group of Talbot's paper prints delivered to influential persons in Italy in 1841; he was the first person to sit for a stereoscopic portrait (taken by Henry Collen, probably in 1841, for Charles Wheatstone); he had several daguerreotype portraits of himself made by Antoine Claudet in about 1850 (with the two men also experimenting with photographs of specimens of colors on porcelain); he opened his 1864 autobiography with a wry quotation supposedly taken from the inside of an oyster and "deciphered by the aid of photography"; and, fittingly, the news of his death in 1871 was recorded in a staged tableau photographed by Oscar Rejlander.[5]

Among the photogenic drawings that Talbot sent Babbage in 1839 was a now-illegible image of the photographer's home inscribed on the back, "Lacock Abbey Self Represented in the Cam. Ob. May 1839." In his January paper, Talbot had described how he had made such pictures (or allowed nature to make them for him) from 1835 onward using a homemade camera obscura; "and this building I believe to be the first that was ever yet known *to have drawn its own picture*."[6] Both this statement and the inscription of May 1839 point to Talbot's own uncertainty about the identity of photography, more particularly about the source of its generative power. Was a photogenic drawing produced by the cultural merger of camera and chemistry, or was it a matter of nature spontaneously representing itself? In the example sent to Babbage, Talbot seems to be suggesting an answer, albeit a provisional one.

If so, then the example and inscription were chosen with care. For Babbage too had been exploring the relationship of culture and nature, most recently in his *Ninth Bridgwater Treatise* of May 1837. In this particular tract, Babbage attempted to reconcile creationist belief and evolutionary evidence by pointing to the creative, even miraculous, possibilities of God's "natural laws," an argument explicitly based on the algorithmic "feedback functions" calculated by his Difference Engine.[7] In other words, Babbage conceived of his computer as a cultural artifact that enabled nature (and therefore God) to represent itself in the form of

mathematical equations. No wonder he felt such "soft delight" at its faithful production of "obedient numbers."

No wonder, too, that American writer Nathaniel Willis referred his readers to the work of Babbage when announcing the discovery of photography in an essay published in *The Corsair* on April 13, 1839. Willis was anxious to make the point that existing art forms were under threat, given that "all nature shall paint herself—fields, rivers, trees, houses, plains, mountains, cities, shall all paint themselves at a bidding, and at a few moments notice. . . . Talk no more of 'holding the mirror up to nature'—she will hold it up to herself." Nature, it seems, had acquired the means to make its own pictographic notations. And Willis saw such an achievement as synonymous with the thinking of Babbage from two years before: "Mr Babbage in his (miscalled ninth Bridgwater) Treatise announces the astounding fact, as a very sublime truth, that every word uttered from the creation of the world has registered itself, and is still speaking, and will speak for ever in vibration. In fact, there is a great album of Babel. But what too, if the great business of the sun be to act register likewise, and to give impressions of our looks, and pictures of our actions . . . the whole universal nature being nothing more than phonetic and photogenic structures."[8] The conception of Babbage's calculating engines thus becomes not only a part of the history of computing but also of the disintegrating field of natural philosophy—and was therefore closely related as well to the photography, poetry, and painting produced in this same period.[9]

Talbot also sent Babbage some photogenic drawings of pieces of lace (photo 8.1). This was a common subject for Talbot, allowing him to demonstrate the exact, indexical copying of intricate details that photographic contact printing made possible. It also allowed him to demonstrate the strange implosion of representation and reality (again, culture and nature) that photography allowed. In the 1839 paper he had sent to Babbage, Talbot told the story of showing just such a photograph of lace to a group of friends and asking them whether it was a "good representation." They replied that they were not so easily fooled, for it "was evidently no picture, but the piece of lace itself."[10] As Root Cartwright has pointed out, contact printing was able to show the lace as a "true illusion" of white lines on burgundy-colored paper. It also meant that Talbot rendered the world in binary terms, as a patterned order of the absence and presence of light.[11] When Talbot included one of these lace negatives in his

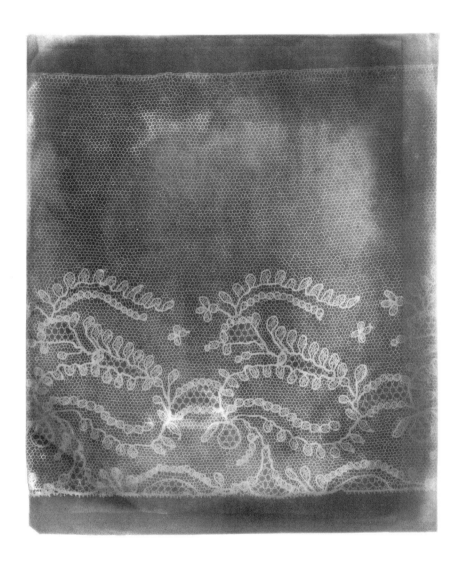

8.1

William Henry Fox Talbot, Lace, *1839*
Photogenic drawing negative
Courtesy of Hans P. Kraus, Jr. Fine Photographs, New York

1844 *The Pencil of Nature,* his accompanying text carefully explained the difference between a contact print ("directly taken from the lace itself") and the positive copies that could be taken from this first print (in which case "the lace would be represented *black* upon a *white* ground"). However, he suggested, a negative image of lace was perfectly acceptable, "black lace being as familiar to the eye as white lace, and the object being only to exhibit the pattern with accuracy."[12] So this is a photograph not so much of lace as of its patterning, of its regular repetitions of smaller units in order to make up a whole.

Babbage too might have been impressed by the photograph's ability to represent accurately the geometric patterns of lacework, for here was mathematics made visible. In one example made in 1839 and given to John Herschel, Talbot even made a photogenic drawing negative of a piece of lace magnified one hundred times, revealing its regular pixelated structure. He had also applied magnification to his earliest extant negative of the inside of a latticed window at Lacock Abbey, telling us in an added inscription that "when first made, the squares of glass about 200 in number could be counted, with help of a lens." He thereby turned this image into a matter of arithmetic, measuring photography's success according to its ability to aid calculation. Talbot's photographs of lace were often produced using the same specimen, as if to show that his medium was capable of a repeatable, even mechanical reproduction of a given set of visual data.[13] And as Douglas Nickel has suggested, "behind Talbot's presentation of lace images lay the development of the machine-made lace industry in England."[14] In 1837, so-called Jacquard cards had been introduced into English lace-making machines for the first time, signaling the relegation of handmade lace to the luxury market.[15] Babbage himself owned a mechanically woven silk portrait of Joseph Marie Jacquard, the Frenchman who in 1804 had completed the building of a loom directed by a train of punched cards.[16] This particular portrait had required twenty-four thousand of these cards for its manufacture, producing a pixelated weave so fine that some observers at first mistook it for an engraving or lithograph. And like a photograph, this image was also an index—not of Jacquard himself but of the equally natural "mathematical" code regulated by his cards.

When Babbage wrote the history of his own thinking about computing, he specifically referred to the development of this loom. In effect, it replaced the creative decisions of the weaver with those of a predetermined code system—a program. In Jacquard's apparatus, the

body of the user was incorporated as a mere prosthesis to a machine; more than that, the human subject became but one part of an assemblage over which it had no more than supervisory control. By early 1836 Babbage had adopted Jacquard's system of cards into his plans for the Analytical Engine, a machine designed to replace the imperfections of earlier French and English efforts that had prepared mathematical tables by means of tiers of human calculators or "computers." The French version of this project, the *Tables du Cadastre,* was set up in the 1790s under the supervision of Baron Gaspard de Prony to formulate accurate ordinance tables. The Frenchman's sixty or eighty human computers were headed by a handful of professional mathematicians who directed their efforts, with the whole system organized according to the clear divisions of labor proposed by Adam Smith in 1776. Employing out-of-work hairdressers with little mathematical skill as his computers, de Prony used the so-called method of differences to make each calculation a relatively simple matter of addition or subtraction.

Babbage's innovation was to imagine replacing these human computers with an ordered conglomeration of gears, wheels, and punched cards. His Analytical Engine continued to rely on a play of numerical differences, with its mechanics organized around a store, or memory, and a mill, or central processing unit, much like a contemporary computer. In essence Babbage sought to design a steam-driven mechanism that worked autonomously from its human operator; it could issue instructions and aural admonitions to its operator and would even automatically print its results. Moreover, by feeding on the outcomes of its own computations ("moving forward by eating its own tail," as Babbage put it), this machine could replicate the very thinking process that was supposed to direct it.[17] "I concluded . . . that nothing but teaching the Engine to foresee and then to act upon that foresight could ever lead me to the object that I desired. . . . The Analytical Engine is therefore a machine of the most general nature. . . . I am myself astonished at the power that I have been able to give to the machine. . . . It appears that the whole of the conditions which enable a *finite* machine to make calculations of *unlimited* extent are fulfilled in the Analytical Engine. . . . I have converted the infinity of space, which was required by the conditions of the problem, into the infinity of time."[18]

Babbage also seems to have had similar thoughts about the earlier Difference Engine. Lady Byron, mother of Ada Lovelace (later to be Babbage's interpreter), repeated these

thoughts in a letter from June 21, 1833, describing their first viewing of the Difference Engine (photo 8.2):

We both went to see the thinking *machine (for so it seems) last Monday. . . . Babbage said it had given him notions with respect to general laws which were never before presented to his mind—For instance, the Machine could go on counting regularly, 1, 2, 3, 4 etc.—to 10,000—and then pursue its calculation according to a new ratio. . . . He said, indeed, that the exceptions which took place in the operation of his Machine, & which could not be accounted for by any errors or derangement of structure, would follow a greater number of uniform experiences than the world has known of days & nights.—There was a sublimity in the views thus opened of the ultimate results of intellectual power.*[19]

In short, each of Babbage's calculating machines was proof incarnate of the possibility of miracles and therefore a confirmation of the existence of a still-active and present God; this was the sublimity, the "ultimate results of intellectual power," to which Lady Byron referred.[20] All this because the computer was not just an instrument that could be used to calculate algorithmic equations; it was itself an algorithm.

At the time he began working on his computing machines, Babbage was also calculating a set of "life tables" for the Protector Life Assurance Company of London. Interestingly, the only working example of a Difference Engine, produced by Swedish printers Georg and Edvard Sheutz between 1843 and 1853, was also employed to calculate tables for William Farr's definitive 1864 publication, *English Life Table*.[21] From the beginning, then, we find the history of computing associated with the transformation of human beings into data—in this case, digitized for the purpose of making predictive judgments that fix them in space and time (that *photograph* them).[22] In Babbage's conception of the computer, the user becomes simultaneously the subject and the object of the apparatus. Indeed, the apparatus itself collapses the boundaries of subject and object altogether; it is *this* power above all else—this ability to undermine the comfortable Cartesian dualities of the previous century—that so astonished its maker.

I have written elsewhere about the way photography embodies a similar collapse, in the process linking its conception with the paradoxical play of disciplinary power that Michel

8.2

Charles Babbage, Difference Engine No. 1: Portion, *1832*
Bronze, steel, cast iron
Science Museum, London

Foucault has associated with panopticism.[23] Conceived by Jeremy Bentham in 1791, the panopticon is, for Foucault, the exemplary technological metaphor for the operations of modern systems of power. Continually projecting himself into a space between tower and cell, the panoptic subject becomes both the prisoner and the one who imprisons, both the subject and the object of his own gaze. As Foucault says, "He inscribes in himself the power relations in which he simultaneously plays both roles; he becomes the principal of his own subjection. . . . [Prisoners] are not only [panopticism's] inert or consenting target; they are always also the elements of its articulation."[24] As an effect of and vehicle for the exercise of power/knowledge, the modern person is, in other words, a being produced within the interstices of a continual negotiation of virtual and real. Thus, for Foucault, panopticism is not just an efficient piece of prison design but also "the diagram of a mechanism of power reduced to its ideal form."[25]

The same might be said for computing.[26] And this, of course, is the point. The history I have been recounting, and the economy of power that it represents, is not only something that lies outside the computer. It is not just something that is conveyed, created, or reconstructed by the computer's compliant circuitry. For the computer is itself the material expression of a certain history, the mechanical and electronic manifestation of a conceptual armature that insistently reproduces itself every time we depress a key and direct a flow of digital data. This history does not end with the conceptions of Babbage. The modern electronic computer is structured according to the algebraic logic of George Boole, another mid-nineteenth-century English mathematician. As its title suggests, Boole's 1854 treatise, *An Investigation of the Laws of Thought,* sought to give mathematical expression to the processes of reasoning in order to then present "some probable intimations concerning the nature and constitution of the human mind."[27] According to the version of binary calculation that Boole proposed, the number one stands for things and zero for the absence of things. This differential registration of ones and zeros, in the form of the perceived presence and absence of an electrical current, remains at the heart of computer culture, together with the three basic operations that Boole outlined: And, Or, and Not.[28] These elements and their operations constitute the very grain of computing's being. It is also, according to Jacques Derrida, at the heart of Western metaphysics as a whole, providing the philosophical infrastructure for all our thinking and actions, including the systematic inequities of both phallo- and

ethnocentrism. But if the logic of computing is omnipresent, it is not necessarily omnipotent. As Derrida has repeatedly shown, any privileging of one over its other is inevitably fractured by internal contradictions that are always already at work within the logic itself.[29] It would seem, then, that the critical art of our time is going to have to take on an infrastructure that is as much philosophical as it is mathematical.

The history embodied in and automatically reproduced by digital culture is obviously an inescapably *political* one. If we are to engage and disrupt this history, then we need not only to use computing to invent new visual forms and narratives but also to recognize and exacerbate those unstable "simultaneities" that constitute computing's own historical identity, those thaumatropic moments where its binary logic does not quite add up, where its method of differences is found to be differing from itself.

This has been only the briefest of historical sketches, but it suggests that computing's future, like photography's, is already inscribed in its past. What is demanded from us is a new perception of the relationship between these three moments (past, present, future)—a new perception of history itself. As Charles Babbage reminds us; "An object is frequently not seen, *from not knowing how to see it,* rather than from any defect in the organ of vision."[30]

This essay is a revised version of "Obedient Numbers, Soft Delight," *Creative Camera,* no. 352 (June–July 1998), 14–19.

+ + +

+ + +

+ + 9

DA[R]TA

A photograph is a universe of dots. The grain, the halide, the little silver things clumped in the emulsion. Once you get inside a dot, you gain access to hidden information, you slide inside the smallest event.

This is what technology does. It peels back the shadows and redeems the dazed and rambling past. It makes reality come true.

—Don DeLillo, *Underworld* (1997)

Fictional nostalgia aside, today's photographic universe is found not in clumps of silver but in the algorithms racing across the surface of German artist Andreas Müller-Pohle's 1995 *Digital Scores* (*after Nicéphore Niépce*) (photo 9.1).[1] No dots. No silver. No emulsion. No hidden information. In fact, nothing but information. The digital code generated by Nicéphore Niépce's 1827 heliograph *View from the Window at Le Gras* (or at least by the watercolor reproduction of it found in Helmut Gernsheim's 1983 *Geschichte der Photographie*) has been spread across eight panels as a messy swarm of numbers and computer notations.[2] Each of these separations represents an eighth of a full byte of memory, a computer's divided remembrance of Gernsheim's own painted memorial to the first photograph. Already a copy of a copy, the *Scores* are less about Niépce's photograph than about their own means of production (they bear the same abstracted relation to an image as sheet music has to sound). We see not a photograph, but the new numerical rhetoric of photography. In this sense, the Niépce image is but a convenient historical staging point for a certain unsentimental reflection on photography in general; the beginning is brought back only to signal its end. In particular, the hand of the artist, restored so forcefully by Gernsheim, has been decisively displaced in favor of the aesthetic decisions of a machine. This work's dense patterns of typographical interference are entirely dependent on Müller-Pohle's choice of fonts, resolution, file format, printing size, or program. The resulting images are therefore unpredictably different in every manifestation, a product of orchestrated randomness and electronic cross-fertilization. Periodically the image notations even spill off the edges of their rectangular frames, like the restless static of a television screen. Dissected under Müller-Pohle's digital electron microscope, photography reveals itself as a dynamic field of particles eight layers thick, momentarily frozen here only for the purposes of gallery presentation.

9.1

Andreas Müller-Pohl, Digital Scores I (after Nicéphore Niépce), *1995*
Iris Giclée print on Aquarelle Arches paper
Courtesy of the artist

Digital Scores is one more reminder that photography is no longer (if it ever was) a matter of inert, two-dimensional imprints of a reality outside itself. Since at least 1989 and the introduction of Adobe Photoshop into the marketplace, photography has been, in the words of French philosopher Jean-François Lyotard, an *immatériel* ("the principle on which the operational structure is based is not that of a stable 'substance', but that of an unstable ensemble of interactions . . . the model of language").[3] Certainly the identity of a photographic image no longer has to do with its support or its chemical composition, or with its authorship, place of origin, or pictorial appearance. It instead comprises, as Müller-Pohle suggests, a pliable sequence of digital data and electronic impulses. It is their configuration that now decides an image's look and significance, even the possibility of its continued existence. In other words, "photography" today is all about the reproduction and consumption, flow and exchange, maintenance and disruption, of data.

In this sense, photography has become one small part of the voracious data economy that characterizes contemporary capitalist life in general. It thereby joins the Human Genome Project (which assumes the human body to be no more than so much organic data), Corbis Corporation (which sells images in the form of infinitely reproducible digital files), the Archer Daniels Midland Company (which provides farmers with information derived from the Pentagon's Global Positioning System of satellites), the music industry (which has sold six billion CDs of digital sound since 1982), the stock market (which lives and dies according to the exchange of electronic money), EarthWatch (a company that sells customers images of anywhere on earth beamed down from its orbiting spy satellites), and the CIA (which calls the electron "the ultimate precision-guided weapon" and worries about the vulnerability of the United States to data-oriented warfare) in seeing the world in terms of the manipulation and exploitation of data.[4] If it wants to be relevant to contemporary social life, it is within and across this stream of data that artwork must henceforth be undertaken. For it is here, here within the very grain of being, that political and cultural action of every kind must now locate itself. This essay is about the possibility of this kind of action, about a type of data-art (or *da[r]ta*) that takes the electronic universe to be its given medium as well as its subject.

It should be conceded from the outset that *da[r]ta* is an attitude rather than a specific practice, and as such is not a new phenomenon. Müller-Pohle's work, for example, is reminiscent not just of Niépce's own conception of photography as a reproduction process but

also of the conceptual art strategies of the 1960s.[5] Australian artist Ian Burn's *Xerox Book No. 1* (1968) is an interesting precedent. The work, produced in a series of twelve, consists of 103 pages of photocopied paper, fronted by a precise description of their mode of production. The first of these sheets is blank. The next is a photocopy of this sheet, followed by a photocopy of the photocopy, and so on for another 100 pages until the final page is an accumulation of black dots—the "visual noise" of the Xerox 660 machine's imperfect copying processes. As in Müller-Pohle's concession to the authorial patterns of digital code, Burn's *Xerox Book* presents the photocopying process itself as an aesthetic object.

Given that this process is not very interesting to look at in itself, one is left to consider the artist's attitude toward it, his manner of thinking, his decision to allow a machine to replace his creative role with an arbitrary accumulation of information (once again, in order to facilitate a certain prescribed randomness).[6] Such efforts, feeding off minimalism's explorations of visual perception, also involve a reflection on the language of art. As Burn (then a member of the Art & Language collective) put it in an essay published in 1970, "Conceptual Art shifts the focus from what is said through the language to an investigation of the language itself. . . . The use of words is itself of no importance. What is important is the information carried by the words."[7] It quickly becomes clear that the conveyance of information is never an innocent activity, involving in the case of the art world a complex economy of value judgments involving not only the artist but also the critic, the museum, the market, the gallery, and the art historian. Like a lot of conceptual artists, Burn went on to make this art world structure, and the power it exercises, the primary "object" of his critical practice.[8] By undermining the author function and its humanist assumptions, so important to art world evaluations, *Xerox Book No. 1* was an early step in that direction.

Also important was its stress on the collection and presentation of information as an aesthetic and critical strategy. This was again a common theme for conceptual art. Hans Haacke's *Shapolsky et al. Manhattan Real Estate Holdings, a Real-Time Social System, as of May 1, 1971,* consisted of two maps and 142 silver gelatin photographs accompanied by typewritten data sheets full of information about the properties owned or controlled by this particular company. Although, as Haacke pointed out at the time, the sheets and photographs "contain no evaluative comment," the Guggenheim Museum's director, Thomas Messer, cancelled a planned exhibition of the piece, thus initiating a debate not only on censorship

but also on the politics of information (and this despite Haacke's insistence again that his pieces of this kind did not advocate any political cause).[9] The Internet makes such debates all the more urgent. In 1996 Aaron Nabil obtained a database from the Oregon Department of Motor Vehicles that matched any Oregon license plate to the name of its owner. He then put this on a searchable Web site so that anyone could access this information. Such information (plus the owner's address and vehicle identification number) was in fact already available to any citizen willing to pay the DMV a four-dollar fee. However, its availability on the Web, and thus its transformation into a flow of electronic data accessible anywhere and anytime, sparked a public outcry. Soon after, Nabil closed down his site. As in Haacke's case, what was at issue was not the accuracy or legal standing of the information but rather the ease and setting of its availability. In Nabil's own words, "The 'art' involved was the confluence of the data and delivery, not the Web page design."[10]

There is, of course, a lot of art being made for and on the Web. The most interesting examples include some reflection on the implications of this particular form of data flow. Take, for example, Canadian multimedia artist Vera Frenkel's electronic Web site *Body Missing* (http://www.yorku.ca/BodyMissing). Between 1939 and his suicide in 1945, Adolf Hitler gathered (through a combination of purchases, confiscations, and lootings from conquered territories) a great collection of European art, all of it destined for a museum to be built in his boyhood home town of Linz.[11] During this same period, he reportedly ordered photographic reproductions to be made of all of Germany's historically important paintings, in case the originals were destroyed by Allied bombing.[12] The schizophrenic identity of the contemporary archive is surely to be found in the space demarcated by these two obsessive acts of storage. Here, too, in Hitler's own anxious turning between original and copy, presence and loss, public and private, history and memory, can we find a prophecy of the major themes of *Body Missing,* and of the Web in general.

The site is structured around a fictional transit bar. This conceit allows Frenkel to weave a complex series of narratives around her work's central trope: personal and historical memories of the artworks that went missing from Hitler's collection in Linz at the conclusion of the war. These works had been stored in salt mines on the outskirts of town, but a number of them have never been recovered. As well as presenting historical background and the words and voices of various visitors to her bar, Frenkel has invited an international group

of artists to add their own pages to her site, inducing a range of creative speculations on the lost corpus. By clicking on word and image links (these are underlined or outlined in color), visitors can share these speculations and, if so inclined, imagine some of their own. Artists Alice Mansell and Mickey Meads, for example, contribute three interrelated stories about a missing painting by Courbet, a scene of lesbian concourse titled either *Venus and Psyche* or *The Awakening*. These stories—part informational, part poetic—comprise a commentary by these artists on both the lost painting and their own interests in it. Other contributors devise images or visual proposals in response to pictures presumed destroyed, thereby enacting a familiar process of substitution for loss.

Here then are the basic components of Frenkel's Web site: an apparently free-hand sketch functioning as a site map, stories of transience and displacement (as Frenkel warns us, "The story is always partial"), historical pictures of Hitler's underground archive, contemporary images and texts inspired by the absent works, and, on every page, designated links leading to all other parts of the site. The combination of these disparate elements—in particular the dissolution of any boundaries between fact and fiction, original and simulation, fixity and movement—already constitutes a sharp commentary on the peculiar character of the electronic archive. But Frenkel's chosen mode of representation, the Internet, is perhaps our most challenging introduction to the new art of archiving. In asking us to "enter" and traverse her Web site, Frenkel embroils us in a technology that itself reproduces the intricacies of the commemorative process.

This process is compellingly described in Jacques Derrida's analysis of Freud's own account of memory.[13] As Derrida points out, Freud finds himself positing memory as an impossible perceptual apparatus in which the blank receptive surface is always already a web of inscriptions, such that this surface also comprises an infinite depth. Frenkel's Web site also approaches this state of being, featuring an endless return to a beginning that is itself no more than a transit lounge leading to yet further returns and further beginnings. At each pause on our journey, we are confronted with a flat but shimmering surface of texts and images comprising nothing but organized numbers—a pixelated series of reproductions in most cases based on imagined originals. These apparitions unfurl down our screen like a Japanese painting, revealing themselves only by slowly erasing the remnants of a previous image. Each activation of an on-screen link takes us to another surface that could be either before or below

the one we have just looked at—below or before but also somehow within, as complex a convolution of space as the temporal interaction of past, present, and future that Frenkel orchestrates in her general narrative structure. What we never get to in all this is a foundational moment—that trace of authenticity that archives are meant to identify, collect, and protect. Could it be that the archive itself, at least in its traditional form, is yet one more of Frenkel's missing bodies?

The world is, of course, full of grandiose buildings designed to store and display collections of objects. Driven by combinations of personal and national ambition, these depositories aim to bring together the significant artifacts of a given culture in a single, stable place. Indeed, these archives often have the stabilization of place—the definition of national identity through the constant recall of a supposedly collective memory—as their primary goal. In Hitler's case, the order to locate a grand archive of art at Linz sought to inscribe one historical origin (his own) within and before another (the emergence of European visual culture).[14] Interesting then that he would simultaneously displace the possibility of any origin whatsoever through the making of a comprehensive set of reproductions of this same culture. This second archival gesture requires a continuous process of dissemination rather than a fixed depository. As reproduction, Germany's art could be seen anyplace and anytime, which also meant that it rested nowhere in particular. It thereby escaped potential destruction, but also shed an important aspect of its Germanness (it could be accessed in London or Sydney as easily as it could in Linz). As Frenkel's Web site reiterates, reproducing things ensures they will not be forgotten, even as the act of reproduction dissipates the specificity on which all memory is based.

This is a dilemma facing archival imperatives in our own electronic age. With all information—no matter what its original form—now able to be stored and transmitted as data, the nature of the archive has also been transformed. The archive is no longer a matter of discrete objects (files, books, art works, etc.) stored and retrieved in specific places (libraries, museums, etc.). Now it is also a continuous stream of data, without geography or container, continuously transmitted and therefore without temporal restriction (always available in the here and now). Exchange rather than storage has become the archivist's principal function, a shift in orientation that is evidenced in the flurry of networked projects that are underway all around the world. The British Electronic Libraries Programme, for

example, is a three-year, 15-million-pound initiative involving some sixty projects (including several to do with artistic material) concerned with the digitization, accessing, and delivery of electronic information. The G-7 nations (the United States, Canada, Britain, France, Germany, Italy, and Japan) have launched eleven pilot projects along the same lines, ranging in focus from maritime information systems to global health care applications. In the United States, the National Digital Library Program, a five-year $60-million project announced by the Library of Congress in 1994, aims to digitize a core of selected primary materials on the theme of American memory. The aim in each of these examples is to make archival material seamlessly interconnected and instantly accessible, regardless of where either the user or the archive is located in real space (a conceptual category that is henceforth considerably diminished in archival thinking).[15] This eradication of space-time restrictions even allows the virtual reconstitution of certain cultural legacies dispersed by war, colonial conquest, or capitalist acquisition. Here we have one of the many ironies of electronic reproduction: the same process that erases national boundaries can also be used to resurrect them.

Frenkel's *Body Missing* is at one level simply an electronic archive of stories and images about Hitler's own earlier archive in Linz. But this work is, as we have seen, also *about* the peculiar character of the contemporary art of archiving. By highlighting the subjective and imaginative aspects of both producing and accessing memory, Frenkel's Web site appears to be less concerned with finding a missing body than with continually posing the question of identity (of the individual, of history, of the archive, of data) in general.

The electronic universe is not confined to newly fashionable media like the Internet. Television for some decades has involved the continuous broadcast of electronic signals to private receivers placed in the home, a relationship now so pervasive that it constitutes a public exhibition space much envied by artists (98 percent of American homes have at least one television set). Indeed, artists often lament the power of network television even as they pine to get on the airwaves they radiate, the aim being to replace its content with more independent programming. But this is easier said than done. In a 1993 pamphlet titled *Culture Jamming,* cybercritic Mark Dery traces various examples of what he calls (borrowing the words of Umberto Eco) "semiological guerrilla warfare" that he argues artists and activists

have waged for some time within the universe of technological communication. Bent on restoring "a critical dimension to passive reception," his essay seeks to identify and link the practices of artist hackers, slashers, and snipers—culture jammers all—"in pursuit of new myths stitched from the material of their own lives, a fabric of experiences and aspirations where neither the depressive stories of an apolitical intelligentsia nor the repressive fictions of corporate media's Magic Kingdom obtain." He mentions in particular the "media hoaxing" practice of Joey Skaggs, who since 1966 has been planting invented inflammatory stories in the news media in order to reveal the extent to which the press "seems to have forgotten the difference between the public good and the bottom line, between the responsibility to enlighten and the desire to entertain."[16]

A more recent example of such a practice, coordinated by an otherwise anonymous collective called the Barbie Liberation Organization, underlines both its strengths and its weaknesses as a form of *da[r]ta*. During 1993, an indeterminate number (some reports mentioned "hundreds") of Teen Talk Barbie and Talking Duke G.I. Joe dolls had their voice boxes swapped by a group of "concerned parents and citizens" so that each ended up speaking the other's clichés (her: "Dead Men Tell No Tales"; him: "Let's Go Shopping"). These altered toys were then placed back in stores ("reverse shoplifting," as the BLO's press release put it) to be bought by unsuspecting children and their parents. Their calls to local media outlets became in effect a protest against the sexist stereotyping reproduced by such dolls. This, at least, was the story run by the American media (and also picked up by radio stations in Canada, Australia, and Brazil). Most of the national television news programs ran stories on the protest; it even inspired a couple of scenes in an episode of *The Simpsons*![17] But the real story has less to do with a questioning of sexism than with the insatiable appetite of the electronic media for "content" of whatever kind. For the BLO was in fact a loose alliance of a few people coordinated by a graduate student named Igor Vamos. Only a dozen or so dolls were actually altered, and most of the contacts between buyers and the media were cleverly orchestrated by Vamos and his friends during a cross-country trip or by phone in the graduate lounge of his art school.

The question is, What effect does such an intervention generate? Some momentary, inevitably superficial commentary on sexist toys made its way onto the national airwaves,

soon to be replaced by equally inane information on other topics. But surely the project's more significant achievement was to point to the opportunities available to other ambitious activists and artists who want to intervene creatively within our culture's ceaseless flow of electronic information.[18]

Such interventions demand some critical engagement with the nature of this flow, with this flow itself as a new form of nature. In his 1996 book *Mediauras,* Samuel Weber sets out to articulate what he calls the "differential specificity" of television. This, he is anxious to assure us, is not the same as seeking its "universal essence," but rather represents an attempt to determine the differences between television and other media such as film, and to acknowledge what an "extremely complex and variegated phenomenon" TV is. He sets out on this mission by first identifying "three distinct, albeit closely interrelated, operations" that he argues are necessary to television: production, transmission, and reception.[19] He therefore begins his analysis, as do most commentators on TV, by positing a tripartite communication model (encoder-message-decoder) that works to divide television's form from its content. The assumption is that television operates like a cable system, a direct and unimpeded flow of programmed images from corporate studio to domestic monitor. But such an assumption immediately limits one's thinking. As Jean Baudrillard has argued, "By trying to preserve . . . *any separated instances of the structural communication grid,* one obviates the possibility of fundamental change, and condemns oneself to fragile manipulatory practices that would be dangerous to adopt as a 'revolutionary strategy.'"[20]

But what happens if we conceive TV a little differently—not as a signal between two points but as an indiscriminate and all-encompassing atmosphere of electronic data, a field of impulses that continually surrounds and traverses us whether a monitor is present or not? The creative work of a pair of Australian operatives, Grieg Pickhaver and John Doyle, begins by collapsing any distinction between radio and television; as fields of data, both are simply out there, ripe for the plundering. Performing as H. G. Nelson and Rampaging Roy Slaven, the two have over several years built up a dedicated national audience for their radio program, *This Sporting Life,* broadcast on government-run station 2JJJ-FM. Running for four hours every Saturday, the satirical program comprises Nelson and Slaven, claiming to be ex-sporting greats turned expert commentators, giving a hilariously scurrilous account of Australian life, past and present. As soon becomes clear to their listeners, sport in Australia has

no boundaries, encompassing everything from politics to art to public morality. The program's humor can only be described as Hogarthian, involving a level of sexual innuendo and near-libelous commentary that simply would not be possible in the United States. Roy and H. G. (the two have become such nationally recognized figures that many real sportspeople claim them as close friends, thus becoming part of the duo's ongoing joke about the dubious authenticity of media personalities) have even run all-night programs covering the counting of the federal election results, a contest open to all sorts of sporting analogies and pertinent slander.

Their most audacious intervention within Australian culture involves a truly sacred event, the annual television broadcast of the Rugby League Grand Final. This day-long extravaganza, renamed the Festival of the Boot by Roy and H. G., features performances not only by a series of football teams but also by such died-in-the-wool Rugby League fanatics as Tina Turner. The one problem Roy and H. G. have to contend with is that Australian sport is already full of provincial self-parody. Undaunted, the duo instructs its listening audience to turn on their television sets but keep the sound off. They then offer a running commentary over the top of the TV broadcast, incorporating everything into their aural satire from the national anthem played at the opening ceremonies (which they replace with an Aboriginal pop song from the 1970s) to the aimless camera pans over the crowd. The result is an extraordinary phantasmagoria of images and sound during which the very form of broadcast television is held up to ridicule and critique. More than that, *This Sporting Life* treats television transmissions as a public sandbox—a bountiful "natural" resource just waiting to be co-opted, reshaped, and transformed.

This is an attitude shared by a number of contemporary artists, for whom television has always been a given, just another part of the infrastructure of modern life. San Diego–based artist Sheldon Brown has for some time been developing a public installation he calls the *Video Wind Chimes,* most recently seen in San Francisco in 1994 (photo 9.2). The piece consists of a sequence of video projectors, metal halide light sources, and projection lenses, all mounted inside fibreglass winged housings. These housings hang from lampposts by means of universal ball joints. Connected to these joints are a set of potentiometers that transform any movement of the joint into different television tuning frequencies. The lens projects a focused television image onto the ground beneath it, displaying that part of

9.2

Sheldon Brown, Video Wind Chimes *(detail), 1994*
Video installation
Courtesy of the artist

the broadcasting spectrum that the wind has currently tuned. Nature gets to zap itself, arbitrarily changing channels according to the vagaries of a prevailing wind pattern. Standing underneath, our bodies are bathed in the pixelated cathode glow of the televisual, and we become television's monitor (Müller-Pohl's data flow in embodied form). As the video windvane sways or turns in the air, the projected signal—actually a combination of sound and image—oscillates between static and coherence. On a windy day, this oscillation is a constant dynamic such that no one frequency remains stable for more than a second or so. The result is a constantly shifting cacophony of telebabble. One does not so much watch an individual channel or program as look at "television" as a total phenomenon. And one looks at this phenomenon, not in terms of the smooth flow of its content, but as an omnipresent electromagnetic spectrum.

In this sense, Brown's project looks back to the pioneering art video of Nam June Paik in the early 1960s. In *Magnet TV* (1965), for example, Paik moved a large magnet over the exterior of a television set, creating abstracting distortions in the regular broadcast signals seen on the monitor. Television was revealed as patterns of light induced from electronic signals. More important, an apparently omnipotent form of corporate culture was transformed into a creative medium. The *Video Wind Chimes* also recalls some earlier cyberart experiments. In its unpredictable play of "organic" chance operations (the wind) and predetermined patterns of information (broadcast television), it returns to a theme already broached in Nicholas Negroponte's notorious 1970 work *Seek*. In this installation, Negroponte placed a group of gerbils in a glass case filled with two-inch aluminum cubes and then had a computer-controlled machine installed overhead that was programmed to move the cubes into predetermined alignments responsive to changes in the existing environment. The social needs of the gerbils, resulting in the constant moving of the cubes, were juxtaposed with the determination of the machine to bring its environment to order; two bodies of information were shown continually adjusting to each other (although not for long; most of the gerbils died).[21]

By linking the wind to the electromagnetic spectrum, the *Video Wind Chimes* erodes any simple division between nature and culture. What it brings to our attention in place of this division is a new kind of weather pattern—a permanent electronic atmosphere whose consequences we have barely begun to comprehend. Another contributor to this atmosphere is the stream of data being beamed over the surface of the planet by the myriad of satellites

that now orbit 20,000 kilometers overhead. We are all being soaked in that stream right now. Take the Global Positioning System (GPS) for instance. Launched and operated by the Pentagon, it consists of twenty-four satellites constantly emitting electromagnetic signals and five ground stations on earth designed to receive and decode them. Someone carrying the right kind of portable receiver can link up with satellites and ground stations to calculate their exact position (to within a centimeter in ideal circumstances) anywhere, anytime, and in any weather. The potential military applications are obvious. But this technology is also being harnessed by agriculture conglomerates and transport companies alike to tell their customers precisely where they are—where they are, that is, within the network of data that now constitutes any location whatsoever.

New York–based architect Laura Kurgan has produced two related installations (*You Are Here: Information Drift* at the Storefront for Art and Architecture, New York, 1994, and *You Are Here: Museu* at the Museu d'Art Contemporani de Barcelona, November 1995) that set out to explore this emerging space of information. In both cases, Kurgan chose to use existing GPS technologies as her stylus, thus allowing her literally to draw with satellites. In the case of the Barcelona project, she installed a real-time feed of GPS satellite positioning data, from an antenna located on the roof of the museum, and displayed it, together with earlier records of mapping data, in light boxes and on the walls and floors of the gallery. Some of these "maps" spelled out the word *museu,* as paced out by Kurgan holding a portable receiver. She teaches GPS to speak Catalan but also to reveal itself as an archive (as a gathering and classification of information). At the same time these drawings are of herself—of herself as spatial and temporal data, as *da[r]ta.* However, she admits, the drawings were produced "not to pinpoint a location but to experience the drift and disorientation at work in any map or any architecture—especially the architecture of information."[22] Given the diffusions built into the system by its military overseers (to deny its full capacities to all but its own operatives), GPS inscribes Kurgan's position as a multitude of approximations within its database. Her drawings therefore comprise a series of corrected and averaged points that trace her interaction with (outer) space. "The GPS information refers to but does not simply represent the space it maps: it exceeds, transforms, and reorganizes this space into another space. Not a representation of space, but a space itself. Or rather, spacing itself, passage and inscription, light and motion, transmission and interface."[23]

What is interesting about all this work is that it refuses to accept the holiness of the operational structure that Weber has posited as the essence of the televisual. Each of these projects disrupts the smooth flow of his communication model by reconceiving television and similar systems as random fields of electronic data directed at no one in particular. Having inscribed itself within this convenient host, *da[r]ta* industriously refigures the electromagnetic spectrum to its own perverse ends, faithfully repeating that spectrum's form but always with a difference. Drawing sustenance from the very thing it disorders, it cannot be killed off without that host also being condemned to death. In short, *da[r]ta* is the name we might give to a new kind of parasite, an info-virus capable of creatively infecting the artificial nature that now immerses ourselves and our planet.[24] Neither organic nor inorganic, neither nature nor culture, neither representation nor real, neither message nor code—neither nor, that is, simultaneously either or—*da[r]ta* enjoys a disturbingly undecidable viral existence. But most important, *da[r]ta* testifies that everything—even a data field as powerful as television—can be infiltrated, occupied, and, at least for a moment, made not to look itself.

This essay incorporates revised versions of "Da[r]ta," *Afterimage* 24:6 (May 1997), 5–6; "Da[r]ta," *Photofile* 50 (May 1997), 42–45; "Die Kunst des Archivierens," in Ingrid Schaffner and Matthias Winzen, eds., *Deep Storage/Arsenale der Erinnerung,* exhibition catalogue (Siemens Kulturprogramm; Munich: Haus der Kunst, July 1997), 46–49; "The Art of Archiving," in Ingrid Schaffner and Matthias Winzen, eds., *Deep Storage: Collecting, Storing, and Archiving in Art,* exhibition catalogue (Siemens Kulturprogramm; New York: P.S.1 Contemporary Art Center, 1998), 46–49.

NOTES

1

1. Lewis Carroll, *Alice in Wonderland*, ed. Donald Gray (New York: Norton, 1971), 94.

2. Derrida describes the situation as far as writing is concerned as follows: "The grammatologist least of all can avoid questioning himself about the essence of his object in the form of a question of origin: 'What is writing?' means 'where and when does writing begin?' The responses generally come very quickly. They circulate within concepts that are seldom criticized and move within evidence which always seems self-evident. It is around these responses that a typology of and a perspective on the growth of writing are always organized. All works dealing with the history of writing are composed along the same lines: a philosophical and teleological classification exhausts the critical problems in a few pages; one passes next to an exposition of facts. We have a contrast between the theoretical fragility of the reconstructions and the historical, archeological, ethnological, philosophical wealth of information." See Jacques Derrida, *Of Grammatology*, trans. Gayatri Spivak (Baltimore: Johns Hopkins University Press, 1976), 28.

3. Daguerre had in fact made confident but premature announcements of his invention in the Parisian press during 1835 and 1838, but Arago's speech is usually taken to be photography's official launch day.

4. Helmut Gernsheim, *The Origins of Photography* (London: Thames and Hudson, 1982), 6.

5. Michel Foucault, *The Archaeology of Knowledge*, trans. A. M. Sheridan Smith (New York: Pantheon Books, 1972), 144.

6. Pierre Harmant, "Anno Lucis 1839: 1st part," *Camera*, no. 5 (May 1977), 39, and "Anno Lucis 1839: 3rd part," *Camera*, no. 10 (October 1977), 40.

7. As early as June 8, 1839, the English journal *The Athenaeum* was complaining that "hardly a day passes that we do not receive letters respecting some imagined discovery or improvement in the art of photogenic drawing." As quoted in R. Derek Wood, "J. B. Reade, F.R.S., and the Early History of Photography: Part 1, A Re-assessment on the Discovery of Contemporary Evidence," *Annals of Science* 27:1 (March 1971), 13–45.

8. In his 1839 paper to the Royal Society, "Some Account of the Art of Photogenic Drawing," Talbot reminds us that there may well have been numerous protophotographers whose names and aspirations have not come down to us: "I have been informed by a scientific friend that this unfavourable result of Mr. WEDGWOOD's and Sir HUMPHRY DAVY's experiments, was the chief cause which discouraged him from following up with perseverance the idea which he had also entertained of fixing the beautiful images of the *camera obscura*." Talbot's paper is reproduced in Beaumont

Newhall, *Photography: Essays and Images* (London: Secker & Warburg, 1980), 24.

9. Niépce wrote to Daguerre on June 4, 1827, as quoted in Victor Fouque, *The Truth Concerning the Invention of Photography: Nicéphore Niépce, His Life, His Endeavours, His Works* (Paris: Library of Authors and of the Academy of Booklovers, 1867 [reprint edition 1973, Arno Press, New York]), 72. Daguerre sent Niépce his letter on February 3, 1828, as quoted in Beaumont Newhall, *Latent Image: The Discovery of Photography* (Albuquerque: University of New Mexico Press, 1967), 34.

10. For a more detailed discussion of each of these figures, see my *Burning with Desire: The Conception of Photography* (Cambridge, MA: MIT Press, 1997), 22–50.

11. Mike Weaver, ed., "Diogenes with a Camera," *Henry Fox Talbot: Selected Texts and Bibliography* (Oxford: Clio Press, 1992), 1.

12. These six images can be found in the collections of the National Museum of Photography, Film and Television, Bradford, England; the Royal Photographic Society, Bath, England; the Talbot Museum, Lacock, England; the Bensusan Museum of Photography, Johannesburg, South Africa; the Rubel Collection, New York (now in the Metropolitan Museum of Art, New York); and in a private collection. There are also salted paper copy prints (made by Harold White) of two of these window images in Japan's Yokohama Museum of Art. It is worth noting that in 1835 Talbot also made a photogenic drawing negative of the stained glass window from the great hall of Lacock Abbey. See Larry Schaaf, *Out of the Shadows: Herschel, Talbot and the Invention of Photography* (New Haven: Yale University Press, 1992), 47.

13. See Larry Schaaf, *Sun Pictures: The Rubel Collection* (New York: Hans P. Krauss, Jr., 1997), 10.

14. Talbot, 1839, as quoted in Newhall, *Photography,* 28.

15. Talbot, August 9, 1839, from a photocopy of an unindexed letter held by the Talbot Museum, Lacock Abbey.

16. The window is a common, if complex, metaphor. It is used, for example, by Alberti in 1435 to describe his newly invented perspective system (later to be embodied in the camera apparatus being employed by Talbot). Leon Battista Alberti, *On Painting,* trans. John Spencer (New Haven: Yale University Press, 1966), 56. For more on the philosophical implications of the window metaphor, see Thomas Keenan, "Windows: Of Vulnerability," in Bruce Robbins, ed., *The Phantom Public Sphere* (Minneapolis: University of Minnesota Press, 1993), 121–141.

17. Jacques Derrida, "The Principle of Reason: The University in the Eyes of Its Pupils," trans. Catherine Porter and Edward P. Morris, *Diacritics* 13:3 (Fall 1983), 19.

18. Talbot uses the phrase "Philosophical Window" in a note to himself in his Notebook C, written sometime after March 1825: "If a solar ray be polarised & introduced into a dark chamber thro' ground glass, or a minute lens, the whole chamber will be illuminated with polarised light. . . . If thro' a plate of mica etc it will give a display of colours— . . . The Philosophical Window—a plate of Mica of a certain thickness which restores the light."

19. Talbot, 1844, as quoted in Weaver, *Henry Fox Talbot,* 91.

20. As quoted in Lindsay Smith, *Victorian Photography, Painting and Poetry: The Enigma of Visibility in Ruskin, Morris and the Pre-Raphaelites* (Cambridge: Cambridge

University Press, 1995), 6. In *The Pencil of Nature,* Talbot too suggests that "the object glass is the *eye* of the instrument—the sensitive paper may be compared to the *retina.*" See Weaver, *Henry Fox Talbot,* 87.

21. Henry Talbot, "Some Account of the Art of Photogenic Drawing," January 31, 1839, reproduced in Newhall, *Photography,* 28.

22. Daguerre, c.1838, as quoted in Helmut and Alison Gernsheim, *L. J. M. Daguerre: The History of the Diorama and the Daguerreotype* (New York: Dover, 1968), 81.

23. See ibid., 194, and Beaumont Newhall, introduction to *An Historical and Descriptive Account of the Various Processes of the Daguerreotype and the Diorama* (New York: Winter House, 1971), 16.

24. William Gilpin, as quoted in Timothy Brownlow, *John Clare and Picturesque Landscape* (Oxford: Clarendon Press, 1983), 12. Brownlow argues that in this passage, Gilpin "uses his eye like a cine-camera."

25. Gilpin, *Forest Scenery,* 1791, as quoted in Malcolm Andrews, *The Search for the Picturesque: Landscape Aesthetics and Tourism in Britain, 1760–1800* (Aldershot: Scholar Press, 1989), 70. The Claude glass was a tinted convex mirror, usually held in the hand and commonly used in the eighteenth century to produce a darkened, reflected image of landscape reminiscent of the paintings of Claude Lorrain.

26. John Constable, 1833, as reproduced in R. B. Beckett, ed., *John Constable's Discourses* (Ipswich: Suffolk Records Society, 1970), 9–10.

27. The phrase *time-anxiety* was coined by Hayden White to describe the intensification of historical consciousness that accompanied the emergence of the modern era. See his "Foucault's Discourse: The Historiography of Anti-Humanism," in *The Content of the Form: Narrative Discourse and Historical Representation* (Baltimore: Johns Hopkins University Press, 1987), 124.

28. Coleridge, "Defects and Beauties of Wordsworth's Poetry," 1817, as reproduced in Jack Davis, ed., *Discussions of William Wordsworth* (Boston: Heath, 1964), 7.

29. Samuel Taylor Coleridge, "The Eolian Harp" (1795) and "This Lime-Tree Bower My Prison" (1797), from Earl Leslie Griggs, ed., *The Best of Coleridge* (New York: Ronald Press, 1934), 15–16, 37–39.

30. Coleridge, from a notebook entry dated February 21, 1825, as quoted in Kathleen Coburn, "Reflections in a Coleridge Mirror: Some Images in His Poems," in Frederick W. Hilles and Harold Bloom, eds., *From Sensibility to Romanticism: Essays Presented to Frederick A. Pottle* (New York: Oxford University Press, 1965), 423.

31. Humphry Davy, "An Account of a Method of Copying Paintings upon Glass etc.," *Journals of the Royal Institution* 1 (London, 1802), as reproduced in R. B. Litchfield, *Tom Wedgwood: The First Photographer* (London: Duckworth and Co., 1903), 189.

32. Coleridge to his wife, November 16, 1802, in Earl Leslie Griggs, ed., *Collected Letters of Samuel Taylor Coleridge,* vol. 2, *1801–1806* (Oxford: Clarendon Press, 1956), 883. See my commentary on this letter in *Burning with Desire,* 87–88.

33. Arago, in his speech to the Académie des Sciences on January 7, 1839, as reproduced in Gernsheim and Gernsheim, *L. J. M. Daguerre,* 82.

34. Arago, in his report to the Chamber of Deputies on July 6, 1839, as reproduced in *An Historical and Descriptive Account of the various Processes of the Daguerreotype and the Diorama by Daguerre* (London: McLean, 1839 [Krauss Reprint Co., New York, 1969]), 14. Not all observers greeted the onset of this "ardent desire" with Arago's enthusiasm. One German clergyman is said to have exclaimed, "The wish to capture evanescent reflections is not only impossible, as has been shown by thorough German investigation, but the mere *desire* alone, the will to do so, is blasphemy" (emphasis added), quoted in Gernsheim, *The Origins of Photography*, 50.

35. Michel Foucault, *The Order of Things: An Archaeology of the Human Sciences* (New York: Vintage Books, 1973), 238.

36. Watling's publication is reproduced in full as part of Ross Gibson's article, "This Prison this Language: Thomas Watling's *Letters from an Exile at Botany-Bay* (1794)," in Paul Foss, ed., *Island in the Stream: Myths of Place in Australian Culture* (Sydney: Pluto Press, 1988), 4–28.

37. Ibid., 24.

38. Victor Burgin, in Geoffrey Batchen, "For an Impossible Realism: An Interview with Victor Burgin," *Afterimage* 16:7 (November 1989), 4–5.

39. Michel Foucault, *Power/Knowledge,* ed. Colin Gordon (Brighton: Harvester Press, 1980), 113.

40. Foucault, *The Order of Things,* xi.

41. Foucault, *Power/Knowledge,* 211.

42. Ibid., 195–196.

43. Foucault, *The Order of Things,* 318–319.

44. Ibid., xxiii.

45. Ibid., 312.

46. Michel Foucault, *Discipline and Punish: The Birth of the Prison,* trans. Alan Sheridan (London: Penguin, 1977), 216.

47. Ibid., 202–203.

48. Foucault, *Power/Knowledge,* 98.

49. Jonathan Crary traces this shift in thinking about the observer in admirable detail in his *Techniques of the Observer: On Vision and Modernity in the Nineteenth Century* (Cambridge, MA: MIT Press, 1990).

50. Coleridge, from a notebook entry dated February 21, 1825, as quoted in Coburn, "Reflections in a Coleridge Mirror," 423.

51. It is interesting to note that in his influential book, *The Mirror and the Lamp,* M. H. Abrams describes a parallel hesitation he sees as inhabiting the field of poetry at this same time: "The title of the book identifies two common and antithetic metaphors of mind, one comparing the mind to a reflector of external objects, the other to a radiant projector which makes a contribution to the object it perceives." See Abrams, *The Mirror and the Lamp: Romantic Theory and the Critical Tradition* (New York: Norton, 1953), viii.

52. See my "The Naming of Photography: 'A Mass of Metaphor,'" *History of Photography* 17:1 (Spring 1993), 22–32.

53. Foucault, *Power/Knowledge,* 97.

54. Niépce, 1816, as quoted in Beaumont Newhall, *The History of Photography, from 1839 to the Present Day* (New York: Museum of Modern Art, 1949), 12.

55. Foucault, *Power/Knowledge,* 186.

56. Foucault, "Nietzsche, Genealogy, History," in Donald F. Bouchard, ed., *Language, Counter-Memory, Practice* (Ithaca: Cornell University Press, 1977), 142.

2

1. Gael Newton, *Shades of Light: Photography and Australia, 1839–1988* (Canberra: Australian National Gallery and Collins Australia, 1988), and Anne-Marie Willis, *Picturing Australia: A History of Photography* (Sydney: Angus & Robertson, 1988). These books were preceded by an anecdotal history by photographer Jack Cato, *The Story of the Camera in Australia* (Melbourne: Georgian House, 1955), and an important body of archival research prepared by Alan Davies and Peter Stanbury (with Con Tanre) for their book, *The Mechanical Eye in Australia* (Melbourne: Oxford University Press, 1985). For critical remarks on the production of Australia's bicentenary, see Anne-Marie Willis and Tony Fry, "The Australian Bicentenary: A Strategy of Appearances," *Ten.8,* no. 30 (Autumn 1988), 18–25, and Susan Janson and Stuart MacIntyre, eds., *Making the Bicentenary* (Melbourne: Australian Historical Studies, 1988).

2. As Galarrwuy Yunupingu, Aboriginal chairman of the Northern Land Council, bluntly reminded whites on the climactic bicentennial day itself, "Our 40,000 years makes 200 years look like a shit." Galarrwuy Yunupingu, as quoted in Terry Coleman, "Australia's Fairy Tales," *Manchester Guardian Weekly,* February 28, 1988, 23.

3. Paul Foss, "Theatrum Nondum Cognitorum," in Peter Botsman, Chris Burns, and Peter Hutchings, eds., *The Foreign Bodies Papers* (Sydney: Local Consumption, 1981), 29–30. For more on the discursive prehistory of Australia, see Bernard Smith, *European Vision and the South Pacific, 1768–1850* (London: Oxford University Press, 1960); Ross Gibson, *The Diminishing Paradise: Changing Literary Perceptions of Australia* (Sydney: Angus & Robertson, 1984); Paul Carter, *The Road to Botany Bay: An Essay in Spatial History* (London: Faber & Faber, 1987); and William Eisler and Bernard Smith, *Terra Australis: The Furthest Shore* (Sydney: Art Gallery of New South Wales, 1988).

4. Michel Foucault, *The Archaeology of Knowledge,* trans. A. M. Sheridan Smith (New York: Pantheon Books, 1972), 49.

5. Michel Foucault, *The Order of Things: An Archaeology of the Human Sciences* (New York: Vintage Books, 1973), xxiv.

6. As quoted in Helmut and Alison Gernsheim, *L. J. M. Daguerre: The History of the Diorama and the Daguerreotype* (New York: Dover, 1968), 84.

7. The 1980s and early 1990s saw the publication of a number of survey histories of the photography produced by regional cultures. Representative examples are Ralph Greenhill and Andrew Birrell, *Canadian Photography: 1834–1920* (Toronto: Coach House Press, 1979); Boris Kossoy, *Origens e Expansao da Fotografia no Brasil: seculo XIX* (Rio de Janeiro: Edicao FUNARTE, 1980); Lee Fontanella, *La Historia de la Fotografia en Espana: desde sus origenes hasta 1900* (Madrid: El Viso, 1981); Alkis X. Xan-

thakis, *History of Greek Photography, 1839–1960* (Athens: Hellenic Literary and Historical Archives Society, 1988); William Main and John B. Turner, *New Zealand Photography from the 1840s to the Present* (Auckland: Fotoforum, 1993).

8. These histories include Helmut Gernsheim, *The History of Photography from the Earliest Use of the Camera Obscura in the Eleventh Century up to 1914* (London: Oxford University Press, 1955); Beaumont Newhall, *The History of Photography* (New York: Museum of Modern Art, 1982); Naomi Rosenblum, *A World History of Photography* (New York: Abbeville Press, 1997); Jean-Claude Lemagny and André Rouillé, eds., *A History of Photography* (Cambridge: Cambridge University Press, 1987); and Michel Frizot, ed., *A New History of Photography* (Cologne: Könemann, 1998). None of them reproduces any examples of Australian photography.

9. Peter Turner is one of the few international scholars to include Australian photographs in his historical survey, reproducing four examples in his *History of Photography* (New York: Exeter Books, 1987).

10. Jacques Derrida discusses the complications of the supplement in *Of Grammatology,* trans. Gayatri Chakravorty Spivak (Baltimore: Johns Hopkins University Press, 1976), 144–164.

11. Docker's cricket image would seem to precede that 1857 wet-collodion photograph of the game by Englishman Roger Fenton that is featured in Gail Buckland's *First Photographs: People, Places, and Phenomena as Captured for the First Time by the Camera* (New York: Macmillan, 1980), 68.

12. By concentrating primarily on questions of style and influence, Newton follows in the footsteps of a number of earlier Australian art historians. Bernard Smith, for example, based his seminal book, *Place, Taste and Tradition* (Melbourne: Oxford University Press, 1945), on a concern with "the mutations which have occurred in styles and fashions originating overseas as they have been assimilated into conditions, social, political, moral and aesthetic, existing in Australia" (30). More recent critics have pointed out the limitations of Smith's approach to Australian art history. "His concept of style isolated stylistic influence as 'the most significant' aspect of art, and led him constantly to affirm sources for Australian work within European movements. Such affirmations—whether accurate or not—did little to characterise the specificity of Australian art. . . . Such an approach endorsed dependency as the dominant or most significant aspect of art in Australia. This fundamental assumption remains problematic. . . . While stylistic dependence was a factor—but only one factor—in Australian art, its significance can be evaluated only when it is considered as having a role in the context of production itself." Ian Burn, Nigel Lendon, Charles Merewether, and Ann Stephen, *The Necessity of Australian Art* (Sydney: Power Publications, University of Sydney, 1988), 42–43.

13. See my "New Vision and Old Values: Australian Landscape Photography Between the Wars," *Photofile* (Winter 1983), 4–5, and Ann Stephen, "Mass Reproduced Photography in the Inter-War Years," *Art Network* 9 (Autumn 1983), 41–45.

14. Newton also points out that although Dupain's *The sunbaker* was taken in 1937, it became a prominent icon in Australia's photographic history only during the 1970s. Its reemergence at this time was one result of the struggle to have Australian photography accepted as an art form, a struggle that included Newton's own curatorial efforts to establish some sort of local artistic tradition for the medium. For a detailed discussion of this image and its

various manifestations, see my "Max Dupain: Sunbakers," *History of Photography* 19:4 (Winter 1995), 349–357.

15. Under the subheading "Photographs as Art History," Willis describes the earlier publications of Gael Newton as following the lead of Beaumont Newhall: "Orthodox art history, primarily discussing work that could be attributed to specific authors and dealing with these bodies of work in terms of influences, schools, styles, movements" (263).

16. Allan Sekula, "Photography Between Labour and Capital," in Benjamin H. D. Buchloh and Robert Wilkie, eds., *Mining Photographs and Other Pictures, 1948–1968* (Nova Scotia: Press of the Nova Scotia College of Art and Design, 1984), 273.

17. Quoted in Edward Stokes, *United We Stand: Impressions of Broken Hill, 1908–1910* (Melbourne: Five Mile Press, 1983), 186–187. Further examples of Wooler's strike photographs are reproduced in "The Anatomy of a Strike 1908–9," *Two Hundred Years,* no. 4 (Sydney: Bay Books, 1987), 94–95.

18. Helen Ennis, *Australian Photography: The 1980s,* exhibition catalogue (Canberra: Australian National Gallery, 1988).

19. See Mary Kelly, "Desiring Images/Imaging Desire" (1984), *Imaging Desire* (Cambridge, MA: MIT Press, 1996), 128: "If pleasure is to be understood in Barthes' sense of the term as a loss of preconceived identity rather than an instance of repletion, then it is possible to produce a different form of pleasure for the woman by representing a specific loss—the loss of her imagined closeness to the mother's body."

20. See my "Anne Ferran: Scenes and Scenarios," in *Art from Australia: Eight Contemporary Views,* exhibition cata-

logue (Melbourne: Australian Exhibitions Touring Agency, 1990), 40–42.

21. This is a tactic much discussed in Australian art criticism. See, for example, my "Preferential Treatment," *Afterimage* 14:2 (September 1986), 4–5, and Ian Burn, "The Re-Appropriation of Influence," in *From the Southern Cross: A View of World Art c.1940–88,* exhibition catalogue (Sydney: Australian Broadcasting Corporation and Biennale of Sydney, 1988), 41–48. Some Australian artists have even argued that "simulation" is no less than "the quintessential quality of Australian life and culture." See Imants Tillers, "Locality Fails," *Art & Text* 6 (Winter 1982), 60.

22. Allan Sekula, "The Body and the Archive," *October* 39 (Winter 1986), 3–64.

23. See Ann Stephen, "Handbacks and Photojournalism," in Annette Shiell and Ann Stephen, eds., *The Lie of the Land,* exhibition catalogue (Sydney: Powerhouse Museum and National Centre for Australian Studies, 1992), 22–23.

24. See the interesting commentary on some of this work by Beth Spencer in "The Order of Things," *Afterimage* 15:9 (April 1988), 19–20.

25. For more on this incident, see Martin Thomas, "The Road to Botany Bay," *Art & Text* 30 (September–November 1988), 94–97.

26. See my "Terrible Prospects," in Sheill and Stephen, eds., *The Lie of the Land,* 46–48.

27. Jean-François Lyotard, "Reply to the Question: What Is the Post-Modern?" *ZX* (Winter 1984), and "Presenting the Unpresentable: The Sublime," *Artforum* (April 1982), 64–69. Commenting on these essays, Sydney critics Rex Butler and David Messer have offered the follow-

ing speculation: "I wonder if a 'true' Sublime art—if it existed—could seem anything other than kitsch to us, because it must always attempt to 'present the unpresentable', that which cannot be represented, and fail. Whether, in fact, the art itself would not always be this fallen Sublime, or kitsch? That there could be a Sublime but never a sublime art, except perhaps in the very form of kitsch?" Rex Butler and David Messer, "Notes Towards a Supreme Fiction: An Interview with Meaghan Morris," *Frogger* 15 (May 1985), 11.

28. Ian Burn has argued, for example, that the painting of Sydney Nolan in the 1940s is not so much an art dependent on overseas models as an art about dependency: "Through his art, Nolan reveals an indifference to the authority of his influences, to their history, which effectively becomes the means of declaration of difference within modernist culture. It is an evasive strategy, of participation and demurring at the same time, without the fetishization of stylistic sources which has characterised other periods of Australian art. Nolan's art rejects any sense of subjection to sources, and approaches influence more as the terms of a collaboration." See Ian Burn, *Dialogue: Writings in Art History* (Sydney: Allen & Unwin, 1991), 213. In another essay in this same collection, Burn and Nigel Lendon point out that Australian abstract artists of the late 1960s and early 1970s appear to make paintings that ape the color field, abstract expressionism, and minimal movements in the United States but in fact disrespectfully borrow from these sources in a completely eclectic and ahistorical manner: "A basic point is this: given the cultural make-up of this country, it is no less characteristic or typical to produce an art whose dependence on that of another country is undisguised than it is to produce an art whose specificity makes its values virtually inaccessible to other cultural traditions. But the interdependence of these 'extremes' suggests that neither is possible without the other" (95).

3

1. Having been expelled from the body of a repulsed photo history, the vernacular is abject indeed. As described by Kristeva, abjection is, after all, "what disturbs identity, system, order. What does not respect borders, positions, rules. The in-between, the ambiguous, the composite." Julia Kristeva, *Powers of Horror: An Essay on Abjection,* trans. Leon S. Roudiez (New York: Columbia University Press, 1982), 4.

In this essay, *vernacular* is but a convenient word to categorize an attitude to the photograph that defies the homogeneity of definition. And it is a word that comes laden with its own history. John A. Kouwenhoven, for example, published an essay in the *Atlantic Monthly* in August 1941 that attempted to distinguish "vernacular" from "folk art," later developing it into a book, *Made in America: The Arts in Modern Civilization* (1948). In chapter 2, "What is Vernacular?" Kouwenhoven associated the term with "the art of sovereign, even if uncultivated, people rather than of groups cut off from the main currents of contemporary life." See John A. Kouwenhoven, *Arts in Modern American Civilization* (New York: Norton, 1967), 13. He repeated and developed his idea of the "vernacular arts" in his 1982 collection of essays, published as *Half a Truth Is Better Than None:* "By it I referred to objects shaped empirically by ordinary people in unselfconscious and uninhibited response to the challenges of an unprecedented cultural environment. . . . Specifically the products of the vernacular arts were the tools, toys, buildings, books, machines, and other artifacts whose texture, shape, and so on were evolved in direct, untutored response to the materials, needs, attitudes, and preoccupations of a society being shaped by the twin forces of democracy and technology. It is my contention that direct sensory awareness of such vernacular objects provides an important kind of knowledge about American culture." John A. Kouwenhoven, *Half a Truth Is Better Than None: Some Unsystematic*

Conjectures About Art, Disorder, and American Experience
(Chicago: University of Chicago Press, 1982), 23–24.

2. See, for example, a book first published in 1896 by
Frank R. Fraprie and Walter E. Woodbury: *Photographic
Amusements, Including Tricks and Unusual or Novel Effects
Obtainable with the Camera* (New York: Arno Press,
1973). The two books that have most influenced the late
twentieth century's approach to photography's history are
Helmut Gernsheim, *The History of Photography from the
Earliest Use of the Camera Obscura in the Eleventh Century
up to 1914* (London: Oxford University Press, 1955), and
Beaumont Newhall, *The History of Photography* (New
York: Museum of Modern Art, 1949, 1964, 1982). A
number of later books have done little more than expand
on the canon established by these two authors, otherwise
retaining their general structures and prejudices. See, for
example, Naomi Rosenblum, *A World History of Photography* (New York: Abbeville Press, 1997), and Jean-Claude
Lemagny and André Rouillé, eds., *A History of Photography* (Cambridge: Cambridge University Press, 1987).

Vernaculars are included in this version of photography's history only when they can be shown to complement its focus on art, as when John Szarkowski
incorporates anonymous images into his exhibitions to
suggest the inherent nature of photography's formal values
or Jonathan Green proposes the snapshot as representing
an influential aesthetic for contemporary artists. In his
1966 exhibition catalogue for *The Photographer's Eye,*
Szarkowski acknowledges the influence of Kouwenhoven's
Made in America (1948), telling readers that "it is the thesis of this book that the study of photographic form must
consider the medium's 'fine art' tradition and its 'functional' tradition as intimately interdependent aspects of a
single history." However, critic Janet Malcolm points out
that there is a significant difference in approach between
Szarkowski and Kouwenhoven: "For where Kouwenhoven's examples underscore the contrast between the

'fine-art' and the 'functional' traditions, Szarkowski's create the opposite impression—one of their sameness." See
John Szarkowski, *The Photographer's Eye* (New York: Museum of Modern Art, 1966); Jonathan Green, ed., *The
Snap-Shot* (*Aperture* 19:1, 1974); Janet Malcolm, "Diana
and Nikon" (1976), in *Diana and Nikon: Essays on the Aesthetic of Photography* (Boston: David R. Godine, 1980),
58–73.

For commentaries on the artistic prejudices of photography's modern historians, see Christopher Phillips,
"The Judgement Seat of Photography" (1982) in A.
Michelson et al., eds., *October: The First Decade* (Cambridge, MA: MIT Press, 1987), 257–293; Mary Warner
Marien, "What Shall We Tell the Children? Photography
and Its Text (Books)," *Afterimage* 13:9 (April 1986), 4–7;
Abigail Solomon-Godeau, "Mandarin Modernism: 'Photography Until Now,'" *Art in America* 78:12 (December
1990), 140–149, 183; Martin Gasser, "Histories of
Photography, 1939–1939," *History of Photography* 16:2
(Spring 1992), 50–61; Anne McCauley, "Writing Photography's History Before Newhall," *History of Photography*
21:2 (Summer 1997), 87–101; Allison Bertrand, "Beaumont Newhall's Photography, 1839–1937: Making
History," *History of Photography* 21:2 (Summer 1997),
137–146; Glenn Williamson, "The Getty Research Institute: Materials for a New Photo-History," *History of Photography* 22:1 (Spring 1998), 31–39; Sarah Boxer, "The
Hill Where Elitists and Populists Meet," *New York Times,*
March 15, 1998, 39–40.

3. This is quickly changing. A commercial exposition,
billed as "The 1st 'Vernacular' Photography Fair," was
held at the Metropolitan Pavilion in New York on October 2–4, 1998. Organized by dealer Stephen Cohen, the
fair's prospectus argues that "the most exciting development in the area of photo collecting has been in vernacular photography." For previews and reviews of this event,
see Jean Dykstra, "In the Vernacular," *Art & Auction,* Sep-

tember 21–October 4, 1998, 49; Eileen Kinsella, "Accidental Art," *Wall Street Journal,* October 2, 1998; Faye Hirsch, "Photo Fairs Multiply," *Art on Paper* 3:3 (January–February 1999), 20–21. There has also been an increase in the number of publications specifically addressing the question of a vernacular photography. See, for example, Daile Kaplan, *150 Years of Pop Photographica,* exhibition brochure (Islip: Islip Art Museum, 1988); Daile Kaplan, "Pop Photographica in Everyday Life, 1842–1968," *Photo Review* 21:4 (Fall 1998), 2–14; and Geoffrey Batchen, "From Genre to Generic," *Art on Paper* 3:3 (January–February 1999), 48–49.

4. See Jacques Derrida, *The Truth in Painting,* trans. Geoff Bennington and Ian McLeod (Chicago: University of Chicago Press, 1987), 43, 52, 53.

5. Craig Owens, "Detachment, from the Parergon," *October* 9 (Summer 1979), 49.

6. See Michel Braive, *The Photograph: A Social History* (New York: McGraw-Hill, 1966); Camfield and Deirdre Wills, *History of Photography: Techniques and Equipment* (New York: Exeter Books, 1980); Heinz K. Henisch and Bridget A. Henisch, *The Photographic Experience, 1839–1914: Images and Attitudes* (University Park: Pennsylvania State University Press, 1994); Alan and Pauline Cotter, *Reflecting on Photography 1839–1902: A Catalog of the Cotter Collection* (Santa Barbara, CA: National Directory of Camera Collectors, 1973); *Guide to Collections,* CMP Bulletin, 9: 1/2 (Riverside: California Museum of Photography, 1989); Don Macgillivray and Allan Sekula, with Robert Wilkie, *Mining Photographs and Other Pictures: A Selection from the Negative Archives of Shedden Studio, Glace Bay, Cape Breton, 1948–1968* (Halifax: Press of the Nova Scotia College of Art and Design, 1983); Stanley Burns, *Forgotten Marriage: The Painted Tintype and the Decorative Frame, 1860–1910: A Lost Chapter in American*

Portraiture (New York: Burns Press, 1995); James B. Wyman, *From the Background to the Foreground: The Photo Backdrop and Cultural Expression,* an exhibition first shown at the Visual Studies Workshop, Rochester, New York, October 1, 1996–March 8, 1997, and accompanied by a special edition of *Afterimage* (24:5, March–April 1997) with essays by Arjun Appadurai, Lucy Lippard, Avon Neal, and Sonia Iglesias y Cabrera and Maria del Carmen León; Renny Pritikin, ed., *Photo Backdrops: The George C. Berticevich Collection,* exhibition catalogue (San Francisco: Yerba Buena Center for the Arts, 1998); Christopher Pinney, *Camera Indica: The Social Life of Indian Photographs* (Chicago: University of Chicago Press, 1997); Mattie Boom and Hans Rooseboom, eds., *A New Art: Photography in the 19th Century: The Photo Collection of the Rijksmuseum, Amsterdam* (Amsterdam: Snoeck-Ducaji & Zoon, 1996); Michel Frizot, ed., *Nouvelle Histoire de la Photographie* (Paris: Bordas, 1995).

7. In terms of reproductions in photographic histories, the image is consistently privileged over a daguerreotype's casing, not only in the various editions of Newhall's *The History of Photography* (1949–1982), but also in the much more recent Bates Lowry and Isabel Barrett Lowry, *The Silver Canvas: Daguerreotype Masterpieces from the J. Paul Getty Museum* (Los Angeles: J. Paul Getty Museum, 1998).

8. See Charles Sanders Peirce, "Logic as Semiotic: The Theory of Signs" (c.1897–1903), in Justus Buchler, ed., *Philosophical Writings of Peirce* (New York: Dover, 1955), 98–119, and my commentary on Peirce's philosophy in *Burning with Desire: The Conception of Photography* (Cambridge, MA: MIT Press, 1997), 197–198.

9. Roland Barthes, *Mythologies,* trans. Annette Lavers (London: Paladin, 1973), 90.

10. Jacques Derrida, *Positions,* trans. Alan Bass (Chicago: University of Chicago Press, 1981), 6. He is referring to Jacques Derrida, "Freud and the Scene of Writing" (1966), in *Writing and Difference,* trans. Alan Bass (Chicago: University of Chicago Press, 1978), 196–231.

11. See Heinz and Bridget Henisch, *The Painted Photograph, 1839–1914: Origins, Techniques, Aspirations* (University Park: Pennsylvania State University Press, 1996).

12. Among the few publications written on this genre of photography are J. Abrahams, *Miniature Photo Jewelry, Photo Medallion Easels and Celluloid Photo Buttons* (New York: J. Abrahams Studio & Factory, 1890); Henriette Kappeler, "Fotoschmuck: Fotografie in Dekorativer Fassung," *Fotogeschichte: Beitraege zur Geschichte und Aesthetik der Fotografie* 44:12 (1982), 11–22; Larry West and Patricia Abbott, "Daguerreian Jewelry: Popular in Its Day," *The Daguerreian Annual* (1990), 136–140; and Jane Spies, "Collecting 'Photographic Jewelry': This Jewelry Is Picture Perfect!" *Warman's Today's Collector* (July 1997), 36–40.

13. See Rosalind Krauss, "Grids," *October* 9 (Summer 1979), 50–64. Krauss, apparently not familiar with nineteenth-century vernacular photography, claims in the course of her essay that "the grid is an emblem of modernity by being just that: the form that is ubiquitous in the art of our century, while appearing nowhere, nowhere at all, in the art of the last one" (52).

14. There have, however, been specialist studies of the photographic album. See, for example, E. Maas, ed., *Das Photoalbum 1858–1918* (Munich: Muenchner Stadtmuseum, 1975); Amy Kotkin, "The Family Photo Album as a Form of Folklore," *Exposure* 16 (March 1978), 4–8; Marilyn Motz, "Visual Autobiography: Photograph Albums of Turn-of-the-Century Midwestern Women," *American*

Quarterly 41:1 (March 1989), 63–92; Philip Stokes, "The Family Photograph Album: So Great a Cloud of Witnesses," in Graham Clarke, ed., *The Portrait in Photography* (Seattle: University of Washington Press, 1992), 193–205. Thanks to Elizabeth Hutchinson for these references.

15. For more on this practice, see Diane Block, *Books and Company: Mid-Victorian Photo-Collage Albums and the Feminine Imagination* (master's thesis, University of New Mexico, 1995); Mark Haworth-Booth, *Photography: An Independent Art, Photographs from the Victoria and Albert Museum, 1839–1996* (London: V&A Publications, 1997), 74–77; François Heilbrun and Michael Pantazzi, *Album de Collages de L'Angleterre Victorienne* (Paris: Editions du Regard, 1997); Isobel Crombie, "The Work and Life of Viscountess Frances Jocelyn: Private Lives," *History of Photography* 22:1 (Spring 1998), 40–51.

16. Thanks to Catherine Whalen for bringing this album to my attention.

17. See Jessica H. Foy and Karal Ann Marling, eds., *The Arts and the American Home, 1890–1930* (Knoxville: University of Tennessee Press, 1994), and Kenneth L. Ames, *Death in the Drawing Room, and Other Tales of Victorian Culture* (Philadelphia: Temple University Press, 1992).

18. See Ed Barber, "High Street Views," and Timothy Flach, "Wedding Work," *Ten.8* 13 (1984), 2–6, 17–19, respectively.

19. A number of studies have been devoted to this aspect of photography's history. See, for example, Judith Maria Gutman, *Through Indian Eyes: 19th and early 20th Century Photography from India* (New York: Oxford University Press, 1982), and Kohtaro Iizawa, "The Shock of the Real: Early Photography in Japan," in Robert Stearns, ed., *Pho-*

tography and Beyond in Japan: Space, Time and Memory (Tokyo: Hara Museum of Contemporary Art, 1994), 37–49. Discussions of still photography have been much influenced by ethnographic studies of indigenous film and television. These studies include Sol Worth and John Adair, *Through Navajo Eyes: An Exploration in Film Communication and Anthropology* (Bloomington: Indiana University Press, 1972), and Eric Michaels, *Bad Aboriginal Art: Tradition, Media, and Technological Horizons* (Minneapolis: University of Minnesota Press, 1994). In order to acknowledge the multiple meanings of ethnographic photographs, some editors of photography catalogues have taken to including interpretations by their subjects, or at least by these subjects' descendants. See, for example, Judy Annear, ed., *Portraits of Oceania,* exhibition catalogue (Sydney: Art Gallery of New South Wales, 1997), and Ann Stephen, ed., *Pirating the Pacific: Images of Trade, Travel and Tourism,* exhibition catalogue (Sydney: Powerhouse Museum, 1993).

20. See Olu Oguibe, "Photography and the Substance of the Image," in Clare Bell, Okwui Enwezor, Danielle Tilkin, and Octavio Zaya, *In/sight: African Photographers, 1940 to the Present* (New York: Guggenheim Museum, 1996), 231–250.

21. Stephen Sprague, "How I See the Yoruba See Themselves," *Exposure* 16:3 (Fall 1978), 16. One can see why Jacques Rangasamy would want to argue that "in the African consciousness, . . . photography is not something natural." For in Africa, as in other places colonized by Europe, photography is a tool that comes loaded with, among other things, the historical baggage of imperialism and its particular perspectives (both visual and political). See Jacques Rangasamy, "White Mischief," *Creative Camera,* no. 335 (August–September 1995), 8–9. Susan Vogel argues that "African artists select foreign ingredients carefully from the array of choices, and insert them into a

preexisting matrix in meaningful ways." She suggests, therefore, that these selections and insertions should be called "Westernisms." See Susan Vogel et al., *Africa Explores: 20th Century African Art* (New York: Center for African Art, 1991), 28–29. We see further evidence of this kind of consciousness within the history of Japan's encounter with photography. For example, the word the Japanese eventually adopted to designate photography, *shashin,* was also used for any "Western-style picture," whatever its medium. See Kohtaro Iizawa, "The Shock of the Real: Early Photography in Japan," in Stearns, *Photography and Beyond in Japan,* 37–49.

22. For more on this practice, see Marilyn Hammersley Houlbeerg, "Collecting the Anthropology of African Art," *African Arts* 9:3 (April 1976), 15–19, 91; Sprague, "How I See the Yoruba See Themselves," 16–29; Stephen Sprague, "Yoruba Photography: How the Yoruba See Themselves," *African Arts* 12:1 (November 1978), 52–59, 107.

23. *Fotoescultura* are barely acknowledged even in Mexican histories of photography. They are mentioned but not discussed or reproduced in Olivier Debroise, with Elizabeth Fuentes, *Fuga Mexicana: un recorrido por la fotografía en México* (Mexico City: Consejo Nacional para la Cultura y las Artes, 1994), and reproduced but not otherwise discussed in Francisco Reyes Palma, *Memoria del Tiempo: 150 anos de fotografía en México,* exhibition catalogue (Mexico City: Museo de Arte Moderno, 1989), and Alfonso Carrillo, ed., *Asamblea de Ciudades,* exhibition catalogue (Mexico City: Museo del Palacio de Bellas Artes, 1992). Thanks to Monica Garza for these references.

24. Pamela Scheinman, "Foto-Escultura," *Luna Córnea* 9 (1996), 97–101.

25. Monica Garza, *Foto-Escultura: A Mexican Photographic Tradition,* exhibition catalogue (Albuquerque: University of New Mexico Art Museum, 1998).

26. Roland Barthes, *Camera Lucida: Reflections on Photography,* trans. Richard Howard (New York: Hill and Wang, 1981), 93. See also Michael Roth with Claire Lyons and Charles Merewether, *Irresistible Decay: Ruins Reclaimed* (Los Angeles: Getty Research Institute for the History of Art and the Humanities, 1997).

27. The phrase comes from Karl Marx and Friedrich Engels, "Manifesto of the Communist Party" (1848), as reproduced in Robert C. Tucker, ed., *The Marx-Engels Reader* (New York: Norton, 1978), 476.

28. See the commentary on Barthes's notion of the "writerly" text in Terence Hawkes, *Structuralism and Semiotics* (London: Methuen, 1977), 114–115.

29. Barthes, *Camera Lucida,* 8–9.

30. Michel Foucault, *The Order of Things: An Archaeology of the Human Sciences* (New York: Vintage, 1966, 1970). For an interesting commentary on Foucault's rhetoric, see Hayden White, "Michel Foucault," in John Sturrock, ed., *Structuralism and Since* (Oxford: Oxford University Press, 1979), 81–115.

31. For one recent history of *Wunderkammer* and their taxonomies, see Lorraine Daston and Katherine Park, *Wonders and the Order of Nature, 1150–1750* (New York: Zone Books, 1998).

32. Jules David Prown, "Mind in Matter: An Introduction to Material Culture Theory and Method," *Winturthur Portfolio* 17 (Spring 1982), 1–19. Material culture is, of course, a rapidly developing and already variegated field of inquiry. See also, for example, Mihaly Csikszentmihalyi and Eugene Rochberg-Halton, *The Meaning of Things: Domestic Symbols and the Self* (Cambridge: Cambridge University Press, 1981); Christopher Musello, "Objects in Process: Material Culture and Communication," *Southern Folklore* 49 (1992), 37–59; Daniel Miller, "Artefacts and the Meaning of Things," in Tim Ingold, ed., *Companion Encyclopedia of Anthropology* (New York: Routledge, 1994), 396–419.

33. See, for example, Marsha Peters and Bernard Mergen, "'Doing the Rest': The Uses of Photographs in American Studies," *American Quarterly* 29 (1977), 280–303, and Christopher Musello, "Studying the Home Mode: An Exploration of Family Photography and Visual Communications," *Studies in Visual Communications* 6:1 (Spring 1980), 23–42.

34. Stuart Hall, "Cultural Identity and Diaspora," in Jonathan Rutherford, ed., *Identity: Community, Culture, Difference* (New York: Lawrence & Wishart, 1990), 225.

35. Both the phrase (*l'intelligible de notre temps*) and the aspiration are borrowed from Roland Barthes; see Jonathan Culler, *Roland Barthes* (New York: Oxford University Press, 1983), 16–17.

36. As Gayatri Spivak puts it, "The sign cannot be taken as a homogeneous unit bridging an origin (referent) and an end (meaning), as 'semiology,' the study of signs, would have it. The sign must be studied 'under erasure,' always already inhabited by the trace of another sign which never appears as such. 'Semiology' must give way to 'grammatology.'" See Gayatri Spivak, "Translator's Preface," in Jacques Derrida, *Of Grammatology,* trans. Gayatri Spivak (Baltimore: Johns Hopkins University Press, 1976), xxxix.

4

This essay is dedicated to the memory of Ian Burn (1939–1993). He taught a generation of Australian image makers how to look rather than just see. I also acknowledge the assistance of Ian Burn, Ann Stephen, Josef Lebovic, Richard King, Eric Riddler, John Spencer, Vicki Kirby, and especially Helen Ennis and Gael Newton, all of whom generously shared ideas and research material relating to Max Dupain's career. Sarah Greenough was equally generous in providing much invaluable information on the work of Alfred Stieglitz. Thomas Barrow kindly made useful suggestions about the essay as a whole.

1. I am thinking here of exhibitions of photographs by Russell Drysdale in Australia in 1987 and Garry Winogrand in the United States in 1988, both of which featured work made from negatives never printed during the artists' lifetimes.

2. Beaumont Newhall, *The History of Photography* (New York: Museum of Modern Art, 1982), 140. It is interesting to trace the fortunes of this image in publications devoted to the history of photography. Newhall's 1938 *Photography: A Short Critical History* reproduces *The Steerage* and two other images by Stieglitz but does not mention *Paula*. *Paula, Berlin* does, however, get the full-page treatment in the 1949 edition, now titled *The History of Photography from 1839 to the Present Day* (and dedicated by Newhall to the recently deceased Alfred Stieglitz). It is similarly prominent in the 1964 (now simply titled *Paula*) and 1982 editions (where it has become *Paula, or Sun Rays, Berlin*). Faithfully following in Newhall's footsteps, Naomi Rosenblum's *A World History of Photography* (New York: Abbeville Press, 1989) reproduces *Sun's Rays—Paula, Berlin* and *The Steerage* on opposite pages (332–333). She describes the former as follows: "A study made in Berlin by Stieglitz in 1889, reveals a fascination with the role of light and with

the replicative possibilities of photography, as well as an understanding of how to organize forms to express feeling" (333). Martin W. Sandler, in his *The Story of American Photography: An Illustrated History for Young People* (Boston: Little, Brown, 1979), gives *Paula* a full-page reproduction. Michel Braive's *The Photograph: A Social History* also gives this image a full-page reproduction, calling it "a vigorous example of the style of this great American photographer, who captures lighting effects with the same sense of urgency as others capture events." See Michel Braive, *The Photograph: A Social History* (New York: McGraw-Hill, 1966), 274. Stieglitz's many biographers and curators (too numerous to list here) invariably reproduce *Paula* as one of their first illustrations, almost always simply dating it to 1889.

3. The cloudy landscape has been identified as *The Approaching Storm* (1887), an image by Stieglitz that was reproduced as the frontispiece to the magazine *Die Photographische Rundschau* in 1888. See Beaumont Newhall, *Photography: Essays & Images* (New York: Museum of Modern Art, 1980), 168.

4. Newhall, *The History of Photography* (1982), 153.

5. Rosalind Krauss, "Stieglitz/Equivalents," *October* 11 (Winter 1979), 129–140. In making this argument, Krauss chooses to ignore the way in which Stieglitz explicitly includes a framed and cropped version of a portrait of his model on the table in front of her. This horizontal format directly contrasts with a vertical, uncropped version of the same image that is pinned to the wall above her. Of course, for Krauss the key difference between *Paula* and any of the *Equivalents* is that in the latter, the cut is "the only thing that makes the image." The whole image is about cropping, is constituted by nothing else but the act of cropping.

6. Diana Emery Hulick, "Alfred Stieglitz's *Paula:* A Study in Equivalence," *History of Photography* 17:1 (Spring 1993), 90–94. Interestingly, Stieglitz's image has also attracted at least one commentary from a contemporary photographer. Thomas Barrow's *Homage to Paula* (1974), from his *Cancellations* series, repeats both the dramatic raking bands of light and the self-referential attempts at self-portraiture that were attributes of Stieglitz's *Paula.* Barrow's photograph, as Kathleen Gauss puts it, signifies Stieglitz's "enduring influence on the medium." On the other hand, by "cancelling" Stieglitz's signature striations with deliberate slashes of his negative, Barrow also violently rejects both the fine print tradition and the revelationary type of photographic practice for which Stieglitz still stands. See Kathleen McCarthy Gauss, *Inventories and Transformations: The Photographs of Thomas Barrow* (Albuquerque: University of New Mexico Press, 1986), 129. However, it should be noted that virtually all the information about Barrow's image given in this publication is incorrect.

7. Alfred Stieglitz, "A Plea for Art Photography in America," *Photographic Mosaics: An Annual Record of Photographic Progress* (New York: Edward L. Wilson, 1892), 135–137.

8. The exhibition list is reproduced in "Alfred Stieglitz: Catalogue of his Camera Club Exhibition (1889)," *History of Photography* 15:2 (Summer 1991), 89–91. In his catalogue essay for this exhibition, Joseph T. Keiley reports that he was gratified to learn from Stieglitz that this show would present "a series of prints that would tell truthfully the story of his work from its beginning to the present time, recording not only his successes but likewise his failures." Apparently, in 1899 *Paula* represented neither. In an e-mail to me dated May 7, 1998, Joel Smith suggests that Stieglitz "may well have kept *Paula* off of exhibition walls in deference to [his wife] Emmy in the early years of their marriage." Smith also points out that Stieglitz's exhibitions in the 1890s were often accompanied by lantern-slide presentations, and these may have included an image of *Paula.* However, no evidence has surfaced to confirm or deny this possibility.

9. This uncertainty has resulted in some confusion in the literature on *Paula.* Geraldine Kiefer, for example, implies there are vintage prints of this image. See Geraldine Wonjo Kiefer, *Alfred Stieglitz: Scientist, Photographer, and Avatar of Modernism, 1880–1913* (New York: Garland Publishing, 1991), 88. Newhall tells us in the 1982 edition of *The History of Photography* (153) that *Paula* was first printed in 1933 for Stieglitz's retrospective exhibition at An American Place. John S. Welch is confident that the photograph was included in the earlier 1921 retrospective at the Anderson Galleries in New York. See John S. Welch, "Woman in Stieglitz's Eye," *History of Photography* 20:4 (Winter 1996), 337.

10. The print held by the Museum of Fine Arts in Boston is inscribed "Paula—Sun Rays—Berlin—1887." This is no doubt why it is reproduced in Doris Bry, *Alfred Stieglitz: Photographer* (Boston: Museum of Fine Arts, 1965), but dated "1889(?)."

11. The text for this brochure is published as Alfred Stieglitz, "A Statement" (1921), in Newhall, *Photography,* 217.

12. Stieglitz, in a letter to Kuhn written in October 1912, as quoted in Kiefer, *Alfred Stieglitz,* 410.

13. De Zayas, writing in *Camera Work,* no. 42/43 (1913), as reproduced in Jonathan Green, ed., *Camera Work: A Critical Anthology* (New York: Aperture, 1973), 267.

14. In that context it is interesting to note that in 1923 Stieglitz claimed that his interest in photographing clouds was prefigured in the work he was doing in the 1880s while a student in Germany: "Ever since then clouds have been in my mind most powerfully at times, and I always knew I'd follow up the experiments made over 35 years ago." As quoted in Sarah Greenough, "How Stieglitz Came to Photograph Clouds," in Peter Walch and Thomas Barrow, eds., *Perspectives on Photography: Essays in Honor of Beaumont Newhall* (Albuquerque: University of New Mexico Press, 1986), 151–165.

15. See James S. Terry, "The Problem of 'The Steerage,'" *History of Photography* 6:3 (July 1982), 211–222; Sarah Greenough and Juan Hamilton, eds., *Alfred Stieglitz: Photographs and Writings* (Washington, D.C.: National Gallery of Art, 1983), 17, 29–30; Kiefer, *Alfred Stieglitz,* 320–332.

16. See Stieglitz's self-serving reminiscence in Dorothy Norman, ed., "Four Happenings," *Twice a Year* 8–11 (1942–1943), as reproduced in Nathan Lyons, ed., *Photographers on Photography* (Englewood Cliffs, NJ: Prentice-Hall, 1966), 112–135.

17. For an influential critical analysis of the formalist attributes of *The Steerage,* see Allan Sekula, "On the Invention of Photographic Meaning," (1974), *Photography Against the Grain: Essays and Photo Works, 1973–1983* (Nova Scotia: Press of the Nova Scotia College of Art and Design, 1984), 2–21.

18. An exhibition catalogue published by the National Gallery of Art, Washington, D.C., in 1992, *Stieglitz in the Darkroom* affords a direct comparison of details from a platinum and silver gelatin version of *Paula* (see p. 12). Thanks go to Sarah Greenough, the curator responsible for the exhibition, for supplying this and many of the other documents called on during the writing of this portion of my essay.

19. Tennant's review is quoted in Newhall, *The History of Photography* (1982), 171.

20. Virtually every popular reference to *The sunbaker* describes it as an Australian icon. This status is confirmed by the feminist homage it has received from a younger Australian art photographer, Anne Zahalka. Her color postcard *The Sunbather #2* (1989) reproduces Dupain's composition but features a pale androgynous sunbather. A similarly configured female sunbather, this time wearing a bracelet of beads composed in the colors of the Aboriginal flag, was featured on the cover of the first edition of *The Republican: Australia's National Independent Weekly,* February 11, 1997. The front-page story specifically contrasted the values embodied in Dupain's image with the "new times" the paper claimed to be representing.

21. Since Dupain's death in July 1992, the name and identity of his sunbather has been discovered. He was a friend of Dupain named Harold Salvage, an English migrant living in Sydney between the 1920s and the end of World War II. Although it is generally accepted that the picture was taken at Culburra, Dupain also told another inquirer, Claire Brown, that it was taken at Bawley Point.

22. Gael Newton, *Shades of Light: Photography and Australia 1839–1988* (Canberra: Australian National Gallery 1988), 125. See also Newton's thoughtful essay "Sphinx" in Daniel Thomas, ed., *Creating Australia: 200 Years of Art, 1788–1988,* exhibition catalogue (Adelaide: Art Gallery of South Australia, 1988), 206–207, and the commentary by Anne-Marie Willis, *Picturing Australia: A History of Photography* (Sydney: Angus & Robertson, 1988), 164–169.

23. Dupain had written a well-illustrated appreciation of the work of Man Ray for *The Home* magazine, published in October 1935: Max Dupain, "Man Ray: His Place in Modern Photography," *The Home,* October 1, 1935, 38–39, 84. Man Ray's *Glass Tears* (c.1930) had been reproduced in *The Home* in its February 1, 1934, issue. Dupain went on to publish photographs of a "Surrealist Party" in *The Home* (April 1, 1937, 52–53) and also a number of "Surrealist Portraits" (e.g., April 1, 1937, 40, and June 1, 1938, 45). His own "weekend work" during the 1930s also showed the influence of Man Ray's images, using montage, strange juxtapositions of objects, and solarization. For more on the Australian context in which such experiments took place, see Christopher Chapman, "Surrealism in Australia," in Michael Lloyd, Ted Gott, and Christopher Chapman, eds., *Surrealism: Revolution by Night,* exhibition catalogue (Canberra: National Gallery of Australia, 1993), 216–317. By the late 1930s, Dupain also owned a few earlier copies of the German magazine *Das Deutsche Lichtbild,* bringing him into contact with Bauhaus-style photography. The key account of the various international influences on Dupain's early work remains Gael Newton's *Max Dupain* (Sydney: David Ell Press, 1980).

24. In 1929, *Art in Australia* published *Sydney Surfing,* a book featuring photographs by Harold Cazneaux and text by Jean Curlewis. Curlewis argues there that surfing is a distinctively Australian attraction ("it staggers tourists—yes, even Americans"): "To visitors from overseas the sun-baking is just as surprising as the bathing. They come to the beach wall and lean over—and their first impression is of a battlefield. For acres the beach is covered with smooth brown bodies that seem sun-slain. Some are flung face downwards—others lie face up, eyes closed, the sun beating on their faces. All are immobile as marble. . . . The sun polishes the skin to an incredible smoothness. Until the Australian surfer looks like—I cannot help it—a young

Greek god." See Curlewis, "Sydney Surfing," in Ken Goodwin and Alan Lawson, eds., *The Macmillan Anthology of Australian Literature* (South Melbourne: Macmillan Australia, 1990), 248–249.

25. See Ian Burn, Nigel Lendon, Charles Merewether, and Ann Stephen, *The Necessity of Australian Art: An Essay About Interpretation* (Sydney: Power Institute, 1988), 20–21. Gruner's *Morning light* (1930), one of a number of his paintings with that title, is reproduced in Ian Burn, *National Life and Landscapes: Australian Painting 1900–1940* (Sydney: Bay Books, 1991), 111. One can also see a vertical version of this axial rotation in Dupain's *Dart* (1935) and Cazneaux's *Sydney surfing* (c.1928).

26. Sydney Ure Smith, "A New Vision of Australian Landscape," *Art in Australia,* 3rd ser., no. 17 (September 1926), 6. Ure Smith was later to become a great supporter of Dupain, often commissioning him to do work for *The Home,* a fashion and lifestyle magazine published by Ure Smith and devoted to "the modern spirit of Australia." See also my "New Vision and Old Values: Australian Landscape Photography Between the Wars," *Photofile* (Winter 1983), 4–5.

27. In an interview with Ann Stephen recorded in December 1980, Dupain surmised that "about 80%" of his photography in the 1930s was commercial work. For more on this period, see Ann Stephen, "Mass Produced Photography in Australia During the Inter-War Years," *Art Network,* no. 9 (Autumn 1983), 40–45.

28. Dupain described his own process of taking photographs as follows: "Subject matter comes to you, you don't go to it. . . . Although I shoot extemporaneously a lot of the time, I prefer to have half a dozen shots in my mind. Probably I have seen them many times under different conditions and have been thinking about them. The mo-

ment will come when I shall go back to them and make the photographs." Max Dupain, in *Light Vision,* no. 5 (May–June 1978), 8.

29. Gael Newton reports that another print of this version of *Sunbaker* has come to light, a small brown snapshot set in the bottom half of a page from an album now owned by Joan Van Dyke. The date of the album remains uncertain. See Gael Newton, "'It Was A Simple Affair': Max Dupain's *Sunbaker,*" in Lynne Seear and Julie Ewington, eds., *Brought to Light: Australian Art 1850–1965* (South Brisbane: Queensland Art Gallery, 1998), 142–147, 308–309. Newton has recently taken to calling these two prints *Sunbaker* (1937) and *Sunbaker II* (1937). However I find this nomenclature as unsatisfactory as the dating. It continues to assume they are simply variants of the same image, when in fact they are significantly different in composition and meaning. It also implies that the image published in 1948 comes after and is secondary to the more famous one, first made public in 1975. The titles for these images have changed over the years. In 1948 Dupain called his picture *Sunbaker,* and he used this title again in his 1975 retrospective for the other version as well. However in his 1980 retrospective it was called *The sunbaker,* and this title was also adopted by the National Gallery of Australia for its Dupain exhibition in 1991. In keeping with the argument of this essay and for the sake of both clarity and historical accuracy, I have chosen to title them *Sunbaker* (1940/1948) and *The sunbaker* (1937/1975).

30. Dupain, in Sydney Ure Smith, ed., *Max Dupain— Photographs* (Sydney: Ure Smith, 1948), 12.

31. Dupain wrote a posthumous appreciation of the work and life of his friend Damien Parer, which was published in the November–December 1946 issue of *Contemporary Photography.* In it, Dupain provided the following self-revealing pen portrait: "He believed in the Australian, not only in the way we all do, but with an inspired vehemence that gave you a sort of thrill and left you impressed and soberly hopeful."

32. C. Holme, "Editor's Introduction," *The Studio* (Autumn 1931), 1.

33. G. H. Saxon Mills, "Modern Photography: Its Development, Scope and Possibilities," *The Studio* (Autumn 1931), 5, 6, 12.

34. Max Dupain letter to the editor, *Sydney Morning Herald,* March 30, 1938, as quoted in Gael Newton, "Max Dupain," *Light Vision,* no. 5 (May–June 1978), 26.

35. Dupain, "Australian Camera Personalities: Max Dupain," *Contemporary Photography* (January–February, 1947), 57.

36. Dupain, "The Narrative Series," *Contemporary Photography* 2:1 (November–December 1948), 15–17.

37. Jack Cato, *The Story of the Camera in Australia* (Melbourne: Georgian House, 1955). For more on the conditions in which Australian photography was produced during the 1950s, see Dagmar Schmidmaier, *The Studio of Max Dupain: Post-War Photographs,* exhibition catalogue (Sydney: State Library of New South Wales, 1997), and Ann Stephen, "Largely a Family Affair: Photography in the 1950s," in Judith O'Callaghan, ed., *The Australian Dream: Design of the Fifties,* exhibition catalogue (Sydney: Powerhouse Publishing, 1993), 43–57. Stephen reproduces an image by Dupain of himself and his family reflected in a car bumper, an image originally published in the 1957 issue of *Australian Photography.* Despite its reference to the techniques of Rodchenko and Moholy-Nagy, this image is, she says, "almost defiantly non-avant-garde." A distorted, denaturalized interpretation of the family

snapshot, complete with self-portrait, it nevertheless incorporates a number of central aspects of postwar Australian life: the family, the car, and the great outdoors. The Australianness of these themes is discussed in relation to a painting by John Brack titled *The car* (1955) in Ian Burn, "Is Art History Any Use to artists?" in *Dialogue: Writings in Art History* (Sydney: Allen & Unwin, 1991), 1–14.

38. The foreword to Newton's catalogue was written by British photo historian Peter Turner: "I write this looking at a photograph by Max Dupain: *Sunbaker,* 1937. It has hung on my wall for two years. At every glance, and I must have made thousands, it speaks of the perception possessed by the world's most gifted photographers. In its modulation of light and tone, taut formality, rigorous geometry and energy, I recall Max Dupain, a man I met in 1977." Peter Turner, Foreword to in Newton, *Max Dupain,* 8. In 1987, Turner reproduced *The sunbaker* in his *History of Photography,* placing Dupain (and Australian photography) in a history of world photography for the first time. See Turner, *History of Photography* (London: Bison Books, 1987), 109. Dupain's dealer, Richard King, calculates that Dupain made fewer than one hundred prints of *The sunbaker.* In 1975 these prints sold for A$85; in 1992, one sold in New York for over A$5,000.

39. Loraine Herbert has pointed out that in both versions, the standing woman is framed on either side by intruding, masculine "aggressive elbows," such that she is "beset from below as well as from above." She also suggests that the woman is actually adjusting her bathing suit in the interests of propriety rather than hygiene. "As any woman knows, it is not so much the sand that worries her as the thought that her bottom is partially exposed to the male gaze." See Loraine Herbert, "Dupain's *Bondi,*" *History of Photography* 20:3 (Autumn 1996), 279.

40. Max Dupain, *Max Dupain's Australia* (New York: Viking, 1986).

41. Newton, "Max Dupain," *Light Vision.*

42. This version of *At Newport* can also be found in the collection of Australian Airlines. An installation photograph of the image, taken by Dupain himself, is reproduced in Biron Valier, "Corporate Sponsorship of the Visual Arts in Australia," *Art Monthly Australia,* no. 19 (April 1989), 5.

43. See Helen Grace's perceptive analysis of Dupain's practice as an art critic: "Reviewing Max Dupain," *Art Network,* no. 9 (Autumn 1983), 46–50. Helen Ennis has also pointed out the irony of Dupain's vehement opposition to manipulation and artificiality. She refers in particular to his photo montages from the 1930s and his contrived, artificially lit flower studies from the late 1980s. See Helen Ennis "Max Dupain (1911–1992)," *Art Monthly Australia,* no. 53 (September 1993), 18.

44. Indeed, photographers, unlike their historians, seem to have no trouble acknowledging the malleability of their medium, and therefore of their own histories. Witness Dupain's casual publication of different versions of his famous images. Or Stieglitz's constant retitling of *Paula* (sometimes emphasizing its function as a portrait and other times, when it becomes *Sunlight and Shadow,* for example, stressing its formal attributes). For them, as Dupain makes explicit in the following interview extract, different prints *are* different images:

Helen Ennis: Now, I did want to touch on *The sunbaker,* one of the most famous Australian pictures now. Do you have any explanations for its fame?

Max Dupain: No, but I'm a bit worried about it. I think it's taken on too much, so much so that you feel that

one of these days they'll say "that bloody sunbaker, there it is again!" . . .

 Helen: Actually I just heard it said last week that you couldn't take that photograph in good conscience now because of all the fear about the sun.

 Max: I thought of that—it might come up as a new image altogether, sooner or later.

Helen Ennis and Max Dupain, from an interview recorded on August 1, 1991, in Castlecrag and published in *Max Dupain Photographs,* exhibition catalogue (Canberra: National Gallery of Australia, 1991), 18.

45. On the history of the writing of Newhall's history, see Mary Warner Marien, "What Shall We Tell the Children? Photography and Its Text (Books)," *Afterimage* 13:9 (April 1986), 4–7, and Allison Bertrand, "Beaumont Newhall's "Photography 1839–1937," *History of Photography* 21:2 (Summer 1997), 137–146. Stieglitz's revelation theory was later turned into a visual formula by Ansel Adams's zone system." "Quite simply, previsualization is the key to the creative and expressive use of the medium on a conscious level." See Minor White, *Zone System Manual: How to Previsualize Your Pictures* (New York: Morgan & Morgan, 1968), 6. The close relationship between the historical method adopted by Newhall and the views of Stieglitz is made explicit in the self-declared "social history" of nineteenth-century American photography published by Robert Taft in 1938 (the year after Newhall's 1937 exhibition at the Museum of Modern Art had opened). In the body of his text, Taft refers to the contemporary development of "a satisfactory and logical system of aesthetics based on the distinguishing features of the photograph" (314). In a note at the foot of this page, Taft refers readers to "Beaumont Newhall's recent penetrating analysis of the problem." He then attaches an endnote that details Newhall's MoMA catalogue and moves straight on to quote the views of Stieglitz, as published in the *New York Times* in 1934 (497). See Robert Taft, *Photography and the American Scene: A Social History, 1839–1889* (New York: Dover, 1938).

46. This connection has been made explicit in a critique of Newton's writing by Anne-Marie Willis: "Beaumont Newhall's *History of Photography* established the writing of photographic history in terms of orthodox art history, primarily discussing work that could be attributed to specific authors and dealing with these bodies of work in terms of influences, schools, styles, movements. Newton's monograph on Max Dupain follows this pattern." See Willis, *Picturing Australia,* 263–266.

5

Thanks go to Ingrid Schaffner for introducing me to this kind of work and then encouraging the writing of this essay.

1. See, in particular, Anne-Marie Willis, "Digitisation and the Living Death of Photography," in Philip Hayward, ed., *Culture, Technology and Creativity in the late Twentieth Century* (London: John Libbey, 1990), 197–208, and William J. Mitchell, *The Reconfigured Eye: Visual Truth in the Post-Photographic Era* (Cambridge, MA: MIT Press, 1992).

2. Peter Bunnell, "Photographs as Sculpture and Prints," *Art in America* 57:5 (September–October 1969), 56–61. The exhibition, *Photography into Sculpture,* was shown at the Museum of Modern Art, New York, April 8–July 5, 1970, and then traveled to eight additional venues. There have been a number of subsequent exhibitions on this specific theme: they include *Photo/Synthesis,* curated by Jason D. Wong in 1976 for the Herbert F. Johnson Museum of Art at Cornell University; *Cross-References: Sculpture into Photography,* curated by Elizabeth Armstrong,

Marge Goldwater, and Adam Weinberg in 1987 for the Walker Art Center in Minneapolis; and *Constructing Images: Synapse Between Photography and Sculpture,* curated by Ingrid Schaffner in 1991 for Lieberman & Saul Gallery in New York.

3. Peter Bunnell, "Photography into Sculpture," *Degrees of Guidance: Essays on Twentieth-Century American Photography* (Cambridge: Cambridge University Press, 1993), 163-167.

4. See, for example, Charles Desmarais, *Proof: Los Angeles Art and the Photograph, 1960–1980,* exhibition catalogue (Laguna Beach, CA: Laguna Art Museum, 1992), and Ann Goldstein and Anne Rorimer, *Reconsidering the Object of Art: 1965–1975,* exhibition catalogue (Los Angeles: Museum of Contemporary Art, 1995).

5. *Information* was curated by Kynaston McShine and shown at the Museum of Modern Art, New York, July 2–September 20, 1970.

6. See David Hockney, *Cameraworks* (New York: Alfred A. Knopf, 1984), and Robert D. Romanyshyn, *Technology as Symptom and Dream* (London: Routledge, 1989), 58–64.

7. See Rupert Sheldrake, *A New Science of Life: The Hypothesis of Formative Causation* (Los Angeles: J. P. Tarcher, 1981).

8. See Rosalind Krauss, "Grids," *October* 9 (Summer 1979), 50–64. In combining the gridded patterning of fabric with the medium of photography (and especially the photogram), Cazabon's work recalls Henry Talbot's early (1835) contact prints of lace and, with it, photography's conception. In choosing the textile as her metaphor, there is also a reminder that photography means literally "light-writing." In a 1985 exhibition catalogue, for example, Ju-

dith Petite offers the following commentary on the lace imprints made in the 1850s by Victor Hugo: "Musing on these impressions as their author urges us to do, we may . . . recall that text and textile have the same common origin, and that ever since antiquity—see Plato's *Politicus*—the interweaving of threads has been compared to that of words." Petite is quoted in Ann Philbin and Florian Rodari, eds., *Shadows of a Hand: The Drawings of Victor Hugo,* exhibition catalogue (New York: Drawing Center, 1998), 32.

9. Roland Barthes, *The Pleasure of the Text,* trans. Richard Miller (New York: Hill and Wang, 1975), 7.

10. Cazabon here references an influential and voluminous body of work on both the relations of sight and touch, and the role of *suture* in the experience of looking and subject formation. On the former, see Michael J. Morgan, *Molyneaux's Question: Vision, Touch and the Philosophy of Perception* (Cambridge: Cambridge University Press, 1977). *Suture* is the word (drawn from the writings of Jacques Lacan) given in cinema theory to the process whereby a spectator is stitched into the narrative fabric of a film and thereby produced as a viewing subject. See Stephen Heath, "On Suture," *Questions of Cinema* (Bloomington: Indiana University Press, 1981), 76-112. In keeping with the fissure that Cazabon's work enacts, it is no surprise to find that *suture* in fact means, against all logic, both "to join" and "to separate."

11. Sigmund Freud, "Femininity," (1933), *The Complete Introductory Lectures on Psychoanalysis,* trans. James Strachey (New York: Norton, 1966), 596.

12. Sadie Plant, "The Future Looms: Weaving Women and Cybernetics," in Lynn Hershman Leeson, ed., *Clicking In: Hot Links to a Digital Culture* (Seattle: Bay Press, 1996), 128–129. On this theme, see also Teshome H.

Gabriel and Fabian Wagmister, "Notes on Weavin' Digital: T(h)inkers at the Loom," *Social Identities* 3:3 (1997), 333–343. Donna Haraway has also used the metaphor of weaving as a way of stitching women into cyberculture: "Networking is both a feminist practice and a multinational corporate strategy—weaving is for oppositional cyborgs." Donna Haraway, "A Cyborg Manifesto: Science, Technology, and Socialist-Feminism in the Late Twentieth Century," in *Simians, Cyborgs and Women: The Reinvention of Nature* (New York: Routledge, 1991), 170.

13. Ada Lovelace, "Notes to Sketch of the Analytical Engine invented by Charles Babbage," in Philip and Emily Morrison, *Charles Babbage and his Calculating Engines* (New York: Dover, 1961), 252.

14. H. Gaucheraud, *Gazette de France,* January 6, 1839, quoted in Helmut and Alison Gernsheim, *L. J. M. Daguerre: The History of the Diorama and the Daguerreotype* (New York: Dover, 1968), 85.

15. Henry Talbot, "Some Account of the Art of Photogenic Drawing," January 31, 1839, reproduced in Beaumont Newhall, *Photography: Essays and Images* (New York: Museum of Modern Art, 1980), 28.

16. This "archiwriting" conjures the "arche-writing" (a writing derived from an origin that "had itself always been a writing") that Jacques Derrida discusses in *Of Grammatology* as "that very thing which cannot let itself be reduced to the form of presence." See Derrida, *Of Grammatology,* trans. Gayatri Chakravorty Spivak (Baltimore: Johns Hopkins University Press, 1976), 56–57.

17. See Michel Foucault, *Discipline and Punish: The Birth of the Prison,* trans. Alan Sheridan (Harmondsworth: Penguin, 1977).

18. Maurice Berger, "Social Studies," in Andy Grundberg, ed., *James Casebere: Model Culture, Photographs, 1975–1996,* exhibition catalogue (San Francisco: Friends of Photography, 1996), 13.

19. Foucault, *Discipline and Punish,* 202.

20. Jacques Derrida, *Positions,* trans. Alan Bass (Chicago: University of Chicago Press, 1981), 94.

21. German photo artist Thomas Demand has taken this implosion of referent and reference even further. Using photographic images culled from the mass media (of, for example, the empty corridor outside the apartment once occupied by serial killer Jeffrey Dahmer or the dorm room where Bill Gates founded what became Microsoft), Demand carefully recreates their architectural features in cardboard and paper and then photographs these life-size stage sets in color. So here we have a photograph, showing nothing—nothing but mise-en-scène—that is able to induce a model, which in turn inspires a photograph (and who knows where it all ends?). Californian photographer Miles Coolidge also works with sets, but his come ready made. For two and a half years Coolidge took color photographs of Safetyville, a one-third-scale theme park near Sacramento, built as a place in which to teach children about road safety. At first glance the architecture looks real, but this reality is as insubstantial as a Hollywood backlot. Indeed, the longer one looks at his 1994 photographs, the more certain incongruities become apparent; young saplings dwarf buildings, wood chips look as large as rocks, the regular-sized curbs seem grotesquely oversized. See Douglas Fogle, *Stills: Emerging Photography in the 1990s,* exhibition catalogue (Minneapolis: Walker Art Center, 1997).

22. Another is contemporary German sculptor Stephan Balkenhol. Ingrid Schaffner has compared this artist's

rough-hewn wooden figures with their expressionless faces to the photographs of August Sander and Thomas Ruff, and speaks of works such as his series of *Kopfrelief* as being "composed like a giant photograph, snapped in wood." See Ingrid Schaffner, "The Living Sound of Wood: Stephan Balkenhol's Neo-expressionless Sculpture," in Jeff Wall, Ludger Gerdes, Hervé Vanel, and Ingrid Schaffner, *Stephan Balkenhol* (Paris: Editions Dis Voir, 1997).

23. Henry Talbot, "Plate V," in *The Pencil of Nature* (1844–1846), reproduced in Mike Weaver, *Henry Fox Talbot: Selected Texts and Bibliography* (Oxford: Clio Press, 1992), 89. For a detailed discussion of Talbot's many photographs of this bust, see Susan L. Taylor, "Fox Talbot as an Artist: The 'Patroclus' Series," *Bulletin of the University of Michigan Museums of Art and Archaeology* 8 (1986–1988), 38–55.

24. Mary Bergstein, "Lonely Aphrodites: On the Documentary Photography of Sculpture," *Art Bulletin* 74:3 (September 1992), 479.

25. See the commentary on *Le Noyé* in my *Burning with Desire: The Conception of Photography* (Cambridge, MA: MIT Press, 1997), 157–173, 252–254, and also Eugenia Parry Janis, "Fabled Bodies: Some Observations on the Photography of Sculpture," in Jeffrey Fraenkel, ed., *The Kiss of Apollo: Photography and Sculpture, 1845 to the Present* (San Francisco: Fraenkel Gallery, 1991), 9–23; 475–498, and Julia Ballerini, "Recasting Ancestry: Statuettes as Imaged by Three Inventors of Photography," in Anne Lowenthal, ed., *The Object as Subject: Essays on the Interpretation of Still Life* (Princeton: Princeton University Press, 1996), 41–58.

26. Robert A. Sobieszek, "Sculpture as the Sum of Its Profiles: François Willème and Photosculpture in France, 1859–1868," *Art Bulletin* 62 (December 1980), 624. See also Bates Lowry and Isabel Barrett Lowry, *The Silver Canvas: Daguerreotype Masterpieces from the J. Paul Getty Museum* (Los Angeles: J. Paul Getty Museum, 1998), 134. They report that at least two 1839 journalists, one English and one French, directly compared the inventions of Daguerre and Collas.

27. For more on nineteenth-century photo-sculpture, see Sobieszek, "Sculpture as the Sum of Its Profiles," 617–630; Gillian Greenhill, "Photo-Sculpture," *History of Photography* 4:3 (July 1980), 243–245; Heinz K. Henisch and Bridget A. Henisch, *The Photographic Experience, 1839–1914: Images and Attitudes* (University Park: Pennsylvania State University Press, 1994), 119; Jean-Luc Gall, "Photo/Sculpture: L'Invention de François Willème," *Etudes Photographiques* 3 (November 1997), 64–81; and the entry on photo-sculpture in Bernard E. Jones, ed., *Encyclopedia of Photography* (New York: Arno Press, 1974), 408.

28. See Ross Gibson, "The Colour Clavecin: On Jacky Redgate," *Photofile* 38 (March 1993), 10.

29. See Wade Lambert et al., "Sculpture Based on Photo Infringes on Photographer's Copyright, Judge Rules," *Wall Street Journal,* December 18, 1990, B10; Timothy Cone, "Fair Use?" *Arts Magazine* (December 1991), 25–26; Constance Hayes, "A Picture, a Sculpture and a Lawsuit," *New York Times,* September 19, 1991, B2; Ronald Sullivan, "Appeal Court Rules Artist Pirated Photo of Puppies," *New York Times,* April 3, 1992, B3; Martha Buskirk, "Appropriation Under the Gun," *Art in America* (June 1992), 37–40. Thanks to Holland Gallup for these references.

30. A. D. Coleman, "When Photos and Sculpture Get Married," *New York Observer,* November 11, 1991.

31. See Roland Barthes, *Camera Lucida: Reflections on Photography* (New York: Hill and Wang, 1981).

6

1. Although this exclamation is one of the most repeated quotations in the history of photographic discourse, there is no substantial evidence that Delaroche ever actually made such a statement. It first appears in Gaston Tissandier's *A History and Handbook of Photography*, trans. J. Thomson (London: Sampson, Low, Marston, Low and Searle, 1876), 63. Contrary to this account, Delaroche was the first painter of consequence to support the daguerreotype publicly and argue for its importance as an aid to artists. See Helmut and Alison Gernsheim, *L. J. M. Daguerre: The History of the Diorama and the Daguerreotype* (New York: Dover, 1968), 95.

2. See Timothy Druckrey, "L'Amour Faux," in *Digital Photography: Captured Images, Volatile Memory, New Montage*, exhibition catalogue (San Francisco: San Francisco Camerawork, 1988), 4–9; Fred Ritchin, "Photojournalism in the Age of Computers," in Carol Squiers, ed., *The Critical Image: Essays on Contemporary Photography* (Seattle: Bay Press, 1990), 28–37; Anne-Marie Willis, "Digitisation and the Living Death of Photography," in Philip Hayward, ed., *Culture, Technology and Creativity in the Late Twentieth Century* (London: John Libbey, 1990), 197–208; and William J. Mitchell, *The Reconfigured Eye: Visual Truth in the Post-Photographic Era* (Cambridge, MA: MIT Press, 1992), esp. 20. For further commentaries on the purported death of photography, see Fred Ritchin, "The End of Photography as We Have Known It," in Paul Wombell, ed., *Photo Video* (London: Rivers Oram Press, 1991), 8–15, and Kevin Robins, "Will Image Move Us Still?" in Martin Lister, ed., *The Photographic Image in Digital Culture* (London: Routledge, 1995), 29–50.

3. Nadar, "My Life as a Photographer" (1900), *October*, no. 5 (Summer 1978), 9.

4. For more on this genre of photography, see Tom Patterson, *100 Years of Spirit Photography* (London: Regency Press, 1965); Jule Eisenbud, *The World of Ted Serios: "Thoughtographic" Studies of an Extraordinary Mind* (New York: Morrow, 1967); Hans Holzer, *Psychic Photography: Threshold of a New Science* (New York: McGraw-Hill, 1969); Stanley Krippner and Daniel Rubin, eds., *The Kirlian Aura: Photographing the Galaxies of Life* (New York: Doubleday Anchor, 1974); Fred Gettings, *Ghosts in Photographs: The Extraordinary Story of Spirit Photography* (New York: Harmony Books, 1978); Dan Meinwald, *Memento Mori: Death in Nineteenth Century Photography*, CMP Bulletin, 9:4 (Riverside: California Museum of Photography, 1990); Rolf H. Krauss, *Beyond Light and Shadow: The Role of Photography in Certain Paranormal Phenomena: A Historical Survey* (Tucson, AZ: Nazraeli Press, 1994?); Jay Ruby, *Secure the Shadow: Death and Photography in America* (Cambridge, MA: MIT Press, 1995); Tom Gunning, "Phantom Images and Modern Manifestations: Spirit Photography, Magic Theatre, Trick Films, and Photography's Uncanny," in Patrice Petro, ed., *Fugitive Images: From Photography to Video* (Bloomington: Indiana University Press, 1995), 42–71; Catherine Wynne, "Arthur Conan Doyle and Psychic Photographs," *History of Photography* 22:4 (Winter 1998), 385–392.

5. N. P. Willis, "The Pencil of Nature" (April 1839), as quoted in Alan Trachtenberg, "Photography: The Emergence of a Keyword," in Martha A. Sandweiss, ed., *Photography in Nineteenth-Century America* (Fort Worth, TX: Amon Carter Museum of Western Art, 1991), 30.

6. Walter Benjamin, "The Work of Art in the Age of Mechanical Reproduction" (1936), in John Hanhardt, ed.,

Video Culture: A Critical Investigation (New York: Visual Studies Workshop, 1986), 27.

7. Walter Benjamin, "A Short History of Photography" (1931), in Alan Trachtenberg, ed., *Classic Essays on Photography* (New Haven: Leete's Island Books, 1980), 199.

8. Michel Foucault, *The Order of Things: An Archaeology of the Human Sciences* (New York: Random House, 1970), 206–207.

9. Ibid., 238.

10. For more detailed versions of this argument, see my *Burning with Desire: The Conception of Photography* (Cambridge, MA: MIT Press, 1997).

11. Henry Talbot, "Some Account of the Art of Photogenic Drawing" (1839), in Beaumont Newhall, ed., *Photography: Essays and Images* (New York: Museum of Modern Art, 1980), 25.

12. *The Athenaeum,* February 22, 1845, quoted in Larry J. Schaaf, "'A Wonderful Illustration of Modern Necromancy': Significant Talbot Experimental Prints in the J. Paul Getty Museum," in Weston Naef, ed., *Photography: Discovery and Invention* (Los Angeles: Getty Museum, 1990), 44.

13. Roland Barthes, *Camera Lucida: Reflections on Photography* (New York: Hill and Wang, 1981).

14. See Claudia H. Deutsch, "Kodak Talks to Buy a Wang Software Unit," *New York Times,* October 4, 1996, C16.

15. This aspiration was voiced by Corbis's CEO, Doug Rowen, in Kate Hafner, "Picture This," *Newsweek,* June 24, 1996, 88–90.

16. For more on Corbis and its operations, see Corey S. Powell, "The Museum of Modern Art," *World Art* 1:2 (1994), 10–13; Steve Lohr, "Huge Photo Archive Bought by Software Billionaire Gates," *New York Times,* October 11, 1995, C1, C5; Edward Rothstein, "How Bill Gates Is Imitating Art," *New York Times,* October 15, 1995, E3; Welton Jones, "Gated Archive," *San Diego Union-Tribune,* October 31, 1995, E1, E3; Corbis, *Corbis Catalogue: Selections from the Corbis Digital Archive,* vol. 1 (Seattle: Corbis Corporation, 1996); Richard Rapaport, "In His Image," *Wired* 4:11 (November 1996), 172–175, 276–283; Geoffrey Batchen, "Manifest Data: The Image in the Age of Electronic Reproduction," *Afterimage* 24:3 (November–December 1996), 5–6; and Geoffrey Batchen, "Photogenics," *History of Photography* 22:1 (Spring 1998), 18–26. There are numerous signs that Corbis is not alone in believing that the electronic image represents the future of the photographic industry. In a recent interview, for example, Eliane Laffont, president of the Sygma photo agency, reports that 50 percent of her spot-news images are now sold and distributed electronically. Sygma has 680,000 of its images digitized and available on-line. See Ken Lassiter, "Photographers Come First with Eliane Laffont of Sygma Photo News," *Photographer's Forum* 20:3 (September 1998), 47–54.

17. See Keith Kenney, "Computer-Altered Photos: Do Readers Know Them When They See Them?" *News Photographer* (January 1993), 26–27.

18. See Martha Rosler, "Image Simulations, Computer Manipulations: Some Considerations," *Ten.8: Digital Dialogues* 2:2 (1991), 52–63, and Fred Ritchin, *In Our Own Image: The Coming Revolution in Photography* (New York: Aperture, 1990).

19. The image used for The New Face of America cover (*Time* Special Issue, Fall 1993) was a female "portrait"

composed by Kin Wah Lam from the digitally merged faces of fourteen models; supposedly representing the racial mix of present-day United States, the "New Face of America" is 15 percent Anglo-Saxon, 17.5 percent Middle Eastern, 17.5 percent African, 7.5 percent Asian, 35 percent Southern European and 7.5 percent Hispanic. This kind of multiexposure montage practice was first associated with computing through the work of American artist Nancy Burson in the early 1980s. Her *Mankind* (1983–1985), for example, merged the planet's three major races according to their respective population percentages. See Nancy Burson, Richard Carling, and David Kramlich, *Composites: Computer Generated Portraits* (New York: Beech Tree Books, William Morrow & Co., 1986). However, such a photographic practice is neither new nor peculiar to digital imaging. Francis Galton, for example, employed a system of "composite portraiture" (combining as many as two hundred faces on a single photographic plate) in the 1870s and 1880s in order to synthesize the essential features of particular racial and social groups (Jews, criminals, lunatics, and so on). See Martin Kemp, "'A Perfect and Faithful Record': Mind and Body in Medical Photography before 1900," in Ann Thomas, ed., *Beauty of Another Order: Photography in Science* (New Haven and London: Yale University Press, 1997), 130–133.

20. James R. Gaines, "To Our Readers," *Time,* July 4, 1994, 4. Despite this attempted explanation, *Time* magazine now refuses to sell this particular back issue and also refuses permission to reproduce it. Interestingly, in 1997, the tables were turned. In November 1997 both *Time* and *Newsweek* featured photographs of Bobby and Kenny McCaughey, the parents of septuplets, on their respective covers. However *Newsweek,* unlike *Time,* chose to digitally alter Mrs. McCaughey's teeth, straightening and whitening them. *Newsweek*'s editor in chief, Richard W. Smith, claimed that the enhancement was in no way analogous to what *Time* did with O. J. Simpson because the alterations

were not made to "harm Mrs. McCaughey or deceive the reader." See Kenneth N. Gilpin, "Doctoring of Photos, Round 2," *New York Times,* November 26, 1997, A14.

21. See Jean Seligmann, "Cher Gets an Unwanted Makeover," *Newsweek,* October 21, 1996, 95, and Alex Kuczynski, "Dustin Hoffman Wins Suit on Photo Alteration," *New York Times,* January 23, 1999, A30. These kinds of manipulations are also taking place within the practice of nature photography. See David Roberts, "Unnatural Acts: A feud over digitally altered photos has nature photographers rethinking the meaning of their work," *American Photo,* March/April 1997, 28–30.

22. For numerous examples of predigital alterations to photographs, see Rosler, "Image simulations, computer manipulations," and Vicki Goldberg, *The Power of Photography: How Photographs Changed Our Lives* (New York: Abbeville Press, 1991).

23. Susan Sontag, *On Photography* (New York: Penguin, 1977), 154. Rosalind Krauss, "The Photographic Conditions of Surrealism" (1981), in *The Originality of the Avant-Garde* (Cambridge, MA: MIT Press, 1984), 112.

24. For more on the role of the photograph within *Blade Runner* (Ridley Scott, 1982), see Giuliana Bruno, "Ramble City: Postmodernism and Blade Runner," *October,* no. 41 (Summer 1987), 61–74; Elissa Marder, "Blade Runner's Moving Still," *Camera Obscura,* no. 27 (September 1991), 88–107; Kaja Silverman, "Back to the Future," *Camera Obscura,* no. 27 (September 1991), 108–133; and Scott Bukatman, *Blade Runner* (London: BFI, 1997).

25. See Laura Shapiro, "A Tomato with a Body That Just Won't Quit," *Newsweek,* June 6, 1994, 80–82; and Lawrence M. Fisher, "Down on the Farm, a Donor:

Genetically Altered Pigs Bred for Organ Transplants," *New York Times,* January 5, 1996, C1, C6.

26. See Peirce's "Logic as Semiotic: The Theory of Signs" (c.1897–1910), in Justus Buchler, ed., *Philosophical Writings of Peirce* (New York: Dover, 1955), 98–119. This erasure of fixed origins would seem at variance with the distinction Victor Burgin maintains between the digital photograph (a copy with no original) and the photograph (which, he implies in the quotation below, is a copy that does indeed have an origin): "The electronic image fulfills the condition of what Baudrillard has termed the simulacrum—it is a copy of which there is no original. It is precisely in *this* characteristic of digital photography, I believe, that we must locate the fundamental significance of digital photography in Western history." See Victor Burgin, "The Image in Pieces: Digital Photography and the Location of Cultural Experience," in Hubertus v. Amelunxen et al., eds., *Photography after Photography: Memory and Representation in the Digital Age,* exhibition catalogue, Siemens Kulturprogramm (Amsterdam: G+B Arts, 1996), 29.

27. Jacques Derrida, *Of Grammatology,* trans. Gayatri Spivak (Chicago: University of Chicago Press, 1976), 48–50.

28. Derrida calls spacing "the impossibility for an identity to be closed in on itself, on the inside of its proper interiority, or on its coincidence with itself." See Jacques Derrida, *Positions,* trans. Alan Bass (Chicago: University of Chicago Press, 1981), 94.

29. Jacques Derrida, "The Deaths of Roland Barthes" (1981), trans. Pascale-Anne Brault and Michael Naas, in Hugh Silverman, ed., *Philosophy and Non-Philosophy Since Merleau-Ponty* (New York: Routledge, 1988), 267.

7

Thanks to Carla Yanni, Thomas Barrow, Larry Schaaf, Sheldon Brown, and Vicki Kirby for their editorial suggestions.

1. The exhibition, curated by Kathleen Howe with the assistance of Floramae Cates and Carol McCusker, was titled *With the Help of Our Friends: Photography Acquisitions, 1985–1995* (August 28, 1996–December 8, 1996). This essay is an expanded version of a talk I gave in conjunction with the exhibition on October 8, 1996, under the title "Photography as Trace." It also incorporates aspects of a talk, "The Matter of Photography," I gave at the College Art Association Annual Conference in New York on February 13, 1997, and elements of an earlier publication, "Evidence of a Novel Kind: Photography as Trace," *San Francisco Camerawork* 23:1 (Spring–Summer 1996), 4–7.

2. See my "Ectoplasm: Photography in the Digital Age," in Carol Squiers, ed., *Over Exposed: Essays on Contemporary Photography* (New York: New Press, 1999), 9–23.

3. Steve Lohr, "Huge Photo Archive Bought by Software Billionaire Gates," *New York Times,* October 11, 1995, C1, C5.

4. For example, Corbis announced on December 4, 1996, that it had expanded its New York stock agency business with the purchase of the LGI Photo Agency. LGI specializes in images for the entertainment business and editorial marketplace. It should be noted that for most of the institutions mentioned, Corbis has actually negotiated nonexclusive rights, with each institution continuing to have some control over where and how its pictures are reproduced.

5. Corbis, *Corbis Catalogue: Selections from the Corbis Digital Archive,* vol. 1 (Seattle: Corbis Corporation, 1996).

6. On September 16, 1997, for example, Getty Communications announced that it would acquire Photodisc Inc., the largest provider of images on the Internet, thus creating the world's largest purveyor of archived photographs. For more on Corbis, see Edward Rothstein, "How Bill Gates Is Imitating Art," *New York Times,* October 15, 1995, E3; Corey S. Powell, "The Museum of Modem Art," *World Art* 1:2 (1994), 10–13; Richard Rapaport, "In His Image," *Wired* 4:11 (November 1996), 172–175, 276–283; Warren St. John, "Bill Gates Just Points and Clicks, Zapping New York's Photo Libraries," *New York Observer,* December 16, 1996, 1, 19; and my "Manifest Data: The Image in the Age of Electronic Reproduction," *Afterimage* 24:3 (November-December 1996), 5–6.

7. See Walter Benjamin, "The Work of Art in the Age of Mechanical Reproduction" (1936), in *Illuminations* (New York: Fontana/Collins, 1970), 219–253.

8. On June 27, 1997, the U.S. Supreme Court declared unconstitutional a federal law that had made it a crime to send "indecent" material over the Internet. This ruling associated the Internet with books and newspapers in terms of its entitlement to freedom of speech (rather than with the more limited rights accorded broadcast and cable television). For general discussions of this decision and other legal debates about indecency on the Internet, see Linda Greenhouse, "Statute on Internet Indecency Draws High Court's Review," *New York Times,* December 7, 1996, A1, A8; Linda Greenhouse, "What Level of Protection for Internet Speech?" *New York Times,* March 24, 1997, C5; and Linda Greenhouse, "Decency Act Fails: Effort to Shield Minors Is Said to Infringe the First Amendment," *New York Times,* June 27, 1997, A1, A16.

9. This aspiration was voiced by Corbis's CEO, Doug Rowen, in Kate Hafner, "Picture This," *Newsweek,* June 24, 1996, 88–90.

10. In 1991 an amateur astronomer, Dennis di Cicco, calculated the exact time and date when this photograph was taken—4:49:20 P.M. Mountain Standard Time on November 1, 1941. Interestingly, this calculation was achieved by first transforming the photograph into astronomical data (derived from the pictured moon's altitude and angle from true north). See Mike Haederle, "'Moonrise' Mystery," *Los Angeles Times,* October 31, 1991, E1, E4. Thanks to Tom Barrow for this reference.

11. For an introduction to the complexities of American copyright law, see Robert A. Gorman, *Copyright Law* (Washington, D.C.: Federal Judicial Center, 1991). As Gorman points out, "Copyright is a form of 'intangible' property. The subject of copyright—the words of a poem or the notes of a song—can exist in the mind of the poet or composer, or can be conveyed orally, without being embodied in any tangible medium. Even when thus embodied, it is possible for persons to recite a poem, sing a song, perform a play, or view a painting without having physical possession of the original physical embodiment of the creative work" (6). For this reason, a computer program is covered by copyright law as a form of "literary work."

12. The Christies auction catalogue of April 17, 1997, for example, reproduces two visibly different versions of this image—one printed between 1958 and 1961 and one printed in 1978 (Lots 278 and 282).

13. Mary Street Alinder, *Ansel Adams: A Biography* (New York: Holt, 1996), 185.

14. Ferdinand de Saussure, *Course in General Linguistics,* trans. Wade Baskin (New York: McGraw-Hill, 1966), 120.

15. Jacques Derrida, "Différance" (1968), in *Margins of Philosophy,* trans. Alan Bass (Chicago: University of Chicago Press, 1982), 63.

16. Scottish scientist Ian Wilmut announced that he had cloned the first mammal from a single adult cell on February 22, 1997. For commentary on this event, see Gina Kolota, "With Cloning of a Sheep, the Ethical Ground Shifts," *New York Times,* February 24, 1997, A1, C17; Lawrence M. Fisher, "Cloned Animals Offer Companies a Faster Path to New Drugs," *New York Times,* February 24, 1997, C17; Michael Specter, with Gina Kolata, "After Decades and Many Missteps, Cloning Success," *New York Times,* March 3, 1997, A1, A8–A10; J. Madeleine Nash, "The Age of Cloning," *Time,* March 10, 1997, 62–65; Sharon Begley, "Little Lamb, Who Made Thee?" *Newsweek,* March 10, 1997, 52–59; R. C. Lewontin, "The Confusion over Cloning," *New York Review of Books,* October 23, 1997, 18–23.

17. Bill Gates, *The Road Ahead* (New York: Penguin, 1996), 258.

18. Ibid., 257.

19. Lyotard claims that "modern aesthetics is an aesthetic of the sublime, though a nostalgic one." See Jean-François Lyotard, "Answering the Question: What Is Postmodernism?" (1982), in *The Postmodern Condition: A Report on Knowledge* (Minneapolis: University of Minnesota Press, 1984), 71–82, and "Presenting the Unrepresentable: The Sublime," *Artforum* (April 1982), 64–69.

20. Foucault opens his Preface to *The Order of Things* by recalling his encounter with a passage written by the novelist Borges. The passage quotes from a "certain Chinese encyclopedia" in which it is written that "animals are divided into: (a) belonging to the Emperor, (b) embalmed, (c) tame, (d) sucking pigs, (e) sirens, (f) fabulous, (g) stray dogs, (h) included in the present classification, (i) frenzied, (j) innumerable, (k) drawn with a very fine camelhair brush, (l) et cetera, (m) having just broken the water pitcher, (n) that from a long way off look like flies." Foucault speaks of the "wonderment of this taxonomy," taking it to demonstrate "the exotic charm of another system of thought." But it also makes him think more keenly about the presumed logic of his own. See Michel Foucault, *The Order of Things: An Archaeology of the Human Sciences* (New York: Vintage Books, 1973), xv–xx.

21. As Gates has suggested, "We make it so easy to call up images, whether art or people or beaches or sunsets or Nobel Prize winners." See Trip Gabriel, "Filling in the Potholes in the 'Road Ahead'," *New York Times,* November 28, 1996, B6.

22. See Roland Barthes, *Camera Lucida: Reflections on Photography,* trans. Richard Howard (New York: Hill and Wang, 1981). Barthes describes his relationship to photography in terms of an intensely personal experience he calls *punctum:* "It is what I add to the photograph and what is nonetheless already there" (55).

23. See Laura Shapiro, "A Tomato with a Body That Just Won't Quit," *Newsweek,* June 6, 1994, 80–82; Lawrence M. Fisher, "Down on the Farm, a Donor: Genetically Altered Pigs Bred for Organ Transplants," *New York Times,* January 5, 1996, C1, C6; Teresa Riordan, "A Recent Patent on a Papua New Guinea Tribe's Cell Line Prompts Outrage and Charges of 'Biopiracy,'" *New York Times,* November 27, 1995, C2. The genetically engineered foods

that are now, or soon will be, available to consumers include abalone, apples, asparagus, carrots, catfish, chestnuts, corn, grapes, lettuce, potatoes, prawns, rice, salmon, walnuts, and wheat. As the *New York Times* reports, "For now the only way Americans can avoid genetically engineered food is to choose certified organic food." See Marian Burros, "Trying to Get Labels on Genetically Altered Food," *New York Times,* May 21, 1997, B8.

24. This has in fact been the case for some time. Experiments in transmitting images by telegraph were attempted as early as the 1870s and were common by the 1890s. The German scientist Alfred Korn worked out a way to transmit photographic images from Berlin to Paris early in the twentieth century, using a selenium photocell that translated light differentials into variations in electrical current. In 1907, *Scientific American* published a photographic reproduction of Germany's crown prince sent by Korn from Berlin over a telegraph wire. By 1935, Associated Press was transmitting photographic images over its Wirephoto network. In the mid-1950s, scientists at the National Bureau of Standards were able to convert photographs into processible digital information, thus making them transmittable between computers. Adobe Photoshop, a software package allowing the manipulation of a digitized photographic image, was introduced in 1989, the year of photography's sesquicentenary. See Marianne Fulton, *Eyes of Time: Photojournalism in America* (Boston: Little, Brown, 1988), and William J. Mitchell, *The Reconfigured Eye: Visual Truth in the Post-Photographic Era* (Cambridge, MA: MIT Press, 1992).

25. See Larry Schaaf, "Anna Atkins' Cyanotypes: An Experiment in Photographic Publishing," *History of Photography* 7:2 (April 1982), 151–172; Larry Schaaf, *Sun Gardens: Victorian Photograms by Anna Atkins* (New York: Aperture, 1985); Larry Schaaf, *Sun Gardens: An Exhibition of Victorian Photograms by Anna Atkins,* exhibition catalogue (St. Andrews, Scotland: Crawford Centre for the Arts, 1988).

26. This poem appears in "Poetry &c by my beloved Father, John George Children, esq. Collected in love and reverence by his grateful & sorrowing child. A. A." This and another manuscript, titled "Autograph Poetry by the late George Children, esq. Collected and arranged in this volume by his granddaughter [Anna Atkins], as a mark of her gratitude, and veneration for his memory, 1853," are held by the Harry Ransom Humanities Research Center, University of Texas at Austin. Further examples of Children's poems are printed in [Anna Atkins], *Memoir of J. G. Children, Esq. Including Some Unpublished Poetry, by His Father and Himself* (London: John Bowyer Nichols and Sons, 1853). Anxious to find artistic qualities in Atkins's cyanotypes, Weston Naef refers to them as "poetic photograms that inspired Atkins' own verses about representation and reality." See Weston Naef, *The J. Paul Getty Museum Handbook of the Photographs Collection* (Malibu, CA: J. Paul Getty Museum, 1995), 17. However he gives no source for the particular poems to which he refers. Nevertheless, it appears that Atkins did follow in her father's footsteps as a poet, reproducing one effort from 1853 on the final page of her *Memoir* to him (313).

27. Atkins makes no mention of her father's (or her own) interest in photography in her biography, *Memoir of J. G. Children,* although she does record his use of a telescope and his involvement in 1842 in the construction of an artificially lit "apparatus . . . for showing dissolving views" from which "beautiful pictures" were painted by a family friend (285–286, 294).

28. Larry Schaaf, *Out of the Shadows: Herschel, Talbot and the Invention of Photography* (New Haven: Yale University Press, 1992), 130–131.

29. Ibid., 130.

30. In 1823 Atkins herself had produced 256 drawings of shells, which were then transformed into engravings to illustrate her father's translation of Lamarck's *Genera of Shells.* The "cut flower mosaic" technique of illustration was invented by a Mrs. Delany in the eighteenth century. See plate 50 in Mrs. Neville Jackson, *Silhouette: Notes and Dictionary* (New York: Charles Scribner's Sons, 1938).

31. Schaaf, *Sun Gardens,* 31.

32. Ibid., 33. The reference is to figure 13A–C, showing the same specimen of Dictyota dichotoma in three different arrangements.

33. In e-mail correspondence exchanged in October 1996, Schaaf made the following comment to me on this possibility: "Mica was available in larger sheets than we are used to now but it was still scarce and relatively expensive. She might have used waxed paper (as in the labels) but I have no direct evidence of this. But the number of specimens that are arranged in subtly different ways—ie, rotated slightly, would indicate that they were printed nude. If one was working with even a very large sheet of mica, one would be likely to orient it more consistently."

34. Larry J. Schaaf, *Records of the Dawn of Photography: Talbot's Notebooks P&Q* (Cambridge: Cambridge University Press, 1996), 29.

35. Graham Smith, "Talbot and Botany: The Bertoloni Album," *History of Photography* 17:1 (Spring 1993), 40.

36. Schaaf, *Notebooks P&Q,* 7.

37. See Larry Schaaf, *Sun Pictures: Photogenic Drawings by William Henry Fox Talbot* (New York: Hans P. Krauss Catalogue Seven, 1995), 18.

38. Allan Sekula, "Photography Between Labour and Capital," in Benjamin H. D. Buchloh and Robert Wilkie, eds., *Mining Photographs and Other Pictures, 1948–1968: A Selection from the Negative Archives of Shedden Studio, Glace Bay, Cape Breton* (Halifax: Press of the Nova Scotia College of Art and Design and University College of Cape Breton Press, 1983), 218.

39. William Henry Fox Talbot, "Some Account of the Art of Photogenic Drawing" (1839), in Beaumont Newhall, ed., *Photography: Essays and Images* (New York: Museum of Modern Art, 1980), 24.

40. William Henry Fox Talbot, *The Pencil of Nature* (1844–46; facsimile edition, New York: Da Capo, 1968), plate 3.

41. Rosalind Krauss, "Notes on the Index: Part I" (1977), *The Originality of the Avant-Garde and Other Modernist Myths* (Cambridge, MA: MIT Press, 1985), 203.

42. Jacques Derrida, *Of Grammatology,* trans. Gayatri Spivak (Baltimore: Johns Hopkins University Press, 1976), 143.

43. Jacques Derrida, *Positions,* trans. Alan Bass (Chicago: University of Chicago Press, 1981), 94.

44. Derrida, *Of Grammatology,* 157.

8

I thank Larry Schaaf, Marlene Stutzman, Danielle Miller, Martin Campbell-Kelly, Alex Novak, and Tom Barrow for their research and editorial assistance.

1. See, for example, my own essays; "Ectoplasm: The Photograph in the Age of Electronic Reproduction," in Carol Squiers, ed., *Over Exposed: Essays on Contemporary Photography,* 2d ed. (New York: New Press, 1999), and "Photogenics," *History of Photography* 22:1 (Spring 1998), 18–26.

2. Charles Babbage to Elisabeth Feilding, March 18, 1841 (*Lacock Abbey [LA] 40–35*).

3. As Babbage wrote to Henry Talbot on January 19, 1838, "My interminable work rarely leaves me any time for other pursuits, it does however itself advance and I have just commenced the description of the mathematical properties of the Calculating Engine" (*LA 38–3*).

4. See Graham Smith, "Rejlander, Babbage, and Talbot," *History of Photography* 18:3 (Autumn 1994), 285–286.

5. See ibid.; Nicholas J. Wade, ed., *Brewster and Wheatstone on Vision* (Orlando, FL: Academic Press, 1983), 36; and Doron Swade, *Charles Babbage and His Calculating Engines* (London: Science Museum, 1991).

6. Talbot, "Some Account of the Art of Photogenic Drawing, or, the Process by Which Natural Objects May Be Made to Delineate Themselves Without the Aid of the Artist's Pencil" (January 1839), in Beaumont Newhall, ed., *Photography: Essays and Images* (New York: Museum of Modern Art, 1980), 28.

7. Although she had not yet read it, Ada Lovelace claimed that this book resembled "one of the curious (multum in parvo) algebraical expressions ... which under a few simple symbols involve & indicate to the initiated quantities endless in their complication & variety of mutual relations." Ada Lovelace to Mary Somerville, June 22, 1837, as quoted in Betty Alexander Toole, *Ada, the Enchantress of Numbers: Prophet of the Computer Age* (Mill Valley, CA: Strawberry Press, 1998), 69. For further commentaries on Babbage's *Ninth Bridgwater Treatise,* see Anthony Hyman, *Charles Babbage: Pioneer of the Computer* (Oxford: Oxford University Press, 1982), 136–142; Allan G. Bromley, "Difference and Analytical Engine," in William Aspray, ed., *Computing Before Computers* (Ames: Iowa University Press, 1990), 59–98; and I. Grattan-Guinness, "Charles Babbage as an Algorithmic Thinker," *Annals of the History of Computing* 14:3 (1992), 34–48. In December 1837, Babbage also wrote an unpublished paper, "On the Mathematical Powers of the Calculating Engine." It is reproduced in Brian Randell, ed., *The Origins of Digital Computers: Selected Papers* (Berlin: Springer-Verlag, 1973), 17–52.

8. Nathaniel Willis, "The Pencil of Nature: A New Discovery," *The Corsair: A Gazette of Literature, Art, Dramatic Criticism, Fashion and Novelty,* April 13, 1839, 70–72. Perhaps Willis's essay was read by Philip Hone, for he too associated photography with the sound of the human voice. Writing in his journal on December 4, 1839, Hone penned the following thought: "It appears to me not less wonderful that light should be made an active operating power in this manner, and that some such effect should be produced by sound; and who knows whether, in this age of invention and discoveries, we may not be called upon to marvel at the exhibition of a tree, a horse, or a ship produced by the human voice muttering over a metal plate, prepared in the same or some other manner, the words 'tree', 'horse', and 'ship'". See Bayard Tuckerman, ed., *The Diary of Philip Hone 1828–1851* (New York: Dodd, Mead, 1889), 392.

9. The link between the invention of photography and contemporary developments in Romantic poetry and painting is discussed in my *Burning with Desire: The Conception of Photography* (Cambridge, MA: MIT Press, 1997). The same connections can be traced with regard to the conception of the computer. It is well known that Babbage was greatly assisted in the articulation of his ideas about the Analytical Engine by Lord Byron's daughter, Ada Lovelace. John Murray, the publisher of his *Ninth Bridgwater Treatise,* was also Byron's publisher, and Babbage opens his autobiographical *Passages* with a quotation from Byron's *Don Juan.* As it happens, Talbot's neighbor was Byron's friend and biographer, the Irish poet Thomas Moore. In late February 1840, possibly thinking of a planned memorial publication on Byron ("The Tribute of Science to Poetry" Talbot called it in his research Notebook P), Talbot made three photogenic drawing negative contact prints of a handwritten manuscript page from Byron's *Ode to Napoleon.* See Larry Schaaf, *Sun Pictures: Photogenic Drawings by William Henry Fox Talbot,* Catalogue Seven (New York: Hans Krauss, Jr., 1995), 32–33.

10. Talbot, "Some Account," in Newhall, *Photography: Essays and Images,* 24. In a letter to Talbot dated February 2, 1840, his mother, Lady Elisabeth, provided another version of this same gratifying story. Having just spoken of Babbage, she then told Henry of meeting a German baron who wanted some photogenic drawings to give to Metternich: "The leaf of the old book particularly enchanted him, & he could not at first believe it was not itself actually laid down under the glass" (*LA 40–13*). See also my commentary on the philosophical dilemma posed by these early photograms in "Photogenics," *History of Photography,* 18–26.

11. Root Cartwright to the author, May 15, 1998. It is well to remember that the other subject Talbot regularly pictured in his earliest contact prints were texts written in his own handwriting. In a 1985 exhibition catalogue, Judith Petite offers the following commentary on the lace imprints made in the 1850s by Victor Hugo: "Musing on these impressions as their author urges us to do, we may . . . recall that text and textile have the same common origin, and that ever since antiquity—see Plato's *Politicus*—the interweaving of threads has been compared to that of words." Petite is quoted in Ann Philbin and Florian Rodari, eds., *Shadows of a Hand: The Drawings of Victor Hugo,* exhibition catalogue (New York: Drawing Center, 1998), 32.

12. See Schaaf, *Sun Pictures,* 26–27.

13. Ibid. One of the remarkable things about Babbage's engines was that they involved significant advances in manufacturing and machining procedures. The Difference Engine, for example, was one of the first machines to have interchangeable parts, such that any nut could fit on any bolt in the apparatus. This drive toward mass production of standardized parts has its counterpart in the development of Talbot's negative-positive system in which numerous copies could be made from a single visual matrix. We already see this idea in play in contact prints being made from the same piece of lace; the lace itself becomes the negative or matrix from which copies are then struck. We see it again evidenced in another of the prints it seems that Talbot sent to Babbage in 1839 (it was eventually sold as part of Babbage's estate), a salt print from a cliché verre negative now titled *Villagio.* Three prints from this particular matrix (which Talbot possibly made in Switzerland in 1834 as part of his earliest photographic experiments) survive, suggesting he thought of the process as a fledgling form of "photogenic etching" or multiple reproduction. For more on this image, see Schaaf, *Sun Pictures,* 12–13.

NOTES TO PAGES 167–173

224

14. Douglas R. Nickel, "Nature's Supernaturalism: William Henry Fox Talbot and Botanical Illustration," in Kathleen Howe, ed., *Intersections: Lithography, Photography and the Traditions of Printmaking* (Albuquerque: University of New Mexico Press, 1998), 19.

15. See Patricia Wardle, *Victorian Lace* (New York: Praeger, 1969), 227. In fact, punched cards were in use in English ribbon factories as early as 1834. Lady Anne Byron made a drawing of such a card after a visit to one of these factories in the summer of 1834. See Toole, *Ada, The Enchantress of Numbers,* 43.

16. See the entry on Joseph Marie Jacquard in J. A. N. Lee, ed., *International Biographical Dictionary of Computer Pioneers* (Chicago: FD, 1995), and Sadie Plant, "The Future Looms: Weaving Women and Cybernetics," in Lynn Hershman Leeson, ed., *Clicking In: Hot Links to a Digital Culture* (Seattle: Bay Press, 1996), 123–135, 349–350. The portrait shows Jacquard holding a compass, sign of mathematical calculation, sitting in front of a small model of a Jacquard loom. It was based on an original oil painting by Claude Bonnedfond.

17. Babbage (1833), as quoted in Joel Shurkin, *Engines of the Mind: The Evolution of the Computer from Mainframes to Microprocessors* (New York: Norton, 1996), 58. As Stephen Johnson suggests, "The name computer is something of a misnomer, since the real innovation here is not simply the capacity for numerical calculation (mechanical calculators, after all, predate the digital era by many years). The crucial technological breakthrough lies instead with this idea of the computer as a symbolic system, a machine that traffics in representations or signs rather than in the mechanical cause-and-effect of the cotton gin or the automobile." Stephen Johnson, *Interface Culture: How New Technology Transforms the Way We Create and Communicate* (New York: HarperEdge, 1997), 15.

18. Charles Babbage, *Passages from the Life of a Philosopher,* ed. Martin Campbell-Kelly (New Brunswick, NJ: Rutgers University Press, 1994), 86, 89, 97, and as quoted in Shurkin, *Engines of the Mind,* 53. In the text that he sent Babbage in 1839, "Some Account of the Art of Photogenic Drawing," Talbot also described his process in terms of a possible resolution of the relations of space and time; photography is, he suggested, an emblematic something/sometime, a "space of a single minute" in which space becomes time, and time space. See my *Burning with Desire,* 91.

19. Lady Anne Byron to Dr. William King, June 21, 1833, as quoted in Toole, *Ada, The Enchantress of Numbers,* 38–39.

20. On November 28, 1834, for example, Lady Byron recorded in her diary that Babbage explicitly "alleged that the engine could show that miracles were not only possible but probable." See ibid., 50.

21. For Babbage's foray into the life insurance business, see Martin Campbell-Kelly, "Charles Babbage and the Assurance of Lives," *Annals of the History of Computing* 16:3 (1994), 5–14, and for more on the Scheutz Difference Engine, see Michael Lindgren, *Glory and Failure: The Difference Engines of Johann Müller, Charles Babbage and Georg and Edvard Scheutz* (Stockholm: Linköping University, Department of Technology and Social Change, 1987).

22. Ironically, Babbage himself was turned into data after his death in 1871. His brain was preserved in alcohol and then dissected thirty-eight years later by Sir Victor Horsley of the Royal Society as a contribution to prevailing information on the physiological peculiarities of "profound thinkers."

23. See my *Burning with Desire.*

24. Michel Foucault, *Discipline and Punish: The Birth of the Prison,* trans. Alan Sheridan (Harmondsworth: Penguin, 1977), 201, 202–203. As it happens, Babbage ran for parliament in 1833 on a platform heavily influenced by Bentham's Utilitarian philosophy.

25. Ibid., 205.

26. If the association of computing with this powerful, constitutive simultaneity seems a bit of a stretch, it is well to remember that we have been talking about the same Babbage who in his autobiography described its phenomenological equivalent. He told of a conversation with his close friend John Herschel in which Herschel "suddenly asked whether I could show him the two sides of a shilling at the same moment." Babbage proposed holding the coin up to a mirror, but Herschel replied by spinning the coin on the table in front of them, thus producing a "method of seeing both sides at once." This method of employing the eye's so-called persistence of vision to see two images merged, each over and within the other, was much later to be formalized by others as the thaumatrope, an early step toward cinema. See Babbage, *Passages,* 140–141.

27. George Boole, *An Investigation of the Laws of Thought on Which Are Founded the Mathematical Theories of Logic and Probabilities* (New York: Dover, 1963), 1. It is interesting that another early commentator on computing, Charles Sanders Peirce, should take up Boolean logic to develop his theory of semiotics and with it a still influential reading of the photograph. See Peirce's "Logic as Semiotic: The Theory of Signs" (c.1897–1910) in Justus Buchler, ed., *Philosophical Writings of Peirce* (New York: Dover, 1955), 106. A decade before, in 1887, Peirce had published an essay on computer logic and the human mind, "Logical Machines," in the first volume of the *American Journal of Psychology* (165–170). Thanks to Are Flågan for bringing this essay to my attention.

28. In fact, it was not until 1937 that C. E. Shannon proposed applying Boolean algebra to problems associated with switching circuits and thereby established the possibility of a binary electronic computing system.

29. This is the theme of all of Derrida's work. For a very brief summary, see *My Burning with Desire,* 178–180. The suggestion that deconstruction be brought to the logic of computing is not a new one. Emmanuel Levinas speaks of the "deconstruction of presence . . . leading us into the strange non-order of the yes and no, the imperious alternative, thanks to which computers decide about the universe, is challenged." See Emmanuel Levinas, "Jacques Derrida: Wholly Otherwise," *Proper Names,* trans. Michael Smith (Stanford: Stanford University Press, 1996), 60.

30. Babbage (1830), as quoted in Larry Schaaf, *Out of the Shadows: Herschel, Talbot and the Invention of Photography* (New Haven, CT: Yale University Press, 1992), 163.

9

1. For more on this series, see Andreas Müller-Pohle, "Analog, Digital, Projective," in Hubertus v. Amelunxen et al., eds., *Photography after Photography: Memory and Representation in the Digital Age,* exhibition catalogue, Siemens Kulturprogramm (Amsterdam: G+B Arts, 1996), 228–231; Andreas Müller-Pohle, *Partitions Digitales (d'après Niépce) I,* exhibition catalogue (Paris: Galérie Condé, 1997); and Andreas Müller-Pohle, *Digitális Partitúrák III,* exhibition catalogue (Budapest: Múcsarnok Kunsthalle, 1998). Even leaving aside the long history of artists' involving themselves with either technology or information (or both), there are also other more unexpected precedents for a photo-related data-art. An essay by Ronald Gedrim—"Edward Steichen's 1936 Exhibition of

Delphinium Blooms: An Art of Flower Breeding," *History of Photography* (Winter 1993)—reminds us that Steichen's first one-person exhibition at the Museum of Modern Art did not feature photographs but was in fact a large three-gallery display of his own flowers. As Steichen made clear in his statements on flower breeding (which he practiced on a grand scale), this exhibition was a technological as much as an aesthetic statement, a celebration of the cultural possibilities of genetic engineering.

2. See the commentary on this image in my *Burning with Desire: The Conception of Photography* (Cambridge, MA: MIT Press, 1997), 123–127.

3. Jean-François Lyotard, "Les Immatériaux" (April 1984), *Art and Text* 17 (April 1985), 50. Lyotard's notorious 1985 exhibition at the Centre Georges Pompidou, titled *Les Immatériaux,* aimed to question how "new materials" might be altering the traditional relationship between human beings and the materials they work. For Lyotard, "immaterials" (most of them apparently "generated from computer and electronic technosciences, or at least from techniques which share their approach") "question the idea of Man as a being who works, who plans and who remembers: the idea of an author." See also John Rajchman, "The Postmodern Museum," *Art in America* 73:10 (October 1985), 110–117, 171.

4. The U.S. Air Force recently designated a twenty-person squadron in South Carolina as an information warfare unit. A spokesperson said, "[Will this] cause us to buy less bullets because we can do as much damage electronically? Possibly." See *Newsweek,* June 10, 1996, 11. See also Steve Lohr, "Ready, Aim, Zap," *New York Times,* September 30, 1996, C1, C2, and David Denby, "My Problem with Perfection: The Consequences of the CD Revolution," *New Yorker,* August 26–September 2, 1996, 73–83.

5. For more on this connection, see Christine Tamblyn, "Computer Art as Conceptual Art," *Art Journal* 49:3 (Fall 1990), 253–256.

6. For more on Burn's work of this period, see Ian Burn, *Minimal-Conceptual Work, 1965–1970,* exhibition catalogue (Perth: Art Gallery of Western Australia, 1992).

7. Ian Burn, "Conceptual Art as Art" (September 1970), in *Dialogue: Writings in Art History* (Sydney: Allen & Unwin, 1991), 127. See also Burn's "The Language of Art" (1968), a text produced as part of a work of art titled *Systematically Altered Photographs;* it is reproduced in *Dialogue,* 120–124.

8. See my "Pictography: The Art History of Ian Burn," in *Dialogue,* xi–xix; Sandy Kirby, ed., *Ian Burn: Art: Critical, Political* (Nepean: University of Western Sydney, 1996), and Ann Stephen, ed., *Artists Think: The Late Works of Ian Burn* (Sydney: Power Publications, 1996).

9. See Haacke's public statement of 1971 about this work in Lucy R. Lippard, *Six Years: The Dematerialization of the Art Object from 1966 to 1972* (New York: Praeger, 1973), 227–229, and also Brian Wallis, ed., *Hans Haacke: Unfinished Business* (New York: New Museum of Contemporary Art, 1986), 92–97.

10. Thanks to Patrick Manning for sharing his research on and correspondence with Aaron Nabil.

11. For a detailed discussion of this project, see Lynn H. Nicholas, *The Rape of Europa* (New York: Knopf, 1994).

12. "Swedish report from Berlin: Hitler, would-be artist, has ordered colored photographs made of all Germany's historical paintings, in case the originals are destroyed by war.—Newsweek." See "Add Hitler Worries," *Art Digest,*

March 1, 1944, 9. "The paintings I have collected throughout the years were never meant for my private enjoyment but always for a gallery to be built in my native Linz on the Danube. That this request be met is my sincerest wish." Adolf Hitler, *My Private Will,* Berlin, April 29, 1945, 4 A.M.

13. Sigmund Freud, "A Note Upon the 'Mystic Writing Pad'" (1925), in Philip Rieff, ed., *Freud: General Psychological Theory* (New York: Collier Books, 1963), 207–212. Jacques Derrida, "Freud and the Scene of Writing" (1966), in *Writing and Difference,* trans. Alan Bass (Chicago: University of Chicago Press, 1978), 196–231.

14. As Derrida reminds us, the word *arkhé* names at once the commencement and the commandment. See Jacques Derrida, *Archive Fever: A Freudian Impression,* trans. Eric Prenoxitz (Chicago: University of Chicago Press, 1996), 1.

15. For more information on these projects, see the electronic bulletin board of the National Initiative for a Networked Cultural Heritage at NINCH-Members@cni.org.

16. Mark Dery, *Culture Jamming: Hacking, Slashing, and Sniping in the Empire of Signs,* Pamphlet #25 (Westfield, NJ: Open Magazine, July 1993).

17. The story appeared in one form or another on over 170 television programs (including *A Current Affair, Dateline, The Tonight Show, Good Morning America, World News Now, CNN Newshour,* and *NBC Nightly News*), on nine radio programs, in over fifty newspapers or magazines (including the *New York Times,* the *Vancouver Courier,* the *Economist, Fohla de Sao Paolo, Ms., New Woman, Playboy,* the *San Diego Union Tribune, Chicago Tribune, San Francisco Examiner,* the *Seattle Times,* the *Oregonian,* the *Los Angeles Times,* and *New York Post*) and has so far been discussed in three books.

18. Vamos and his associates (principal among them are Melinda Stone and Matthew Coolidge) have gone on to a number of other projects that concentrate on creatively manipulating the culture of information. For one such project, see Kate Haug, "The Human/Land Dialectic: Anthropic Landscapes of the Center for Land Use Interpretation," *Afterimage* 25:2 (September–October 1997), 3–5. In this context, it is worth noting the efforts of rtmark.com, a cooperative established in 1991 to further anticorporate activism by channeling funds from donors to "workers for sabotage of corporate products." On September 8, 1998, for example, rtmark.com announced that a group of Internet activists supporting the Mexican Zapatistas was going to attempt to disable the Web sites of the Frankfurt Stock Exchange, the Pentagon, and Mexican president Ernesto Zedillo by swamping them with demands from a system called FloodNet (which, according to rtmark.com's publicity, has been described by the FBI as "worldwide electronic insurrection").

19. Samuel Weber, "Television: Set and Screen," in *Mass Mediauras: Form, Technics, Media* (Stanford: Stanford University Press, 1996), 108–128.

20. Jean Baudrillard, "Requiem for the Media" (1972), in John Handhardt, ed., *Video Culture: A Critical Investigation* (Rochester: Visual Studies Workshop Press, 1986), 140.

21. For histories of these early cyberart experiments, see Jonathan Benthall, *Science and Technology in Art Today* (New York: Praeger, 1972), and Douglas Davis, *Art and the Future: A History/Prophecy of the Collaboration Between Science, Technology and Art* (New York: Praeger, 1973).

22. Laura Kurgin, "You Are Here: Information Drift," *Assemblage* 25 (December 1994), 17.

23. Laura Kurgan, *Usted Está Aquí/You Are Here: Architecture and Information Flows,* exhibition catalogue (Barcelona: Museu d'Art Contemporani de Barcelona, 1995), 128.

24. As Derrida recounts, "This is what happens with a virus; it derails a mechanism of the communicational type, its coding and decoding. On the other hand, it is something that is neither living nor nonliving; the virus is not a microbe." Peter Brunette and David Wills, "The Spatial Arts: An Interview with Jacques Derrida," in Peter Brunette and David Wills, eds., *Deconstruction and the Visual Arts: Art, Media, Architecture* (New York: Cambridge University Press), 12. See also Richard Dienst, "Derrida and the Televisual Textual System," *Still Life in Real Time: Theory After Television* (Durham, NC: Duke University Press, 1994), 128–143.

INDEX